AMERICAN IMAGES: PHOTOGRAPHY 1945-1980

EDITED BY PETER TURNER

AMERICAN IMAGES: PHOTOGRAPHY 1945-1980

PENGUIN BOOKS/BARBICAN ART GALLERY

This exhibition is sponsored by · P E A R S O N ·

Penguin Books Ltd, Harmondsworth, Middlesex, England
Viking Penguin Inc., 40 West 23rd Street, New York, New York 10010, USA
Penguin Books Australia Ltd, Ringwood, Victoria, Australia
Penguin Books Canada Ltd, 2801 John Street, Markham, Ontario, Canada L3R 1B4
Penguin Books (NZ) Ltd, 182-190 Wairau Road, Auckland 10, New Zealand

First published 1985
Published simultaneously in hardcover by Viking and in paperback by
Penguin Books

Made and printed in Great Britain by Balding & Mansell Limited
Typeset in Bodoni by Transcript Limited

Catalogue co-ordinated by Diana Souhami
Designed by Paul McAlinden

CONTENTS

ACKNOWLEDGEMENTS

It is Pearson's policy to sponsor each year one major artistic event. As most of our businesses have strong North American connections, we are particularly pleased to have the chance to be involved in the **American Festival** and to sponsor this illuminating exhibition of **American Images.** We are also delighted that Penguin Books, which is part of the Pearson group, is publishing the catalogue and adding to the enjoyment of the exhibition.

Michael Blakenham
Chairman, Pearson plc

Recent American photography owes a considerable debt to Walker Evans (1903-75) to whose memory this catalogue is respectfully dedicated.

Credit must go to Gerry Badger for first suggesting an exhibition on this scale and participating in its early stages. Suppport was provided by Ansel Adams (1902-84), Beaumont Newhall and Mike Weaver as Patrons of the project. The Festival of America provided the perfect opportunity to show the exhibition. The support of Pearson plc, the sponsor who provided substantial funds towards the origination of the display and the British American Arts Association both ensured the exhibition's realization. To these two organizations, the Barbican Art Gallery is particularly indebted.

Peter Turner and John Benton-Harris have been the motivating force behind the show and without their unstinting efforts as organizers, **American Images** would never have happened. They in turn, would like to thank the many individuals, galleries and institutions who gave so readily of their time and enthusiasm. Russ Anderson and Maggi Weston of The Weston Gallery were instrumental in helping locate many pieces for the show. Lewis Baltz was also a valuable ally, offering advice and assistance over a long period. James Enyeart and The Center for Creative Photography, Tucson, Arizona, were very helpful, especially during initial research. Elspeth Moncrieff of The Barbican Art Gallery and Tom Gallagher in New York City offered great assistance as did Jeff Fraenkel of the Fraenkel Gallery and Peter MacGill of Pace MacGill. A.C. Cooper Ltd, London, provided a high level of sympathetic craftsmanship in preparing reproduction prints of valuable originals.

Individual and corporate lenders to the exhibition are credited beside the pictures they so generously allowed to be shown.

The Barbican Art Gallery

Special acknowledgement is due to the following for permission to use photographs:
Ansel Adams photographs: The Ansel Adams Publishing Rights Trust
Diane Arbus photographs: The Estate of Diane Arbus
Wynn Bullock photographs: Edna Bullock
Imogen Cunningham photographs: The Imogen Cunningham Trust
Paul Strand photographs: **Beatrice Albee, Prospect Harbor, Maine** 1945, copyright © 1971, The Paul Strand Foundation, as published in **Paul Strand: A Retrospective Monograph, The Years 1915-68** Aperture, Millerton, New York, 1980; **Church on a Hill, Northern Vermont** 1945, copyright © 1950, 1977, The Paul Strand Foundation, as published in Paul Strand, **Time in New England** Aperture, Millerton, New York, 1980; **Tombstone and Sky** New England, 1946, copyright © 1950, 1977, The Paul Strand Foundation as published in Paul Strand, **Time in New England** Aperture, Millerton, New York, 1980; **Schoolboy, Charente, France** 1951, copyright © 1971, The Paul Strand Foundation, as published in **Paul Strand: A Retrospective Monograph, The Years 1915-68** Aperture, Millerton, New York, 1980; **Young Boy, Gondeville, Charente, France** 1951, copyright © 1976, The Paul Strand Foundation, as published in Paul Strand, **Sixty Years of Photographs** Aperture, Millerton, New York, 1976
W. Eugene Smith photographs: The heirs of W. Eugene Smith
Dan Weiner photographs: Sandra Weiner
Edward Weston photographs: Arizona Board of Regents, Center for Creative Photography
Minor White photographs: The Minor White Archives, Princeton University

FOREWORD

'SOMETHING IS HAPPENING HERE BUT YOU DON'T KNOW WHAT IT IS, DO YOU, MR JONES?'

BOB DYLAN – BALLAD OF A THIN MAN

This remark was contributed to the annals of popular music in 1965 – in the middle or epicentre of the period covered by **American Images — Photography 1945-1980.** When used as a talisman and quoted in the context of this exhibition, it only serves to act as a challenge. No one can have lived through the period since VE and VJ days without being aware of something cataclysmic 'happening' in the land of Emerson's Utopia. Bob Dylan, messiah to the kids of the sixties, never intended his chorus to be revived in such an alien context as here but the sniping, questioning attitude he engendered among his devotees has been the *modus operandi* of this exhibition and the instance of the **American Festival** the perfect occasion on which to unveil this show. For **American Images** set out from the beginning to be an exposé of the development of post-war American culture, as witnessed through the eye of the camera lens. The result proves to be a broad, analytic view of this period of American photography. Yet behind the selection of each image is the awareness that it was created in a fuller social and artistic context and never in isolation.

During the years 1945-80 – from the Marshall Plan to the abortive rescue of the Iranian hostages, from Zanuck's **The Longest Day** to Coppola's **Apocalypse Now** – what 'happened' was that America experienced the most turbulent times socially and politically, and the most creative times culturally. In this period the military and economic strength of the country, irresistible in 1945, has been sapped by the burdens of empire, and demoralized by internal conflicts. Her military dominance has been balanced by that of another 'super-power', her political influence countered by socialist advances even to the neigbourhood of her shores, and her economic supremacy challenged by the assiduity of the Orient. Yet in that same period the cultural hub of the world has been relocated from Europe to America. Her corporate and personal wealth has supported a flowering of talent in both the 'serious' and popular arts that is out of all proportion to anything that had happened in America previously and as stimulating and divisive as anything that happened in Moscow, Berlin, Paris or London before and immediately after, the First World War. Can anything be achieved by a study of American culture over the last four decades as seen through the lenses of its photographers? The answer must be a new perspective that, while the country might still seem as potent a military and economic force as forty years ago, the experience of the period has given its countrymen a greater awareness of the transience of success and the frailty of power.

Bob Dylan's refrain was clearly aimed in the most acerbic tones at a 'Mr Jones', a character of Welsh or British blood, not at someone of more obvious American extraction or name. So the remark becomes a greater challenge to this exhibition to be an informed anaylsis of one of the most striking of America's post-war cultural developments, from the British point of view. However much Britain might have been subjected to the all-pervading influence of modern American affairs upon her way of life, the exhibition has tried to achieve a non-partisan and distanced perspective on the most formative, dynamic, and yet potentially destructive periods of America's history. Some might say that it is too recent a period of history for us to gain appropriate distance, and thus a balanced perspective; others might say that the British have become as much absorbed into American culture and influence as any other race, and we are therefore unable to divorce ourselves sufficiently to be able to judge properly at all. The memories and shocks of Dallas, Saigon, Kent State and Watergate, are still with us as much as those of Suez, Belfast, Brixton and Port Stanley, driving us to search out our own past as we search the past of others. The perspective works on so many different levels that **American Images** refers to us all as we view it, in as many poignant ways.

To conclude with another American song writer's words that perceptively reflect the poignancy, futility and repetition of change as well as the inevitability of rise and fall, Don Van Vliet, echoed later by David Byrne, huskily asserted: 'The same as it ever was!'

John Hoole
Curator
Barbican Art Gallery

INTRODUCTION

This exhibition and book which chronicles thirty-five impor-
tant years in American photography, is not as it may first
appear a history in the factual, impartial, scrutinizing sense;
nor is it truly a survey, with that word's implications of
exactitude. Even so, it contains elements of both. Nor have I
attempted a celebration of American ideologies, though this
can be found in the grouping that has been created. No,
American Images is more an investigation. An attempt to
uncover and map (in a rough, hand-drawn sort of way) a
particular passage for photography in the United States. The
journey is from one predominant form, humanism, to another,
best described as formalism. My aim has been to examine,
visually, why those good-natured sometimes avuncular pic-
tures of the post-war years should be replaced by the deman-
ding, testing documents so characteristic of photography in the
late 1970s. And I have questioned, too, why American photo-
graphs, images that have influenced picture-making interna-
tionally, should look the way they do.

As well as bearing witness to major and rapid alterations
in the status of photography as a cultural manifestation, these
thirty-five years saw tremendous changes in the social, political
and economic landscape of America. My proposition was to use
one as the measure of the other. To look beyond the sometimes
enclosed and self-referential world of photographers and place
their work within a broader scenario. Beyond the medium
itself lay America's other visual arts, and then her broader
cultural myths and mores – from automobiles and architecture
to literature and rock and roll. When Bob Dylan sang that
'something is happening', he was not just addressing America's
youth, but the whole world.

Should it seem curious that an Englishman should be so
concerned with American photography when we have a strong
and viable tradition of our own, one need only look to the
recent past for an answer. In the early sixties when Marshall
McLuhan in his book **Understanding Media**, foresaw the world
as a global village he predicted a revolution in information
technology that would change our cultural concepts. 'We have
become irrevocably involved ... with each other' was his view.
Thus the embracing sweep of American culture and counter-
culture has travelled. And if jeans and fast food are not yet a
total part of British collective consciousness we have all
learned at least a little of their homeland from films, television
and the transmitted self-confessions of a thousand rock 'n
rollers. For photographers, America has another significance,
one that transcends the pervasive internationalism of Levis,
Coke and hamburgers. American photography and photo-
graphic culture has been at the core of fundamental changes in
the way the Western world views and responds to photographs.
From the elevation of mass-market magazine photographers to
demi-god status, to the emergence of a multi-million-dollar art
market in fine photographs, America has been the epicentre of
a massive movement to legitimize this medium as a major and
accessible form of expression and communication.

Perhaps more than ninety per cent of this activity has

occurred over the past four decades, but its roots lie further
back. As a young nation untroubled by the pressures of a
constrained visual tradition, the United States was uniquely
sited to take on a mechanical means of picture-making. The
announcement of photography in 1839 was well coincident with
America's opening-up; it was an exciting extension of man's
technological and creative aspirations in a land that fed on the
spirit of pioneering. Even so it was not until the early twentieth
century, with the publication of Alfred Stieglitz's monumental
journal **Camera Work** (1903-17), that concepts of art joined
those of commerce in the minds of America's best practition-
ers. Stieglitz's public struggle to provide a home for the
avant-garde eventually came to a halt, but not before founda-
tions were laid. The years separating United States involve-
ment with World War I from her signing a peace with Japan in
1945 saw the beginnings of new directions. The photographer
functioning purely as an artist, already demonstrated by
Stieglitz, was a role taken up by Edward Weston. Charles
Sheeler, established as a painter, tackled formal problems with
a camera that encouraged cross-currents between media.
Documentary photography transcending its utilitarian role
was ably shown by Walker Evans in the 1930s with publication
of his seminal work **American Photographs.** The power of
photographs to persuade and change (a legacy from Lewis
Hine and Jacob Riis) was used by Jessie Tarbot Beales in the
1920s and later by photographers of the Farm Security
Administration project. And pictorial elegance allied to the
world of fashion and high society was explored at length,
notably by Edward Steichen. In short (for this is a vastly
contracted account), the close of World War II saw a stage set
for photography's ascendancy.

The panorama that followed, one of development, change
and exchange, is discussed in this book by Gerry Badger.
Additionally, Lewis Baltz and Jonathan Green bring detailed
perspectives to bear on issues critical to the medium's growth.
Finally, Bill Jay argues a case for the relevance of humanism,
our starting-point, at a time when it seemed to have almost
vanished from the mainstream. Although facts are indisput-
able, the relevance of them to such a recent history is
necessarily open to interpretation. With this in mind, diverg-
ing and sometimes contradictory views are expressed in these
essays. Far from regretting a lack of specific agreement
between these contributors, I welcome it as a sign of vitality
and willingness to admit the complexities surrounding the
medium. However, what I would like to consider here is the
rationale supporting the selection of pictures that follows.

It must be said that this is a very partial account of
American photography. It was once suggested that there are
more photographs in the world than bricks; should this be even
partially true, I am guilty of many omissions. However, taking
the world outside photography as a starting-point I have
attempted to locate works that function as acts of correspond-
ence – images reflective of their place and time. Imagine a
chronology of events that begins with optimism after victory

9

over Japan, expands into an economic boom which fosters growth and development, passes through massive technological changes and great increases in financial opportunity and ends riding a wave of recession. Or consider public paranoia at the advance of communism, a war in Korea, another in Vietnam, one President assassinated and another resigning in disgrace, a country torn by civil disturbance with political conventions held under the protection of combat troops armed with rifles, bazookas and flame-throwers. Imagine, too, a chronology that involved surfing, Woodstock, peace, love, LSD, meditation, earnest learning, a growing art market and social responsibility. Finally, imagine 'The American Dream' and how artists might respond to its fables and view its realities. An accepted duty of artists is to question and it is to this concern I have looked when choosing material.

Inevitably some serious contributors to photography are not represented, in certain instances by their own choice. Those who are shown have been placed where their work seems most apt, often at the time when it surfaced and began to influence what, photographically, was to follow. It should, then, be acknowledged and recognized here that these photographers have gone on to refine and sometimes change their direction. This said, I believe the strengths and substance of America's contribution to the medium is clearly shown. I think, too, that the images are worthwhile, frequently innovatory and consistently supportive of photography's recently accepted claim to be a twentieth-century art of particular significance.

Peter Turner

As a New Yorker, my first contact with the medium that became my profession was from the street photographers and photo-journalists that feature in the first half of this exhibition. Their pictures contained the pulse of my city – they told me why it seemed worth becoming a photographer. Now, after twenty years in Britain, the visual education I received then still informs me. However, my concern with 'American Images 1945-1980' is not to examine my personal evolution, but to reveal the rich and exciting diversity of post-war photographers that this medium has attracted – comedians, critics, detectives, social workers, writers, poets, story-tellers, intellectuals, musicians and magicians.

The compilation of talents assembled here gives us a small glimpse into the alchemy they have practised over this time period and reminds me of a particular observation by my late friend and teacher Alexey Brodvitch: 'America is vitality. It should be an endless inspiration to anyone with a camera. The strange combinations that take place here every day are an enigma which could happen nowhere else.' I believe that photography has its own unique possibilities and that it serves us best when taken directly from life – through accidental revelation, by imposing our instinctive sense of order on a turbulent and chaotic world and by arresting significant moments of time. In the words of the philosopher Francis Bacon: 'The contemplation of things as they are, without substitutions or imposture, without error or confusion, is in itself a nobler thing than a whole harvest of invention.'

John Benton-Harris

PETER TURNER
As editor for nine years of **Creative Camera** and co-founder of an independent photographic publishing house, Turner is most closely identified with photography in print. He has written for many magazines, organized a large number of exhibitions and contributed writings to fifteen books and catalogues. Turner has exhibited his photographs widely and received a major award from the Greater London Arts Association. He works now as an independent photographer and teacher.

JOHN BENTON-HARRIS
A native New Yorker, Benton-Harris has been resident in Britain since 1965. Known on both sides of the Atlantic for his incisive, often witty documentary photographs, he has been widely published in books and magazines. In 1978 he received three Merit Awards from The Art Directors Club of New York and he has had two major awards from the Arts Council of Great Britain. Benton-Harris's works are in public collections in Britain and the United States.

GERRY BADGER

FROM HUMANISM TO FORMALISM:
THOUGHTS ON POST-WAR AMERICAN PHOTOGRAPHY

'All my pictures have their originating impulse in the contemporary American scene. Some of the things that have made me want to paint, outside of other paintings, are; American wood and ironwork of the past; Civil War and skyscraper architecture; the brilliant colors on gasoline stations, chainstore fronts and taxi-cabs; the music of Bach; synthetic chemistry; the poetry of Rimbaud; fast travel by train, auto and aeroplane, which brought new and multiple perspectives; electric signs; the landscapes and boats of Gloucester, Mass; 5 & 10 cent store kitchen utensils; movies and radio; Earl Hines's hot piano and Negro jazz music in general.'

This famous 'catalogue' of the painter, Stuart Davis, has been uttered in substance by a number of leading American painters of the twenties and thirties, among them Charles Sheeler, Charles Demuth, Edward Hopper, and Ben Shahn. Similar sentiments might have been expressed by many of the Abstract Expressionists of the fifties, and trumpeted by the Pop artists of the sixties. It is not a particularly profound statement in itself: it simply reiterates the salient fact that the central force behind American art since the 1920s has been the reality of the American experience. Most worthwhile art is culture specific, and culture surely must be a specific issue in a young, dynamic society seeking to appropriate the pre-existent cultural legacies of others. Inevitably, and properly the presence of the land, its peoples, the new myths and symbols being created, had to effect a more persuasive pull upon its artists – modern society's potential soothsayers and shamans after all – than transposed models in art and thought, beguiling and influential though they were.

The photographer, more so than any other visual artist, must be prescribed, some may say hamstrung, by the *mise en scène* before his or her eyes, stimulated and challenged more by immediate environment than by anything else. The photographs in this exhibition not only represent a highly visible American tradition, they chart directly, though hardly unequivocally, the post-war American experience, be it wet-dream or nightmare.

A pertinent starting-point for any discussion of post-war American photography is just prior to the outbreak of the war in Europe. In 1936, a fledgling art historian, Beaumont Newhall, was engaged by the Museum of Modern Art in New York to compile a retrospective overview of photography in celebration of its forthcoming first centenary, an exhibition entitled, modestly enough, **Photography 1839-1937.** Assembled from Newhall's researches in the United States, Great Britain, and France – but, significantly, not Germany – this was the first 'modern' survey of the medium. There had been previous, isolated shows in Europe of a broadly similar, though less ambitious vein, but certainly this was the first serious historical and aesthetic consideration of photography countenanced by a major American art institution.

Newhall's comments thirty years later indicate that it was *terra incognita*, not only for him but for his willing patrons.

'Had I known of the work of Albert Renger-Patzsch and August Sander I certainly would have had representative collections in the exhibition . . . I did not know that there were other historians of photography in the United States. Had I met the late Edward Epstean, who was translating Potonnie's History of the Discovery of Photography, and the late Robert Taft, whose monumental Photography and the American Scene was in manuscript, I would have been saved much effort.'★

Despite its shortcomings, the exhibition was a conspicuous success. Reaction was favourable enough for the board of the Museum to initiate a regular programme of photography exhibits and institute a permanent department of photography, which opened officially in 1940, under Newhall's directorship.

Just as fundamental as Beaumont Newhall's historical survey was the Museum's first one-person exhibition a year later, **American Photographs,** by Walker Evans. Whether by luck or by judgement, the Museum's first involvement with the photographic medium seems inspired. Not until the sixties would it become generally apparent that Evans was the most important and influential American photographer of his generation, perhaps of the twentieth century. But in his eloquent catalogue afterword to Evans's spare and understated imagery, Lincoln Kirstein was in little doubt. His prescient words must have appeared to many at the time like so much precocious hyperbole. Today they seem reasoned, perceptive and measured.

'Walker Evans is giving us the contemporary civilization of eastern America and its dependencies, as Atget gave us Paris before World War 1 and as Brady gave us the War between the States.

This at first may seem an extravagant claim for a young artist in relation to a subject as vast as contemporary American civilization. But after looking at these pictures with all their clear, hideous and beautiful detail, their open insanity and pitiful grandeur, compare this vision of a continent as it is, not as it might be or as it was, with any other coherent vision that we have had since World War 1. What poet has said as much? What painter has shown as much? Only newspapers, the writers of popular music, the technicians of advertising and radio have in their blind energy accidentally, fortuitously, evoked for future historians such a powerful monument to our moment. And Evans's work has, in addition, intention, logic, continuity, climax, sense, and perfection.'

Evans's not over-large, nor especially broad *oeuvre* spans twentieth-century American photography, from the thirties to the eighties with perhaps a slight hiatus during the late forties and early fifties. At its zenith, in 1938, his work integrated, summarized, and partially subverted the three dominant strains in American photography at that time, and was crucial

★Newhall, Beaumont 'This was 1937', **Popular Photography,** May 1967, vol. 60, no. 5.

in presaging an understanding of the medium fostered by many of the major figures of the sixties and seventies. It also paralleled several fundamental issues in twenties and thirties American painting – namely, the focusing upon a native vernacular (Stuart Davis's catalogue might have been tailored specifically for Evans), the insistence upon the primacy of the object as subject, and the links with nineteenth-century transcendentalism. Define Evans and you – almost – define the mainstream.

Evans's approach can be termed either formalist, poetic, or transcendental-documentary, a fact that indicates its elusive nature. It stands at the centre of photographic expression, at least the mode of photographic expression which gained a powerful ideological leadership in the sixties. Of all the documenters of the thirties, Evans's voice was loudest in advocating the creative independence of the photographer and the medium and in calling for a liberation of the traditionally-held role of documentary. His work, rich, complex, subtle, demands a reading that can oscillate between art and document, fact and artefact, illusion and reality, form and content. He points directly to the sixties.

At the end of the thirties, there were three primary photographic traditions engaging the attentions of the small band of serious photographers in America, with a fourth yet to be transplanted from Europe. Firstly, there was the tradition to which Evans ostensibly belonged, the social documentary movement, brought to a peak by the Depression and the New Deal under the auspices of the Farm Security Administration's Photographic Unit. It is one of those apt ironies of history that the work completed by Evans during his eighteen-month tenure with the Unit has come to be regarded as its most profound achievement. Art, it would seem, has outlasted even highly superior propaganda.

The second tradition, photo-journalism, uses many of the tenets of social documentary. However, photo-journalism is less radical, less overtly propagandist, and more superficial. Its propagandist thrust is as much commercial as political. American picture magazines have hardly been dedicated to the subversion of the status quo. Photo-journalism might also be characterized as social-documentary with a formalist bent. The form is the page and the mode of expression, given the largely middle-American audience, simplification and over-statement. A lot of mystique has been formulated around the photo-journalist, his 'concern', and the fanatical, devoted attention given to devising image and text layout. Much of this attention is devoted to formalist doodling, to decorating the page rather than unfolding narrative. As Jonathan Green has written: '**The photo-essay, rather than being as Life has stated, "the best and most complex product of photography ... a distinct art form of great editorial complexity and sometimes profound emotional and aesthetic impact," was possibly photography's worst and easiest product. It sorely hindered the possibilities of individual expression since it obscured the photograph's power to provoke, challenge, or disturb. The photo-essay reinforced the popular notion of photography as simplistic, immediate, thematic, and dialectic, relegating photography's use to only the sensational or the pictorial. A great leveller of individual differences, it saw all people through sentimental eyes, as either degraded or noble.'**

The third elemental photographic tradition at work in 1938 was formalism. Its chief prophet at that time was Alfred Stieglitz, its most dynamic practitioners Edward Weston and Ansel Adams. As in all broadly-based artistic traditions,

individual philosophies tended to vary, but serious American art photography in the thirties, and since, might usefully be characterized as 'transcendent formalism' – going beyond a representation of the material objects. Through the agency of a literal yet concentrated depiction of the things of this world – photography's singular *métier* – a powerful tension between object and image is created. The photographer seeks to sustain this dialogue, setting up, as Barbara Novak put it, '**an objectivity so profound that it becomes a form of impersonal expressionism.**'★

However, the formalist tradition remained the conscious province of the avant-garde, and the avant-garde's foothold in utilitarian, puritan America was always precarious. Despite the imprimatur of the Museum of Modern Art, the leading lights of the art photographic vanguard – Evans, Strand, Weston, were known only to a scattered few. Nevertheless, two further small but significant advances for creative photography were made at the end of the thirties. In 1938, Edward Weston received a Guggenheim Fellowship – the first ever awarded to a photographer. And a year earlier, Laszlo Moholy-Nagy had included a photography course in the curriculum of his New Bauhaus at The Institute of Design in Chicago, thereby adding a fourth tradition, that of European experimental formalism, to a receptive American photography.

On a broad front, the displacement to America of representative members of the European art avant-garde was of immense significance. Senior figures like Moholy-Nagy, Duchamp, Mondrian, Ernst, and Albers, detonated the explosion of Abstract Expressionism and the School of New York. The American avant-garde, after decades of awkward subservience to Paris, finally prevailed. By the end of the fifties, American painting, mass culture, literature, music and the performing arts, reflected a new-found *élan* entirely absent in the pre-war days of provincial deference.

Yet for a time photography, true to habit, lagged behind the other arts. Popular, utilitarian notions about the medium stubbornly remained. The twin traditions of social documentary and photo-journalism together continued to represent the dominant ethos in American photography throughout the fifties, despite the ever-increasing rumblings of the avant-garde. Photography stayed trapped generally in the *Zeitgeist* of the thirties.

But distortedly so. The documentary ethos rested upon the humanist idealist belief that photography was a socially progressive tool. The camera's proper function was to persuade and inform. The humanist documentary photographer, though often claiming vague, liberal leanings, would still contend that there was a clear distinction between persuasion and propaganda, between the dissemination of fundamental truths and ideological tenets. Some photographers were aware of the ideological stances of the magazines for which they worked, but many persisted in the assumption that their 'seeing' was objective, even if their editor's was not. Humanist documentary photography was guilty of self-deceit on a massive scale. There were photographers who consciously utilized photography as a radical critique of society's anomalies – though with the spectre of McCarthyism hanging over fifties America they were few, and even those few subscribed to the idea of 'pure' documentary, and the notion (in Edward Steichen's phrase) of the '**universal elements and emotions in the everydayness of life**'.

★Novak, Barbara **American Painting in the Nineteenth Century**, Praeger Publishers Inc., New York and The Pall Mall Press, London, 1969.

The tenor then of humanist documentary photography in its journalistic manifestation of the fifties was acquiescence, an affirmation and promotion of the proper image, a calling forth of mass cultural values in the name of universal and eternal verities. Far from being aligned on the left against the modernist, formalist, arty-crafty conspiracy, most 'documentary' photography of the period was aligned firmly, albeit often unconsciously, on the right.

The great American social documentary tradition, a tradition begun by those radical humanists, Riis and Hine – was appropriated almost entirely by the establishment. Firstly, Willard Morgan, and then Edward Steichen, successors to Newhall at the Museum of Modern Art, eschewed formalist photography largely in favour of documentary. They favoured also photography's journeymen, its professionals rather than its artists. The two prime forces in fifties photographic criticism, Bruce Downes, editor of **Popular Photography** magazine, and Jacob Deschin, critic for the **New York Times,** championed the same cause. Most of the major photographic shows at the Museum of Modern Art up until 1955 concentrated upon the journalistic mode, culminating, in that year, in that brontosaurus of a show, **The Family of Man,** Steichen's gargantuan paean to humanist documentary photography, and more specifically, to the popular aesthetic of the picture magazines.

The Family of Man opened at the Museum of Modern Art in January 1955. It contained 503 photographs by 273 photographers. The leitmotifs of the exhibition, listed by Dorothy Norman under Steichen's direction, were, '**creation, birth, love, work, death, justice, the search for knowledge, relationships, democracy, peace, and opposition to brutality and slaughter.**' The images, as befits such grandiose themes, were mounted in an elaborate setting designed by the architect, Paul Rudolph, a setting which might have been devised specifically as a warning against commissioning architects to design photographic exhibitions. Rudolph, not unnaturally, saw the images as elements in prefabricated building structures, and displayed them accordingly, a decision which certainly reinforced the pomposity of the whole enterprise.

As an enterprise, which in essence it was, **The Family of Man** fulfilled all expectations, drawing some 3000 visitors a day during its New York run alone. The enthusiasm with which it was received could hardly have been equalled by any show, photographic or otherwise, and proved the existence of a massive potential audience for a certain kind of photography. It toured forty-one countries in three separate versions, attracting a total audience of around nine million. The book of the exhibition has sold to date some four million copies.

Much has been written about **The Family of Man,** both at the time and in retrospect. A lot of this criticism has been negative. Even Jacob Deschin damned it with faint praise, echoing the feelings of photographers, if not the public. The exhibition was, in his words, '**essentially a picture story to support a concept ... an editorial achievement rather than an exhibition of photography in the usual sense.**'

Probably the most astringent criticism of the show, however, has emanated from the left, in particular from Susan Sontag, although her thoughts have been echoed by other commentators. In her book **On Photography** she indicts the exhibition primarily for its assumption that there is a human condition or nature that is universal. '**By purporting to show that individuals are born, work, laugh, and die everywhere in the same way, The Family of Man denies the determining**

weight of history – of genuine and historically embedded differences, injustices, and conflicts.' The human experience is universalized, and thereby trivialized, into a series of simplistic and woolly-minded – though undoubtedly liberal – platitudes. The real complexities of life, rooted in the social order, are overlooked.

The Family of Man presented a rag-bag of certified, nominally archetypal notions in a form easily digested by a mass audience, whose presiding values it both summarized and confirms. Such presentation tended to militate against anything but vague superficialities, and certainly against formal quality. **The Family of Man** was, in short, the embodiment of fifties photo-journalistic values, their zenith. It was also the last great fling of this mode, a mode that was becoming less relevant both to photographers and, though more gradually, to the communications industry.

'Meaning' was the problem increasingly felt by serious photographers of the fifties, and might explain why **The Family of Man** in itself, in spite of its enormous public success, had little perceptible effect on the subsequent direction of American photography. Photographers throughout the decade felt increasingly that the collective hand of the editorial staff in what might be termed 'public' photography – from Steichen on down to every editor, art director, and layout specialist in every magazine – influenced inordinately the shape and very meaning of published work, the work conceived at source by one individual. W. Eugene Smith came to be regarded as a hero among magazine photographers not simply in recognition of the calibre of his work, but because he persistently kicked against the editorial system, resigning from **Life** magazine twice and remaining resolutely the scourge of editors.

The number of those who might be counted amongst photography's avant-garde was on the increase. They realized (as the best and most acute photographers probably always had realized) that photography does not lend itself easily to the unequivocal statement and to the explication of large issues. A simple reaction to **The Family of Man** could not resolve the thorny issue of meaning. Indeed that particular issue will run as a constant, tantalizing undercurrent through much of sixties and seventies photography. Yet certainly the shift towards personal, interior concerns, seems to have been engendered by the belief that in so doing a more honest, heartfelt, meaningful and relevant form of photographic expression might be attained.

The career of Aaron Siskind is exemplary in this respect. During the late thirties and early forties, Siskind was one of the leading lights in the **Photo-League,** a New York organization of socialist-minded documentarians, whose collective programme was to re-invigorate the Riis-Hine tradition. Siskind was instrumental in organizing the **Harlem Document,** the most ambitious project undertaken by the League. However, he incurred the ideological wrath of some of the more politically idealist members of the group with his **Tabernacle City** study, a documentation of Martha's Vineyard architecture which headed towards the formal. They saw a recidivist in the making. In 1944, Siskind spent the summer in the fishing village of Gloucester, Massachusetts, and made a series of still-lifes of rotting strands of rope, a discarded glove, two fish-heads, and other objects he found along the wharves and shoreline. '**For the first time in my life subject matter, as such, had ceased to be of primary importance. Instead, I found myself involved in the relationships of these objects, so much so that these pictures turned out to be deeply moving**

and personal experiences ... these photographs are psychological in character. This may or may not be a good thing. But it does seem to me that this kind of picture satisfies a need. I may be wrong, but the essentially illustrative nature of most documentary photography, and the worship of nature *per se* in our best nature photography, is not enough to satisfy the man of today, compounded as he is of Christ, Freud, and Marx. The interior drama is the meaning of the exterior event ... There are, I suppose, many ways of getting at reality. Our province is this small bit of space, and only by operating within that limited space – endlessly exploring the relationships within it – can we contribute our special meanings that come out of man's varied life. Otherwise, our photographs will be vague. They will lack impact, or they will deteriorate into just 'genre' as so many documentary shots do.'★

The village of Gloucester was distinguished as a place of inspiration for American artists. It is entirely appropriate that Siskind should discover there, for himself, American transcendentalism, around the time that American painters, specifically New York painters, were developing their own, contemporary inflexion of the genre tinged with surrealism and charged with the rhythms and energies of the New York streets that Siskind knew so well. Notwithstanding the importance of New England to him as a place of personal discovery, Siskind has always seemed happier in the city. His finest work is generally urban in character. His classic subject matter, of decaying, peeling, painted façades, evoked the same energies, and contains the same gestural and calligraphic elements so beloved of the New York School, in particular his close friend, the painter Franz Kline. Siskind, like a number of other photographers, became part of the New York School circle. He and a select few became habitués of the Cedar Bar, debated passionately the same issues, and took their work in parallel directions.

In 1952, formalist photography gained an important forum. A new magazine appeared for photographers, a venture subsidized by photographic people themselves. Its credo, announced in the inaugural issue, was quite specific: '**Most of the generating ideas in photography now spread through personal contact. Growth can be slow and hard when you are groping alone. It quickens when you meet other photographers who have worked and thought intensely about their medium ... Aperture is intended to be a mature journal in which photographers can talk straight to each other, discuss the problems that face photography as profession and art, comment on what goes on, descry the new potentials. We, who have founded this journal, invite others to use Aperture as a common ground for the advancement of photography.'**★

The statement was signed by Minor White, Dorothea Lange, Ansel Adams, Beaumont and Nancy Newhall, Dody Warren, Ernest Louie, Melton Ferris, and Barbara Morgan. A 'regular' subscription, for four issues, cost \$4.50, and for those taking out a 'sustaining' subscription, at \$25, there was the gift of an original, signed print by Ansel Adams – the image being of the photographer's choice. The editor and production manager, selected by the group, was Minor White.
As Jonathan Green points out in his essay (see page 52) under the guidance of White, **Aperture** was to become a vital force in American photography. It brought together individuals who truly felt alone and beleaguered in the climate of the times. **Aperture** was a rag-bag, to be sure, but a rag-bag that often contained some powerful images and that frequently sustained pertinent, trenchant, committed and cogent writing. Its energy sprang from Minor White, an intense, charismatic, almost

demented individual who bore the twin crosses of Roman Catholicism and homosexuality; the one willingly, the other perhaps not. Spirit however, could never quite vanquish flesh, which made his quest for the spirit ever more desperate. Ultimately such a personal quest had to be made alone. It would seem significant that when he died in 1976, the Minor White 'school' appeared to die with him, almost overnight, with few remnants or rites of passage.

White's urge to transform the material world into images resonant with personal experience may have seemed idiosyncratic, but was, in fact, one manifestation of a movement. Poets, novelists, painters, and performing artists all sought an art that was concerned with distilling personal experience, with immediacy, with process as the intuitive, spontaneous reflection of the unconscious. The watchword of American fifties art was 'process' – the doing of art for art's sake. It permeated every art form, from bebop and rhythm 'n blues, to 'action' painting, 'stream of consciousness' writing, 'method' acting. To 'experience', to feel, intuitively, directly, without inhibition, became the art form, with clear links to French existentialism. And the stuff of raw, undiluted experience was out there on the city streets or on the road.

The road, especially that linking the twin centres of fifties avant-gardism, New York and San Francisco, became, and remained an evocative symbol. The automobile, those fifties Dodges and Buicks, replete with a dazzling chrome sensuality, was a potent fetish. The road, the trail, the quest, the odyssey, had always been a powerful part of the American myth, synonymous with space and freedom. In the fifties, it became crucial, representing the restlessness, rootlessness, nervousness and alienation of the generation born just before or during the thirties, a generation touched to the quick by the traumatic world events of childhood.

In 1955, a Swiss photographer, an itinerant, disaffected fashion photographer turned photo-journalist named Robert Frank, received a Guggenheim Fellowship, due in no small measure to advocacy on his behalf by Walker Evans. Frank first came to the United States in 1947. By 1953, after several extended visits, he had inculcated himself precariously into the New York avant-garde circle.

The odyssey undertaken by Frank in fulfilment of his Guggenheim commitment, was a remarkable parallel to the criss-cross night dashes over the continent made in **On the Road** by *auteur*-protagonist, Jack Kerouac (later to work with Frank), and his fictional anti-hero, Dean Moriarty – from east to west, New York to San Francisco, and from north to south, Butte, Montana, to New Orleans and Florida, with Denver, Colorado, as a constant locus. The book Frank derived from his travels appeared first in Paris in 1958, entitled **Les Americains**, and was then launched upon a largely unsuspecting United States photographic community as **The Americans**, a year later. Introducing a Frank portfolio, his mentor Walker Evans succinctly outlined both the tone of the work and its radical position in relation to establishment sanctified photography, concluding with a devastating gibe at Steichen, a favourite target of his for almost thirty years: '**This bracing, almost stinging manner is seldom seen in a sustained collection of photographs ... It is a far cry from all the woolly, successful "photo-sentiments" about human family-hood, from the mindless pictorial salestalk around fashionable, guilty, and therefore bogus heartfeeling.'**

★Chiarenza, Carl **Aaron Siskind: Pleasures and Terrors**, New York Graphic Society, Boston, 1982.
★Szarkowski, John **Mirrors and Windows**, The Museum of Modern Art, New York, 1978.

14

The Americans has had a fundamental influence upon the course of post-fifties photography. It was perhaps the most influential single happening in American photography since the Second World War. Its impact upon publication was great, and immediate, even traumatic. And yet the book was hardly received with open arms by the photographic press. Amongst the adjectives used to describe Frank's images were 'sick', 'warped', 'joyless', 'dishonest', 'sad', and 'neurotic'. Arthur Goldsmith, in an article in **Popular Photography**, May 1960, called 'An Offbeat View of the USA', summed up the general tenor of most of the criticism, by diagnosing Frank as suffering from **'intense personal vision marred by spite, bitterness, and narrow prejudices.'**

Many commentators have attempted to pin down the radical nature of **The Americans**. At the time of publication, attention was focused primarily upon the book's iconography, specifically upon its doggedly downbeat tone. Frank dealt with a United States that Middle America preferred to ignore, particularly during the comfortable, prosperous Eisenhower years. Frank showed a seedy, grey America, the dark underbelly, populated by isolated, alienated people – hat-check girls, waitresses, truckers, midnight cowboys, 'niggers' and 'commie queers'. He showed a landscape of desolation, that seemed to consist entirely of highway detritus, dingy diners, decrepit automobiles and greasy gas stations, lit perpetually by the cold drizzle of an unfriendly dawn – an America, in short, filtered out of most Americans' consciousness, despite its ubiquity.

However, such an America had never been filtered out of the consciousness of the American artist. Frank's vision of sad cafés and sadder people is not so far removed from Hopper's, or Evans's, whose own **American Photographs** was a profound influence. **The Americans**, in several obvious places at the very least, 'quotes' Evans's book. And yet Frank's determinedly nihilistic, though not overtly polemical viewpoint, caused outrage and then puzzlement, for it lacked the mitigating virtues of Hopper's painterliness, or Evans's photographic eloquence. It seemed doubly damnable, attacking at one and the same time both the canons of what a foreigner might say about America, and the canons of accepted photographic good manners.

But the most vehement reaction to **The Americans** came from the photographic establishment, specifically the 'soft left', the advocates of classic photo-journalism. This led a number of later observers, among them John Szarkowski, to identify the book's style rather than its content, as the 'pharisaical' aspect of Frank. **'The subject of Frank's later pictures seemed tentative, ambivalent, relative, centrifugal; the photographer's viewpoint and the disposition of the frame seemed consistently precarious and careless – lacking in care.'** ★

This stylistic argument, however, might be carried too far. In his statement Szarkowski might have been proposing a definition of 'stream of consciousness' photography, which in the climate of fifties art and fifties New York photography, was hardly so radical, or even uncommon. Amongst other New York photographers, Sid Grossman, Louis Faurer, Roy de Carava, Leon Levinstein and William Klein all affected gritty, rough-and-ready styles of street photography akin to Frank's, in several cases much earlier than Frank. They did not, though, with the exception of Klein, attract either the attention or the critical flak drawn by Frank.

Klein's role as a stylistic influence at this time is an interesting one. His presence and importance in the mid-fifties, New York, avant-garde scene have largely been either overlooked or underrated. Klein's book on New York, his equivalent to **The Americans**, entitled **Life is Good and Good for You in New York; Trance Witness Revels**, was published as far back as 1956, and scored quite a success, much more so than Frank's *magnum opus*. The direct, confrontational, street-wise style, and energetic, zesty graphics of **New York** were quintessentially Beat – as was, of course, the book's full title. It made quite an impact on younger photographers – not simply the avant-garde, but commercial and advertizing photographers too. Klein in a sense might be said to be the acceptable face of Frank, and was as equally influential as a stylist, adding an upbeat, as it were, to Frank's downbeat.

Both its form and content exemplify the fifties, not, as some critics have suggested, as a reflection of the social and political mood of the country, but as a product of fifties culture. Frank, inspired in particular by Walker Evans, reworked an iconography familiar from American art and literature, and reworked it in a typically spontaneous, apparently casual, gestural, elliptical fifties manner.

But Frank was also an outsider, a recently arrived European. His view, intriguingly, was that of both insider and outsider, which might explain something of the book's acknowledged ambiguity and opacity. In an interesting critique Jno Cook argues against the customary, overtly metaphorical readings of **The Americans** in favour of a much more literal interpretation, the literal view of the New World seen afresh with appalled Old World eyes. **'The American, Frank says (and he says so over and over) has no culture, no history, no relationship to the land. America is like a land of children wearing masks, acting out roles with no comprehension of the self, no awareness of the infinity of history and humanity, no awareness of what is called culture.'** ★

If that view seems far fetched, one might take a close look at the vision of America made by Frank's supposed *bête noire*, Henri Cartier-Bresson. Cartier-Bresson, nominally a humanitarian optimist, had reserved his bleakest mood for the American continent. One might consider, also, how Frank's black sarcasm was tempered by his American followers of the sixties, notably Lee Friedlander and Garry Winogrand, and transformed into the cool irony of the insider. To paraphrase part of Alain Bosquet's text in the original French version of **The Americans**, if Frank, with his rather 'perverse pride', was giving American photographers 'lessons in civilization', he certainly found many adept, willing, and in some cases, masochistic pupils.

During the 1950s there was an increasing ground swell of photography that might be described as formalist or at least personally expressive rather than illustrative or functional. Many photographers, disenchanted with the sterility of the principal photographic market-place – the picture magazine, wanted to work independently, free of editorial constraint. Some actually did, carefully juggling two wholly separate aspects of their careers, work done on assignment and work done 'for themselves' – photography for money and photography for photography's sake. In the 1960s however, the previously rather forlorn hope of practising photography full-time, professionally, as a painter practises painting, suddenly became an attainable dream because of a radical shift in establishment values.

★Szarkowski, John **Mirrors and Windows**, The Museum of Modern Art, New York, 1978.

★Cook, Jno 'Robert Frank's America', **Afterimage**, vol. 9, no. 8, March 1982.

Photography was elevated to the academy and the museum – with caution at first, but then with ever increasing velocity. In one decade, from around 1963-73, the whole infrastructure for the support of the photographic artist, in the form of museum, gallery, and publishing interest, academic programmes, and critical commentary, expanded enormously. So much so that by the mid-seventies it exhibited comparable complexities, factions and rivalries, though not comparable status and money – as the whole apparatus sustaining painting and sculpture.

In 1962, Nathan Lyons, Aaron Siskind, Henry Holmes Smith, Jerry Uelsmann, Minor White, and several other teachers of photography founded the influential Society for Photographic Education (SPE). In 1964, the University of Texas purchased the Gernsheim Collection, of mainly nineteenth-century photography, for over a million dollars. In 1965 Massachusetts Institute of Technology asked Minor White to head a new Creative Photography Laboratory. In 1969, Nathan Lyons established The Visual Studies Workshop in association with the State University of New York at Buffalo. In 1972, the first chair in photography, the David Hunter McAlpin professorship, was offered to Peter Bunnell, former curator at the Museum of Modern Art in New York. In 1974, Cornell Capa established the International Center for Photography in New York. In 1975, the University of Arizona at Tucson founded a major archive and study centre, The Center for Creative Photography. In 1979, the SPE numbered over 1500 members. The same year Yale established a memorial chair and named Tod Papageorge the Walker Evans Professor of Photography. By 1980, there were photography and history of photography courses in universities in every state of the union.

The work of those who had laboured long and hard for the cause of fine photography during the years of neglect now bore fruit. Beaumont Newhall, Minor White, Ansel Adams, and the others forming photography's tiny vanguard saw decades of effort rewarded, although, ironically, it was more probably the commercial and populist success of **The Family of Man** rather than the intellectual success of **Aperture** or **The Americans** which raised the photographic consciousness of the establishment. Ironically, too, as the picture magazines declined (for complex reasons including the enormous expansion of television) the role of photographic education grew, primarily in the universities. As John Szarkowski wrote in **Mirrors and Windows**: 'An intuitive recognition that photography was ceasing to be a specialized craft (like stone carving), and becoming a universal system of notation (like writing), perhaps made it easier for educators to believe that it did fit within the proper boundaries of liberal education.'

Until the post-war years, photographic courses, either technical or academic, were almost non-existent in American spheres of higher education. The most significant institution to teach photography prior to the Second World War was Moholy-Nagy's New Bauhaus, later to become the Institute of Design at the Illinois Institute of Technology. Here, a basic and ambitious curriculum was created by a succession of figures who had widespread influence, in both theoretical and practical terms – as educators, critics, curators and artistic practitioners. Those who taught in Chicago, notably Frederick Sommer, Aaron Siskind, Harry Callahan, Henry Holmes Smith, Gyorgy Kepes, Arthur Siegal, Edmund Teske, and Art Sinsabaugh might be said to have been the ripples from the stone dropped by Moholy-Nagy, spreading to other centres, and then in their turn sending out their own ripples – at Rhode Island School of Design, the University of New Mexico, in Rochester, Tucson and San Francisco.

A typical centre, one of the few active as far back as the forties, was the Los Angeles Art Center School. Art Center, a private, commercial art-orientated school, offered a course in photography to potential designers, illustrators, animators, and fine artists. What made Art Center notable was the influence of one photography teacher, the eclectic Edward Kaminski. Until his death in 1964, he enlightened many about creative photography, among them Wynn Bullock, Todd Walker, and Lee Friedlander. His approach reinforces an important aspect of the introduction of photography into university art departments: its effect on the painters and traditional print-makers who taught in the schools. It is a point made by Szarkowski in **Mirrors and Windows**: 'Painters, photographers, and printmakers have always been fascinated and influenced by each other's work, but in the new art schools an institutionalised proximity – and competition for money, enrolment, space, and staff – gave a new edge to the old curiosity. Artists who previously would have considered their disciplines to be mutually discrete became increasingly alert to the ideas, effects, techniques that might be borrowed from one medium and persuaded to serve another.'

The sixties have been defined as the 'media' generation. Never before had the human eye been so assaulted and so regaled by such a variety of visual imagery – painted, printed, stencilled, photographed, both moving and still. Only in the sixties did the power and effect of modern mass communications, through publication, films, television, advertising, radio and popular music, become generally apparent. Western society was persuaded, both frontally and subliminally, of a whole new set of signs, symbols, emblems, and metaphors. And the generation gap, which opened in the fifties now became a chasm. America was divided between those who had grown up with traditional, pre-war, basically Edwardian values and those who had grown up under the baleful influence of the new media.

All this making of myths, manners, and mores could hardly escape the attention of artists, particularly as one of the key artistic issues just prior to the sixties was 'what happens after Abstract Expressionism?' What happened after Abstract Expressionism, among other things, was Pop Art, an art which latched directly on to the media explosion, and yet, reassuringly, recycled many of the old iconic themes of American art. The prototypical Pop Art painting was, after all, **Lucky Strike**, by Stuart Davis, painted in 1921. However, Pop Art did add a contemporary inflexion to the shop-worn themes. Pop was brash, immediate, non-painterly, superficial in the best sense. It shared a common root with Abstract Expressionism in the imported Dada and Surrealism of the immediate pre-war years, particularly Dada, by virtue of its gleeful, ironic promulgation of bad taste. The Pop artists also added a new twist to the old Dadaist game of utilizing ready-mades in order to operate in the irresistible territory between representation and illusion.

The vernacular photograph, both in the imagery of artists such as Warhol and Rauschenberg, and in its own right, as seen in newspapers or magazines, became one of the most powerful icons of the decade. Think of the sixties, and we immediately can conjure up a photographic image – from Warhol's **Marilyn** to Eddie Adams's **Execution of a Suspected Vietcong Leader**. For the first time our primary experience of world events was visual. The written word was eclipsed. Every traumatic event of the sixties was visible, sometimes as it

happened, courtesy of the double-edged miracle of television. The still photographs of the same event acquired tremendous resonance as permanent traces of what was experienced as a series of moving images. Every decade in this century has produced its memorable news photographs, but in no decade prior to the sixties have they seemed so potent, or so personal. News photographs today function as collective snapshots, personalized mnemonics and tokens of events that have been truly collectively shared. And they function as stark reminders that compared to the television moving pictures, or the physical witnessing of actuality itself, there is no one authentic, authoritative, immutable reality. The image-conscious, picture-wise sixties generation, weaned on a proliferation of variegated views beamed directly into their living rooms, have been persuaded unalterably that there are many realities, many truths.

The nature of reality, and combining different states of reality, was a primary concern in sixties culture – the so-called 'psychedelic generation'. One of the seminal views of the decade can be found in Michaelangelo Antonioni's celebrated film, **Blow Up** (1966). The film's broad, metaphysical theme is the elusive and tenuous hold we have on reality itself. Throughout, there is a constant see-sawing between actuality and artifice, carried in the narrative by the hero's perplexity regarding the question, did he or did he not capture on film a murder which may or may not have happened. One of the film's many ironies is that the fashion photographer protagonist is seen at intervals to be working on his own project, a documentation of low-life far removed from the fashion world. And yet it is made clear by Antonioni that this 'social' concern is as empty and facile as anything else touched by his amoral, archetypal sixties hero.

In 1962, a decision was made of considerable importance for the course of sixties and seventies American photography. When an aged Edward Steichen retired from directing the Department of Photography at the Museum of Modern Art, his successor was John Szarkowski. Since that date, Szarkowski has been curator-in-chief of American photography, the keeper of the seal, filling a role first held by Stieglitz, and then by Steichen. Szarkowski, like his two eminent predecessors, has annoyed and infuriated many, yet few who have had anything to say about American photography in the last decade and a half have been able to do so without reference to him.

One of his key early curatorial statements came in the exhibition and book. **The Photographer's Eye** (1966). He chose as his theme nothing less than the aesthetic parameters of the medium – how photographs look and why they look that way – and demonstrated immediately that he was going to present a challenge to traditional notions of both humanist documentary and transcendent formalism. His stance favoured lyric documentary. In book and exhibition, he championed such masters of the personal document as André Kertesz, Henri Cartier-Bresson, Walker Evans, and Robert Frank, and two emergent American photographers, Garry Winogrand and Lee Friedlander. He selected also, anonymous or near-anonymous vernacular images, from sources like the State Historical Society of Wisconsin and, with the help of people like the French collector, André Jammes, showed a keen eye for the then ignored field of nineteenth-century photography. The premise of the exhibition seemed relatively simple, but in effect was complex and far-reaching. It was that photography's uniqueness derives from its ability to record the world and that its fascination as a medium derives from the fact that this facility is nominal only.

The Photographer's Eye was a polemic for straight photography. There was no sign at all of manipulative formalism, and not much of expressive metaphor. Most of the work followed the dictum of Walker Evans, and was 'literal, authoritative, and transcendent'. Despite the inclusion of European work, the photographer's eye, that of the selector, was essentially American, echoing familiar themes – fidelity to the object and the expressive qualities derived from objective description.

The photographers championed by Szarkowski in the sixties therefore, follow closely the old mainstream path of American art, and parallel the special concerns of sixties American artists, particularly their renewed interest in vernacular landscape. Photographers combined the lucidity of Evans with the irony of Frank, to produce a vision perfectly in accord with the Pop Artists and individuals like Robert Rauschenberg. What Mario Amaya has said, in **Pop Art … And After,** of sixties American painters might be said of sixties American photographers, and summarizes the Szarkowski position neatly: '**Whatever might be implied by the subject matter, such artists are not offering explicit social comment or political protest. The subject matter is there because that is how they found it. They are cool, detached and passive in their acceptance of these visual facts, as cool and detached as a brave new world that accepts the H-bomb as a means of peace. This is their age, an age of contradiction, compromise and ambiguity in which they paranoically search for security, sated with overproduction, leisure and waste; an age when to be amoral is often the ultimate in morality, where a truer sense of beauty can often be found only in the ugly, where the mass produced is more telling than the unique, and where ironies are more meaningful than tragedies. All this is expressed in their work.**'

In 1966, a new term was coined to describe this school of detached ironies – photographers of the social landscape. Garry Winogrand and Lee Friedlander were among a dozen young turks featured in an exhibition at Brandeis University called **Twelve Photographers of the American Social Landscape.** Later that year Winogrand and Friedlander appeared with Danny Lyon, Duane Michals, and Bruce Davidson in **Towards a Social Landscape,** curated by Nathan Lyons, director of the photography museum at George Eastman House, just one of a number of important and influential surveys of contemporary trends organized by Lyons in the sixties. In his catalogue introduction, Lyons made a significant point: '**Photography has achieved an unprecedented mirroring of the things of our culture. We have pictured so many aspects and objects of our environment in the form of photographs (motion picture and television) that the composite of these representations has assumed the proportions and identity of an *actual* environment.**'

The term 'landscape' used in this context indicates an awareness not simply of the urban or suburban landscape, but also of the landscape of photography. Sixties photographers were the first generation to be widely aware, as a result of the increase in museum and publishing activity, of the broad spectrum of their medium. Their imagery therefore, embraced not just the landscape before the camera, but the conceptual 'landscape' of the artist as photographer and as one keenly interested in photographs. Attitudes became more attenuated, the photograph became a much more subtle and complex summation of what photographers knew or felt about the whole process of imaginatively perceiving reality and transcribing that perception on to a sheet of photographic paper.

In 1967 Szarkowski presented one of the decade's most controversial exhibitions, and further explained his understanding of the medium. **New Documents** featured Friedlander and Winogrand, and was the first major show-case for another New York photographer, Diane Arbus. It says much for both the perception of Szarkowski, and the awesome extent of his influence at MOMA, that this trio represents the three figures accepted as the most dominant of the sixties. In his introductory remarks to the work, Szarkowski reaffirmed the keystone of his theoretical structure: **'In the past decade a new generation of photographers has directed the documentary approach towards more personal ends. Their aim has been not to reform life, but to know it. Their work betrays a sympathy – almost an affection – for the imperfections and the frailties of society. They like the real world, in spite of its terrors, as the source of all wonder and fascination and value – no less precious for being irrational ... What they hold in common is the belief that the commonplace is really worth looking at, and the courage to look at it with the minimum of theorizing.'**

Of the trio, it was Diane Arbus who predictably drew the critical attention, and who continued to do so, especially after her suicide in 1971. It was not the geometric, analytical formalism of Friedlander, or the convoluted, complex formalism of Winogrand that made **New Documents** such a controversial exhibition. It was the subject matter of Diane Arbus's imagery: new content rather than new form was the issue that gripped the photographic world of the mid-sixties.

In the work of Arbus, Szarkowski found the perfect model of documentary photography's shift to the personal. Her portraits have all the intimacy of snapshots, albeit bogus snapshots. They are frank, confidential, privately motivated images of a section of American society who had been persuaded to pose for the photographer. The fact that her images looked like snapshots was significant. Since Frank, the snapshot aesthetic had been an important talisman for the photographic avant-garde, signifying a longed-for innocence, integrity, and spontaneity, a pure exposition of the transfiguring power of the medium rather than the photographer. It was a select section garnered for Arbus's sophisticated snapshot gallery. Dwarfs, transvestites, nudists, female impersonators, and strippers – **'assorted monsters and borderline cases'**, as Sontag put it – seemed to make Arbus's gallery one of alienation, deformity, exotic sexuality, and open insanity. And even when Arbus focused upon 'normal' Middle America, which she did more frequently than one might suppose from much of the reaction to her work, 'straights' were rendered bizarre as 'freaks' by the unflattering gaze of the photographer's full frontal flashlight and uncompromisingly close stance.

The most common criticism of Arbus is that she utilized the most empathetic of photographic forms – the snapshot – to create a fictitious aura of intimacy. Her obsessive fascination with society's outsiders is seen as voyeuristic, an essentially juvenile revolt against inherited class background and the establishment. This personal revolt was not uncommon. It was a form of *épater les bourgeois* familiar from sixties and seventies counter-culture, that massive expansion of the Beat sensibility which diversified into a bewildering variety of youth movements – hippies, yippies, bikers, mods, teeny-boppers and punks.

Personal documentary photographers of the sixties may be distinguished by their involvement or non-involvement with these counter-cultures. They may be divided into two broad, loose groups, each exploring a different premise thrown up by the Evans/Frank tradition. One group, including Winogrand and Friedlander, were concerned with an openly visible and dominant aspect of American society, focusing on the sanctified rituals of Middle America. The other group, which includes Arbus, delved into the underground and hidden aspects of society – such as Danny Lyons, photographing bikers and prison inmates, or Larry Clark, photographing drug addicts and teenage sexual mores. One group concentrated on more formal aspects of the medium, the other on the more gestural and expressionistic. One group photographed generally with the studied detachment of outsiders, the other with the nominal empathy of insiders.

The approach of the sixties documentary generation and their spokesman, John Szarkowski, has been criticized. There is little doubt that this generation and its primary advocate ushered in academicism, an era of self-referential, frequently arch, always extremely knowing photography – a photography which plumbed unforeseen depths of boredom and *déjà vu* in the seventies. And there is little doubt that Szarkowski's tendency to deal principally with the formal qualities of the medium has given rise to the idea that this generation is uninterested in meaning. This notion is hardly denied by the pronouncements of its chief practitioners, Garry Winogrand and Lee Friedlander: **'I don't have anything to say in any picture ... I photograph to find out what something will look like photographed.'** And **'The pleasures of good photographs are the pleasures of good photographs, whatever the particulars of their makeup.'**

Perhaps the main indictment against social landscapists is that their work, in blurring traditional distinctions between photograph as witness and photograph as artefact, blurs also the levels at which it might be interpreted. The work's enigmatic front – not to mention statements like those above – calls into question its seriousness. As Martha Rosler has remarked, Friedlander's work has its antecedents in the street photography of such people as Eugene Atget and Walker Evans. **'But both Atget and Evans appear serious where Friedlander may seem clever, light, or even sophomoric.'** Rosler continues: **'It would be an ironically false assumption to suppose we can infer from the photo something important about the part of the world depicted in it. Yet making connections is an ineradicable human habit, and the meta message of framing is that a significant incident is portrayed within. Looking at his photos, we are in the same situation as Little Red Riding Hood when she saw dear old Grandma but noticed some wolflike features and became confused. Our pleasant little visit has some suggestion of a more significant encounter, but we don't have enough information to check. The level of import of Friedlander's work is open to question and can be read anywhere from photo funnies to metaphysical dismay ... His work can be taken by the casual viewer as value-free sociology and, because of his denial of photographic transparency, as artful construction for photography buffs.'** ★

The problem area for many examiners of sixties and seventies documentary photography, particularly art critics, lies in the photographer's heretical negation of the generally preconceived notion of his or her role and the photograph's function. As the writer Jane Livingstone has pointed out, **'We automatically look for emotionally and morally evocative qualities in photography in a way we don't in painting or sculpture.'** Uncertainty, doubt and ambiguity, means doubtful

★ Rosler, Martha 'Lee Friedlander's Guarded Strategies', **Artforum**, vol. 13, no. 8, April 1975.

morals. Martha Rosler, analyst, materialist, determinist, would deny photography the right to be allusive and the least bit ambiguous because the photograph is supposed to be literal and authoritative – and strictly minus transcendent possibility. Lack of tendentiousness is Friedlander's heresy.

Yet Friedlander does not deny transparency – the clear observing window. His 'view' of the United States is no more nor less a 'view' than that of Walker Evans. It is clearly documentary. His is no more nor less a moralistic a statement than that of Robert Frank. He restructures looking in order to affirm both the illusion and the allusion of transparency. Similarly, while it is clear that the work of Diane Arbus is an extended, indulgent self-portrait, it is more. In all the extensive commentary on her work, only Szarkowski points to a wider meaning, when he remarks that, rather than conventional photo-journalism, it was the photography of Arbus that best summed up a certain *Zeitgeist* of the sixties, especially the new knowledge of America's moral frailty engendered by a sense of failure in Vietnam. '**The photographs that best memorialize the shock of that knowledge were perhaps made halfway round the world, by Diane Arbus.**'

The imagery of Arbus in one sense accords perfectly with that of Friedlander. Despite their surface directness, her photographs are remarkably allusive. For example, in spite of her predilection for subjects like nudists, hermaphrodites, and transvestites, she seldom dealt with open sexuality, though her images reek with a sublimated, repressed eroticism. She constantly shifts from normal, middle-class Americans to outsiders – from the '**most ordinary to the most exotic of us**' – as Szarkowski put it. The barriers are class as well as psycho-social. Thus a reading is set up that invites connections to be made not only about the nature of Arbus's personal state of mind, but also about her society's collective position. Was there ever a more telling image made about American middle-class smugness than **Woman with Veil, Fifth Avenue, New York, 1968**? Portraits by Arbus tell their individual tales and simultaneously point an accusing, collective finger at society.

By virtue of his force as a writer, his personality, his position, and to some degree his uncompromisingly purist stance John Szarkowski appears the dominant force in sixties photography, yet there were other dedicated advocates at work. Many of these figures, maintaining a more catholic appreciation of the medium, had a broader based, if not such a high profile influence on the divergent directions of the seventies.

Two figures seem important from a British viewpoint – Nathan Lyons and Peter Bunnell. Lyons was Director of the Museum of Photography at Rochester's George Eastman House during the sixties. He produced a number of important anthology shows of the contemporary medium, setting the background with a selective, balanced historical view, **Photography in the Twentieth Century** (1963). To balance the viewpoint of **Towards a Social Landscape**, his examination of documentary photography, Lyons produced **The Persistence of Vision** (1967), which surveyed new work in the manipulated and mixed-media fields. The mixed-media area, which had lagged behind 'straight' photography, received great stimulus in the sixties from two factors – the advocacy of expressive formalism by Minor White and his cohorts, and a new interest in collaging painted and photographic elements in an image, engendered by the first stirrings of Pop, and in particular by the work of the master collagist of the era, Robert Rauschenberg. **The Persistence of Vision** featured the work of five leaders of a mode, which, in the seventies, was to become an important force – Jerry Uelsmann, Robert Heinecken, Ray

Metzker, John Wood, and Donald Blumberg, the last named in pointed collaboration with the painter, Charles Gill.

Peter Bunnell, as curatorial associate in the Department of Photography at the Museum of Modern Art, organized the exhibition, **Photography as Printmaking**, in 1967. This was the first attempt to place a recent upsurge in synthetic work into historical perspective, and again to challenge '**the traditional critical separation between "straight photography" which seeks to mirror external reality ... and the aesthetic that emphasizes the distinctive surface quality of the print itself ...**' Many photographers, both straight and synthetic, were printmakers, argued Bunnell, yet '**not all of the photographers who possess vision impart equal sensitivity into printmaking.**' Bunnell, who during his stay at the Modern added a necessary, catholic balance to the puritanical Szarkowski, produced an important exhibition that easily outweighed the woolly polemic accompanying it. However, both Bunnell and Lyons went on to newer things in the seventies, Bunnell to Princeton University and Lyons to the Visual Studies Workshop in Rochester. Both played leading roles in American photography and championed a wider exploration and understanding of the medium, and both were instrumental, at a crucial time, in focusing attention back upon the photograph as a crafted object.

By the beginning of the seventies, consideration of the photograph, not simply as art, but as art object, was an extremely relevant issue. In 1969, a former magazine editor, Lee Witkin, opened a small gallery in New York City devoted to the exhibition and sale of photographic works. Although it was not the first commercial photographic gallery – Julien Levy's gallery in the thirties, and Helen Gee's Limelight gallery in the fifties were notable New York precedents – Witkin's enterprise was timely and blessed. The Witkin Gallery was an instant success, provoking, within a few years, a whole commercial gallery infrastructure. Auction houses began to hold sales of nineteenth-century photographs and the better known, bluechip twentieth-century 'masterworks', with all the attendant bally-hoo. Prices asked for photographic work of all description soared, more in hope than actuality. More and more students enrolled in creative photographic courses: more and more teachers were engaged to cope with the influx of students. More 'creative' photography, it would seem, has been produced in the United States alone since 1970 than in the 130 years prior to that decade.

Photography became the province of professors and curators in the sixties, and the province of buyers and sellers in the seventies. Together, the academy and the art market ensured the final triumph of formalism. Nearly every vestige of humanism was vanquished. Formalism was rampant. As Hilton Kramer wrote in 1976: '**If there is something new on the photographic scene today, it is not formalism itself but the willingness to proclaim it in high places — to celebrate it, to elevate it to a position of authority and power ...**

'**The time is certainly propitious. Two things were required before the formalist impulse of photography could hope to win parity with the more representational modes. Photography itself had to gain the confidence of a large segment of the art public. And that confidence had to be achieved under the aegis of the gallery and museum, which automatically elevates the aesthetic above all other interests.**'★

And where did such acceptance, and the frenzied form-

★Kramer, Hilton 'Celebrating Formalism in Photography', **The New York Times**, 12 December 1976.

19

alist activity that followed in its wake, lead? Certainly, it has kept the walls of galleries covered and given critics something to write about. Here and there it has produced work which is of lasting merit. But the overriding impression is one of ennui. In a recent acid diatribe, Vicki Goldberg rails against the emptiness of seventies Californian photography, noting that the rest of American photography is not immune to California's ills: **'What happened was that photographers leaped on the bandwagon and damn near collapsed it. Students, legions of students, all wanted to do what the teacher did, or else what commanded a high price in the galleries. So we got conceptual and what might be called semi-conceptual photographs by the carload, often turned out by people who really didn't have any concepts ...**

'After conceptualism we got role playing and the media, which were actually important issues until five thousand photographers decided they were the road to originality ... We got self expression, which a just God would have spared us, and in which many a photographer has indulged at the expense of those near and dear ... We got mixed media, which is the cheap and snappy way to look like an artist ... We got cute funk and pseudo comic strip literary efforts ... We got this not just from California but everywhere, and some of us got tired.'★

Yet, while so much of late seventies photography seems facile, there were some notable achievements. The documentary approach as redefined in the sixties still flourished. Despite the encroachment of so much structural formalism, documentary remained the dominant form of photographic expression, retaining a more restrained, though no less assured vigour than that of the sixties. However, documentary photography, as the sixties demonstrated, is paradoxical and constantly evolving. While pertaining nominally to have nothing to do with the formalist issues of the art photography contingent, the word documentary defines a style as much as an ethic, it labels a formal as well as moral or conceptual stance.

The question of documentary style began to concern a loose group of young photographers in the mid-seventies. It had become clear that the work of many of the Social Landscapists involved a formal restructuring of the world. They had succeeded in proposing an objective attitude towards subject by emphasizing a subjective attitude towards form. The relationship between a subject and a photograph of a subject is fragile, and easily disturbed. It was felt by members of this new group that perhaps a better, less tendentious balance might be struck between form and content, by eliminating the formal presence in addition to the emotional, political, or philosophical opinion of the photographer.

In 1975, an exhibition was organized by William Jenkins of the International Museum of Photography at George Eastman House, bringing together the members of this group, ten 'photographers of the man-altered landscape'. **New Topographics** was one of the seminal shows of the seventies, and defined the currents of that decade's straight photography as **New Documents** defined the sixties. The term 'topographics' is crucial: with its multiple references, to the land, to mapping, to objective, scientific description, and to a style of nineteenth-century image-making, the primary attitudes of the photographers are suggested.

Firstly, the New Topographers looked to the pioneer photographers of the American West who were concerned with a description free of stylistic conceit, made elegant by their divine innocence. Secondly, they looked towards photography made by conceptual and land artists, where the photograph, as 'pure' record of event or idea, functions as the art object — combining the two distinct entities of actual subject matter with referential subject matter. The work of Edward Ruscha in the sixties is fundamental in this respect. His books of photographs, **Twenty-six Gasoline Stations** (1962). **Some Los Angeles Apartments** (1965), and others, denote a world chosen at random, and recorded with apparent disregard for aesthetic frills or assumed significance as images.

Of course, nominal artlessness is an attempt to conceal art. The stance of the New Topographers was extremely sophisticated, the decision to negate style a self-conscious stylistic decision. The work of the New Topographers is linked as much to art as to photography: since the sixties, phenomenological investigation had been a prime concern of artists, growing out of Pop, and becoming rooted around conceptualism in its various forms. Ironically, it was the New Topographers, conceptual purists in the documentary mode, who helped forge stronger links with the art world, not the contrived and effortful posturings of many mixed-media enthusiasts.

The other main preoccupation of seventies photography was colour. Colour photography exploded upon the American scene in 1976 with all the impact made by **The Americans** sixteen years previously. Once again, a major body of new work hit the photographic community with the force of a thunderbolt. Once more, the Museum of Modern Art was the catalyst. And once again, the critics lined up in strength to denounce the Emperor's new clothes. The source of this attention was a one-man exhibition and book presented in 1976 – **William Eggleston's Guide.** In seventy-five images of Memphis and other parts of the Deep South, Eggleston demonstrated a typically Social Landscapist gestural style – sophisticated snapshots of vernacular America – except that they were in colour. Eggleston's imagery, compared with Frank's, is, if anything, even more dense, fragmentary, elliptical, and elusive. As with Frank, its importance resided more in influence than in ultimate meaning. And yet the world of Eggleston has its own arcane, diabolical significance. It was not evident, however, to all, including Hilton Kramer of the **New York Times. 'The truth is, these pictures belong to the world of snapshot chic — to the post-Diane Arbus, antiformalist aesthetic that is now all the rage among many younger photographers and that has all but derailed Mr Szarkowski's taste so far as contemporary photography is concerned.**

'To this snapshot style, Mr Eggleston has added some effects borrowed from recent developments in, of all things, photo-realist painting — a case, if not of the blind leading the blind, at least of the banal leading the banal. For purely negative reasons, this is a show — made possible, as they say, by grants from Vivitar Inc. and the National Endowment for the Arts — that has to be seen to be believed.'★

Whatever the reactions to his work, Eggleston was at the forefront of a generation that finally made colour photography artistically respectable. Prior to the mid-seventies, colour was not seen as a serious issue. Rather, it was regarded as a decorative adjunct that facilitated the commercial acceptance of photography but which precluded artistic expression. Without the confines of the commercial treadmill, the photographer

★Goldberg, Vicki review of Louise Katzman, **Photography in California, 1945-80,** in **American Photographer,** vol. 12, no. 4, October 1984.
★Kramer, Hilton 'Art: Focus on Photo Shows', **The New York Times,** 18 May 1976.

was faced with two choices: making a picture in which the colour was extraneous or a picture which seemed little better than a handsome, insubstantial ornament. Before the seventies, only two colour photographers, Ernst Haas and Elliot Porter, could be counted amongst the medium's more respected figures. For most serious photographers, the colours of Kodak were not the colours of the world.

But as Hilton Kramer suggested, the influence of photo-realist and colour-field painting, possibly coupled with the lure of the galleries, suddenly overcame the resistance of photographers to colour. It is difficult to determine the exact reasons – whether prolonged exposure to colour; in television, advertising, photo-realism, and colour photography utilized in painting in which colour was an organic part of meaning rather than a distinct problem; or whether the rise of gallery photography lowered the tolerance level for decoration. However, as if by prearranged signal, colour became respectable, and within five years or so, photographers had more or less reworked all the issues of post-war American photography, this time in gaudy chromatics instead of sombre black and white.

In 1973 Susan Sontag published a notable series of five articles in **The New York Review of Books.** Less than a year later, critic Allan Sekula followed Sontag with a similar series in **Artforum.** Their basic theme was the socio-political role of photography. Their basic dictum was bleak, harsh, and might be considered even anti-photographic. Their conclusions, and those of other meta-photo commentators of the seventies, challenged the photograph's newly accepted value as art, and questioned its efficacy as an instrument of knowledge, communication, and culture. At issue was the basic notion of photographic transparency. Photographs do not seem to be statements about the world so much as pieces of it. To photograph a thing is to appropriate it. The camera does not lie so much as mask the truth behind an apparently clear, yet essentially distorting window.

Sontag and Sekula were attacking a fundamental doctrine of American establishment photography – the modernist formalist ethic that draws a discrete curtain of formal wonder over the essentially propagandist and exploitative nature of the process. Theirs was a wide-ranging criticism, which has not yet been thoroughly refuted, certainly not in print. When Sontag's essays were published together in book form in 1977, most American critics their pride stung, reacted with loud, but hardly adequate, counter arguments. Many leapt upon her factual errors – unfairly, for the book was a work of social criticism rather than photographic research – and concluded that Sontag did not understand the medium. In fact, she understands it only too well as a medium of powerful contradictions that should not be ignored.

And yet her critique is deliberately negative, provocative and tendentious. The tradition of basic precepts by which she judges is essentially literary and basically Structuralist, with three primary sources in Walter Benjamin, John Berger, and Roland Barthes. Jonathan Green has pointed out its fiercely intellectual stance, implying **'a subtle elitism that assumes the hierarchy of the intelligentsia over the proletariat.'** One might also add that Sontag's indictment against the voracious, colonizing enterprise of the photographer might be applied equally to the writer, the sociologist, or the psychologist, but that does not invalidate some of her most damaging criticisms, especially in the area of photographic transparency – the source of the medium's problems and, let it be said, its endless fascination.

However, Sontag and the new social critics have had effect on the course of late seventies American photography where it matters – in photographic practice. A few heads have been persuaded to stir out from under the focusing cloth. And in another of those ironies endemic to photography, it has been those who have proclaimed the disinterestedness of photography's descriptive facility – the New Topographers – who have led American photography effectively back from the formal hedonism of the mid-seventies to a new sense of morality. Although these critics stimulated a growth in utilizing conceptual procedures, principally serial photography and photographs combined with text, to explore photographic meaning, straight photography paradoxically remains the medium's most expressive force – politically or formally and although the absolute meaning of a straight photograph tends to be elusive, thus negating 'literary' narrative, what might be termed 'poetic', or visual meaning, a meaning as imaginative, as subtle, as complex, and as valid, is inescapable to the open mind. Thus the new practitioners of a post-modernist return to a degree of humanism do not manifest systematic, programmatic political stances, but rather, as the best American photographers – Evans; Frank, Winogrand – have always shown, an individual intuition about the nature of their society. For example, Chauncey Hare's **Interior America** (1978) reveals a clean, understated desperation with the state of things lacking in Frank, or even Arbus. Joel-Peter Witkin, in his series, **Evidences of Nameless Atrocities,** produces a mixed media photography, post-Arbus, post-Francis Bacon, that is at once awesomely powerful and richly complex, referring to both interior and exterior worlds, to life, death, art, sexuality and politics. Robert Adams and Lewis Baltz, arguably the best of the New Topographers, focus with undisguised irony on the 'man altered', that is, the man despoiled landscape, with a concern made clear by their quiet, oblique passions. In American photography today, though there is much sterile formalism, there is a growing undercurrent of personal disquiet with the quality of American life in the supposedly affluent eighties.

The pattern of post-war American photography has been diverse and by no means clear-cut. This essay has touched only upon what I believe are the central forces behind this immense rise in the fortunes of the medium. My view is necessarily biased, and no doubt intolerant. I retain the right to be ambiguous and contradictory, for I feel keenly the ambiguities and the contradictions of the photographic endeavour. I have affirmed assiduously the hegemony of the straight photograph where others might not, for I believe that the primary issue centres around transparency. Indeed, I would almost, but not quite, go as far as to define photography by the root issue of transparency.

What seems to emerge clearly from a complex picture is that there has been a radical reappraisal of the concensus regarding the photographer's function. There has been a distinct shift from the broadly humanist viewpoint of the forties and fifties to the formalist viewpoint of the sixties and seventies, a shift that has brought its own attendant dangers, and which has spawned an inevitable and healthy reaction. Nevertheless, the formalist revolution has registered a number of profound achievements. Firstly, the ancient controversy of whether photography was truly worthy of consideration as art has been laid decently to rest. Photography has been accepted – at least in America – by the museum and the academy as a significant art medium and as the worthy object of serious

intellectual attention. Secondly, a freeing of creative shackles on photographers, made possible by establishment support, has resulted in an immensely vital body of new work. Between 1945 and 1980, American photography sustained a period of growth and generated a degree of unrestrained experimentation unequalled since the great decade of the 1850s in Britain and France. The result has been a vast, sprawling kaleidoscope, exhibiting peaks and troughs, but nevertheless exemplifying a vigorous and continuing extension of photography's traditions, satisfying us that those traditions were by no means as restrictive, narrow, simplistic, superficial, impoverished or undernourished as had been supposed.

American photography can claim its place as an integral part of the triumph of American art since 1945. Justly so, for it is clear that American photographers, whether they acknowledged it or not, have tended to march closely in step with the fundamental precepts of American art – no matter how divergent those paths sometimes might have appeared. The camera is peculiarly suited to the American psyche, for the need to grasp reality, to ascertain the physical actuality of things seems to be an intrinsic part of the American experience, and as such is an essential ingredient of American art. As Barbara Novak wrote in **American Painting in the Nineteenth Century**: **'From the very beginning, artists in America have tried to create measurable certainties and have utilized scientific, mathematical, and mechanical aids to achieve their aims.'** Thus photography, with its in-built, voracious appetite for cataloguing the material things of the world, makes quintessentially American art. The enormous visual inventory that is post-war American photography, enlarged more during that period than at any other, provides us with a collective view of a society that is without parallel in terms of its variety, exuberance, individuality, lack of inhibition and insatiable curiosity.

GERRY BADGER
An architect active as image-maker and writer on photography since the early 1970s, Gerry Badger's pictures have been widely exhibited and he is one of Britain's leading photography critics. He has organized several exhibitions and received awards for his photography from the Arts Council of Great Britain and the Greater London Arts Association. ★ P.T.

I.
1945-50

ANSEL ADAMS

Born 1902. Died 1984. Ansel Adams did more than any other photographer to bring the beauty and technical subtlety of his medium to public attention. He trained as a concert pianist and went on to become a passionate conservationist whose photographs embodied the grandeur of America's landscapes. A long-time champion of fine photography, Adams helped found the Department of Photography at the Museum of Modern Art, New York, was instrumental in creating Aperture, the much-respected journal of photography and later in the establishment of the Friends of Photography — a California-based centre of exhibitions, publications and workshops.

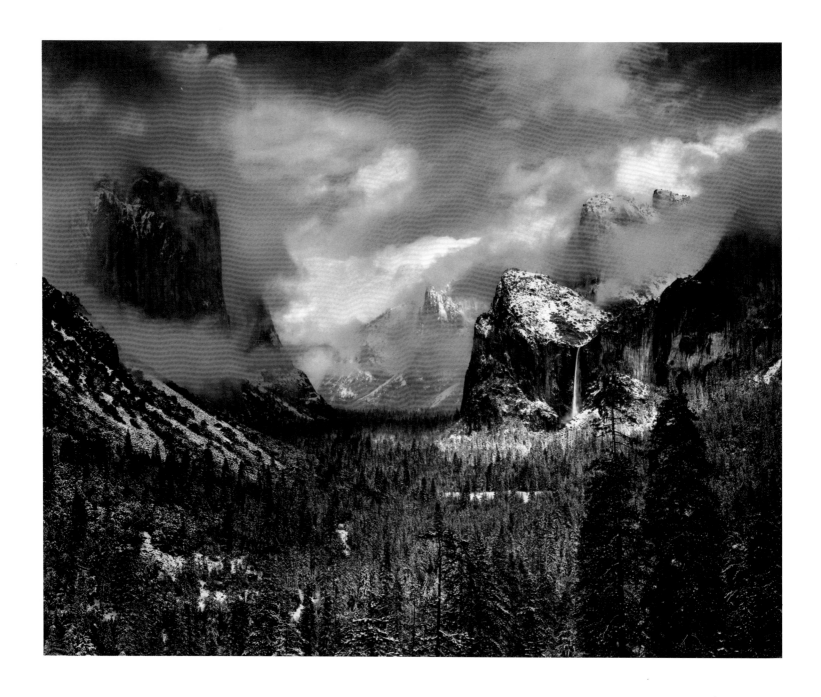

Clearing Winter Storm, Yosemite National Park, California 1944
Collection of the Southland Corporation

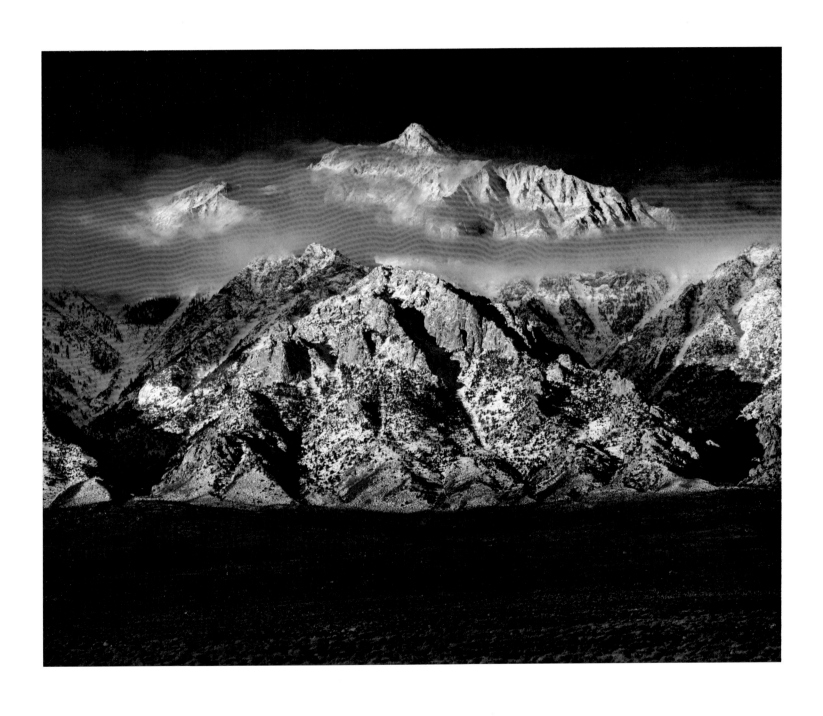

Mount Williamson, Sierra Nevada from Owens Valley, California 1944
Courtesy of The Weston Gallery

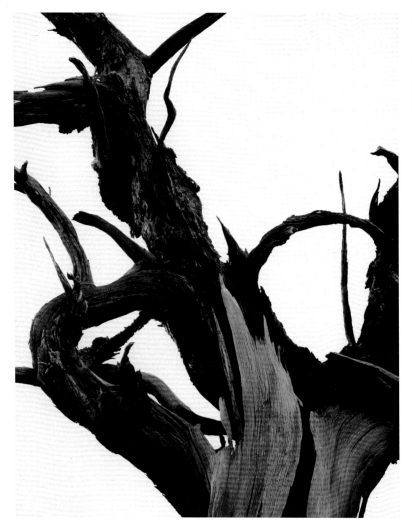

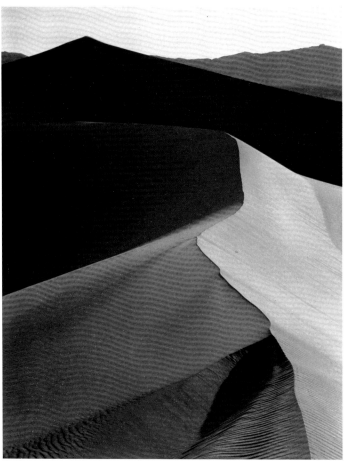

Dead Tree, Sunset Crater National Monument, California 1948
Courtesy of The Weston Gallery

Sand Dunes, Sunrise, Death Valley National Monument, California 1948
Collection of the Southland Corporation

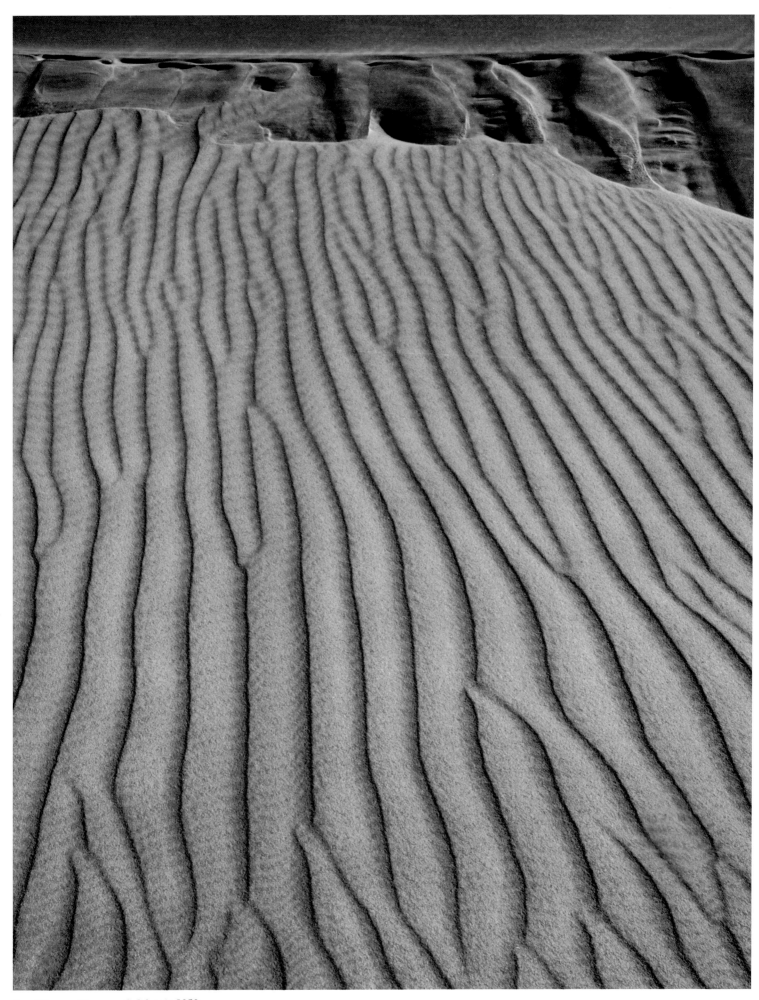

Sand Dunes, Oceano, California 1950
Courtesy of The Weston Gallery

PAUL STRAND

Born 1890. Died 1976. A student of Lewis Hine and protégé of Alfred Stieglitz in the early years of this century, Strand is credited with making the first consciously modern photograph in 1916. Working internationally as both film-maker and still photographer he involved social and avant-garde aesthetic concerns in his work which dealt with a perceived realism of twentieth-century life. Strand's concern for political and humanist ideologies caused him to leave America for France in 1950 as a gesture of protest against the prevailing administration.

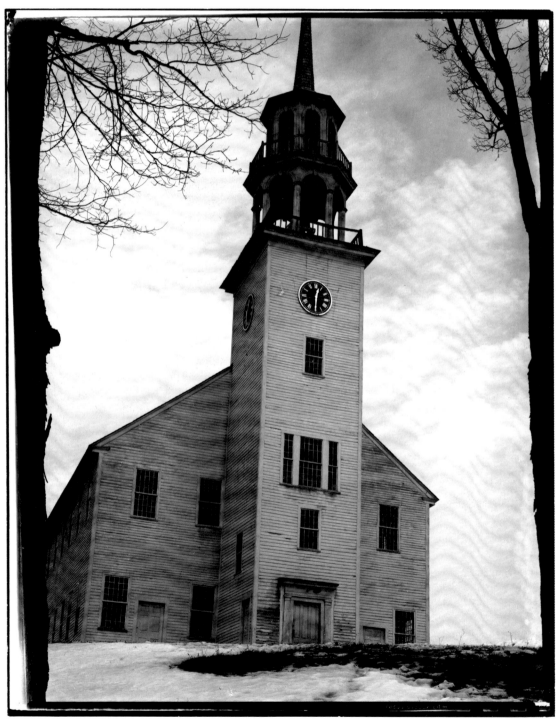

Church on a Hill, Northern Vermont 1945
Courtesy of The Paul Strand Archive and Library

28

Tombstone and Sky, New England 1946
Courtesy of The Paul Strand Archive and Library

Beatrice Albee, Prospect Harbor, Maine 1945
Courtesy of The Paul Strand Archive and Library

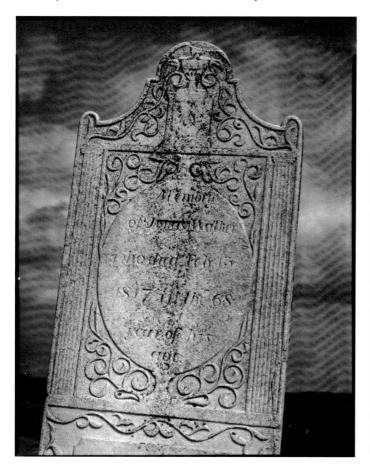

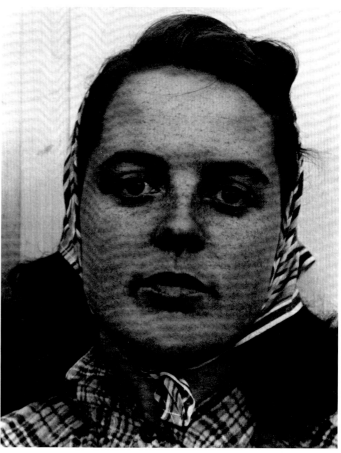

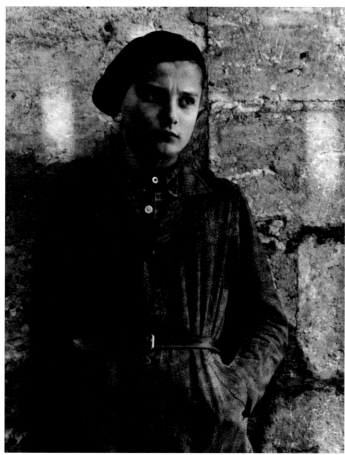

Schoolboy, Charente, France 1951
Courtesy of The Paul Strand Archive and Library

Young Boy, Gondeville, Charente, France 1951
Courtesy of The Paul Strand Archive and Library

EDWARD WESTON

Born 1886. Died 1958. Weston was noted for his single-minded devotion to the medium of photography, and his life, work and attitude exemplify the best purist traditions. A one-time commercial photographer, he abandoned financial gain for a more naturalistic existence, exploring literally and visually the sensuality of life around him. He used the techniques of photography to imbue his subjects with a sense of animate form — he sought, in his own words, to make pictures in which, 'the camera should be for a recording of life, for rendering the very substance and quintessence of the thing itself, whether it be polished steel or living flesh'.

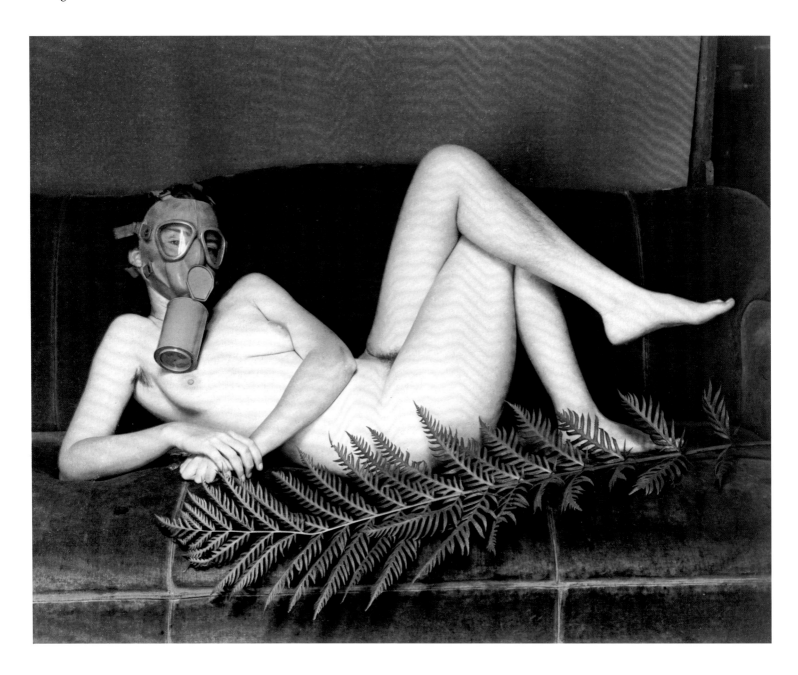

Civilian Defense 1942
Courtesy of The Weston Gallery

Nude 1945
Courtesy of The Weston Gallery & Matthew Weston

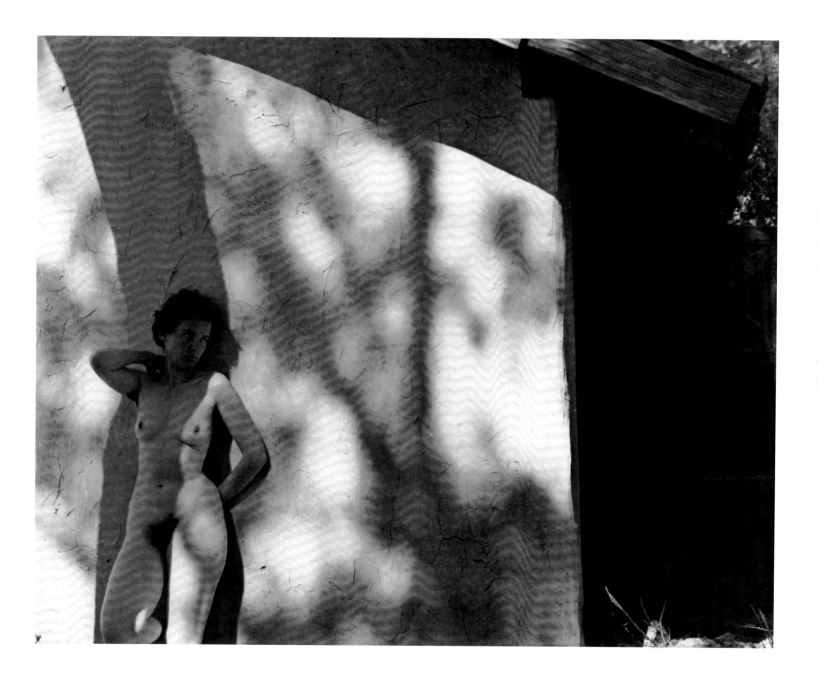

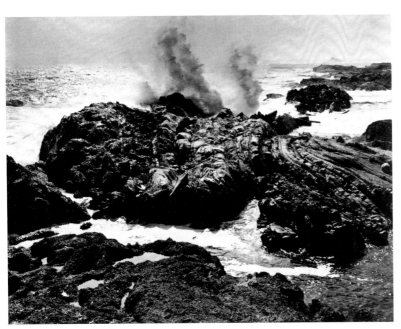

Point Lobos 1947
Courtesy of The Weston Gallery & Matthew Weston

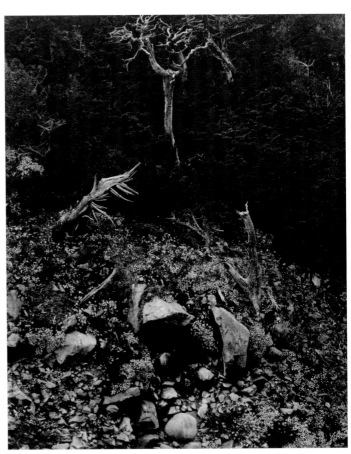

North Wall, Point Lobos 1946
Private Collection

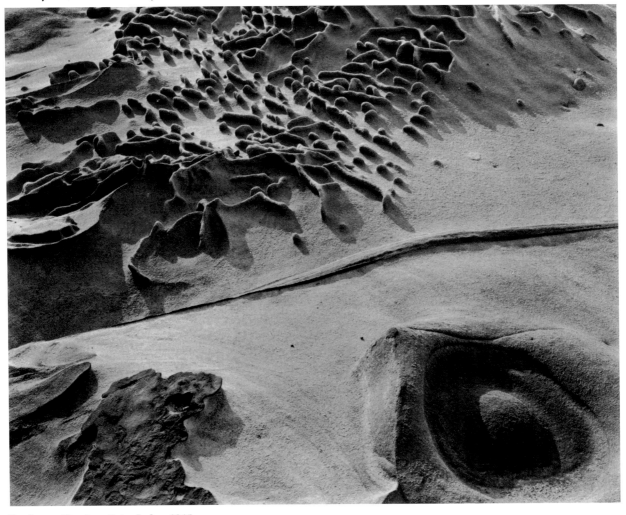

Sandstone Erosion, Point Lobos 1945
Private Collection

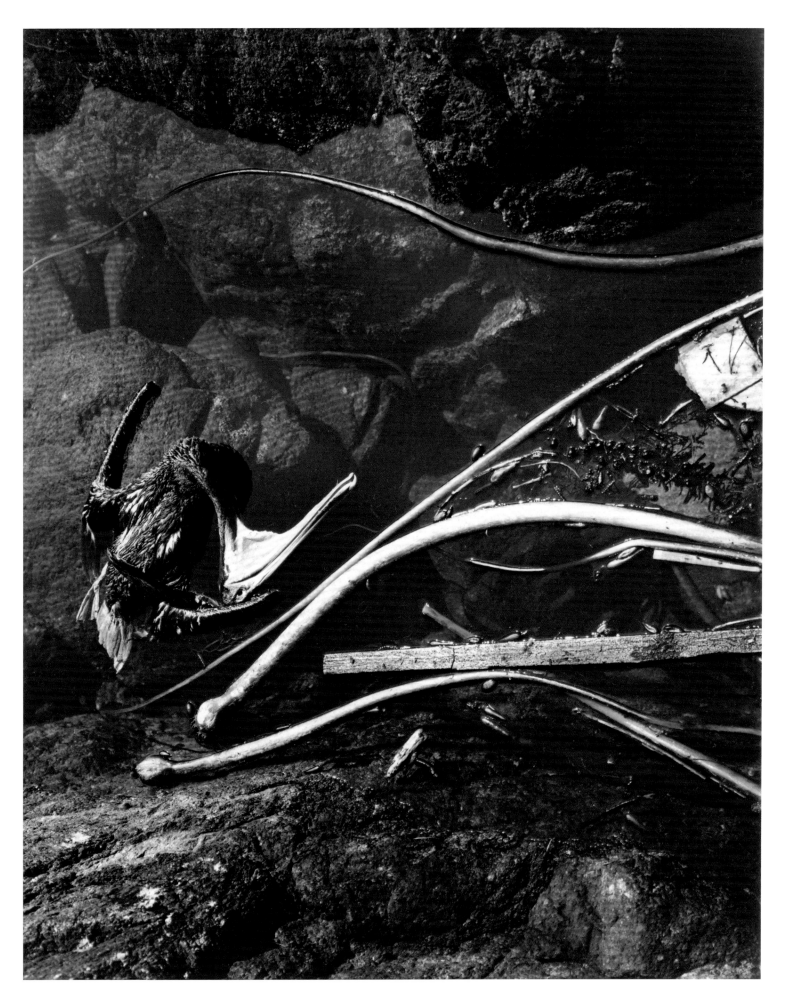

Pelican 1945
Courtesy of The Weston Gallery & Matthew Weston

WRIGHT MORRIS

Born 1910. An established writer on American life, Morris is equally
gifted as a photographer. In several of his published works he has explored
relationships between image and text, using words to create a seemingly mythic
atmosphere and his pictures to substantiate their resonance, if not existence.
Morris's aim, verbally and visually, is to arrest history — to retain the importance
of times past that they may inform the future.

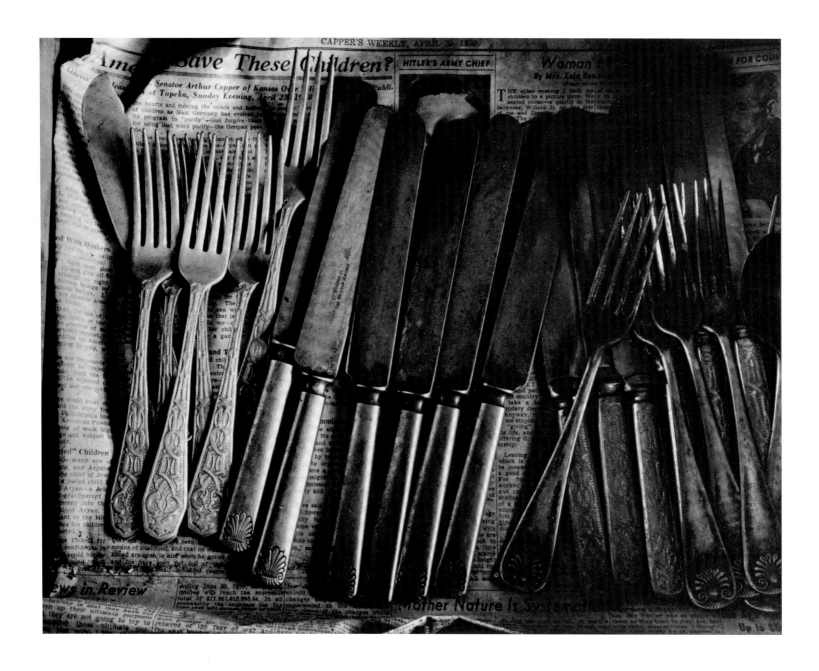

Drawer with Silverware, Homeplace 1947
Courtesy of The Weston Gallery

Barber Shop, Weeping Warer, Nebraska 1947
Courtesy of The Weston Gallery

Model T in Shed, Homeplace 1947
Courtesy of The Weston Gallery

Jukebox, Southern Indiana 1950
Courtesy of The Weston Gallery

WEEGEE

Born 1899. Died 1968. In essence the consummate press photographer, for newspapers were his clients, Arthur Fellig, who used 'Weegee the Famous' as a pseudonym, pictured the often dramatic face of New York City with a unique style. Drawn to the excesses of high-life and low-life, he photographed drunkenness, suicide, theatregoers, opera lovers, murder victims, street brawls and human tenderness with the same unabashed directness.

Norma at Sammy's 1943
Collection of Wilma Wilcox/Side Gallery

Easter Sunday, Harlem, New York 1940
Collection of Wilma Wilcox/Side Gallery

Welcome Home 1946
Collection of Wilma Wilcox/Side Gallery

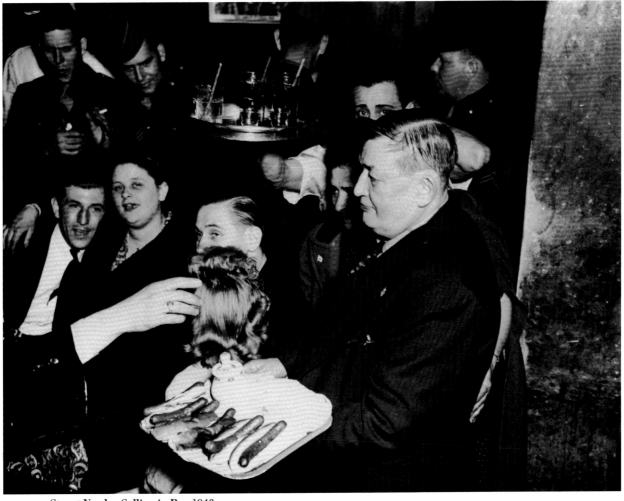

Street Vendor Selling in Bar 1943
Collection of Wilma Wilcox/Side Gallery

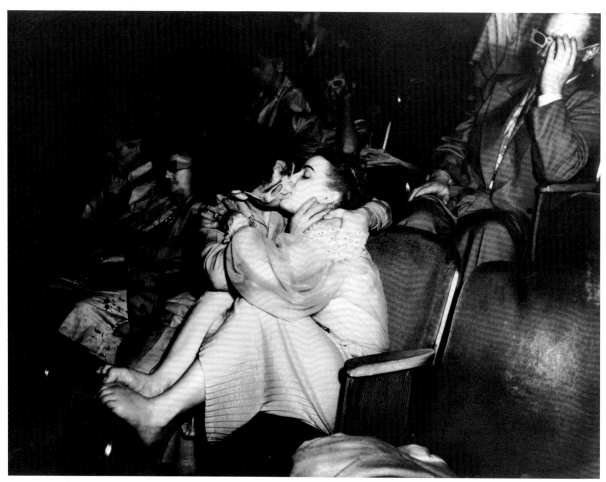

Love in Cinema 1940-5
Collection of Wilma Wilcox/Side Gallery

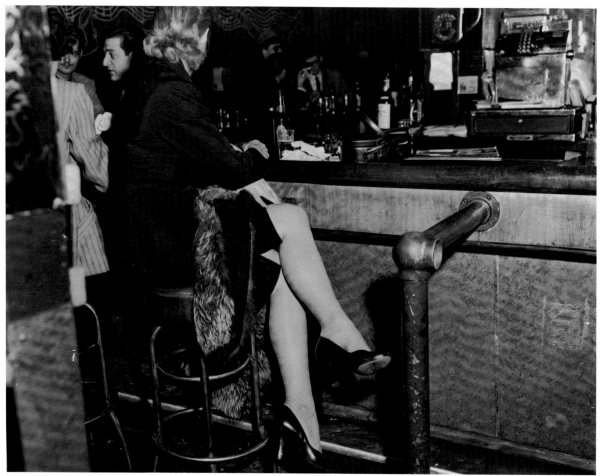

Legs at Bar c.1945
Collection of Wilma Wilcox/Side Gallery

GORDON PARKS

Born 1912. Gordon Parks is a man of many parts; he works in film, music and writing as well as photography. In the latter medium he was acclaimed for his picture stories published in Life magazine. He is known best now as a film maker – Shaft (1971) which he wrote and directed was an international success. Parks is black and used personal tenacity together with the access his colour offered to show one part of American society to another. As black consciousness rose. Life ran his stories on Black Muslims, Stokely Carmichael, Eldridge Cleaver and the Black Panthers.

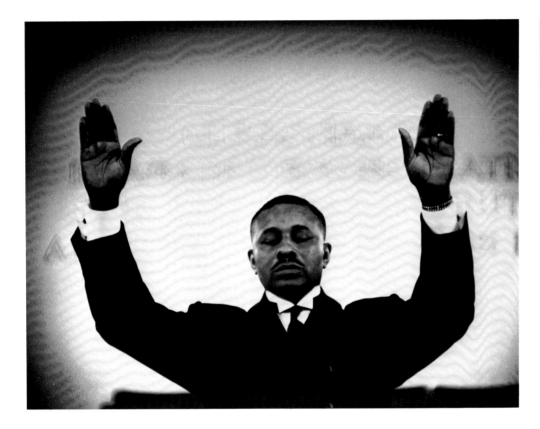

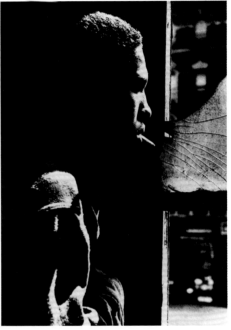

Pastor Ledbetter, Metropolitan Baptist Church 1953
Courtesy of the artist

Red Jackson, Harlem Gangleader 1948
Courtesy of the artist

ARTHUR ROTHSTEIN

Born 1915. Made famous by his pictures for the Farm Security Adminis-
tration Project in 1935-40, Rothstein went on to become a staff photographer
with Look magazine. There he continued to make penetrating pictures of
American life, combining the ideal of mass communication with his personal
concern as a creator of individually powerful pictures.

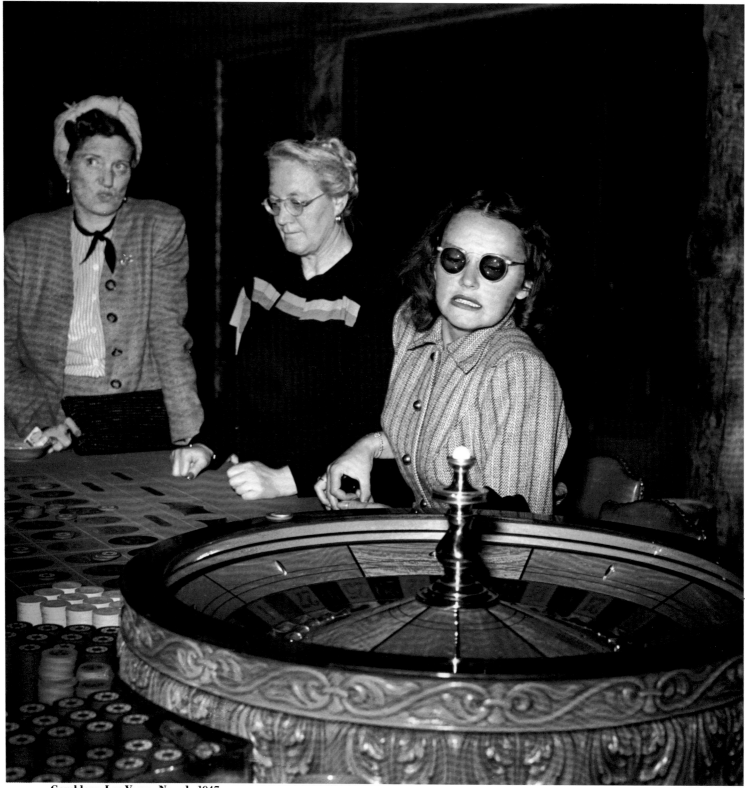

Gamblers, Las Vegas, Nevada 1947
Courtesy of Monah and Alan Gettner

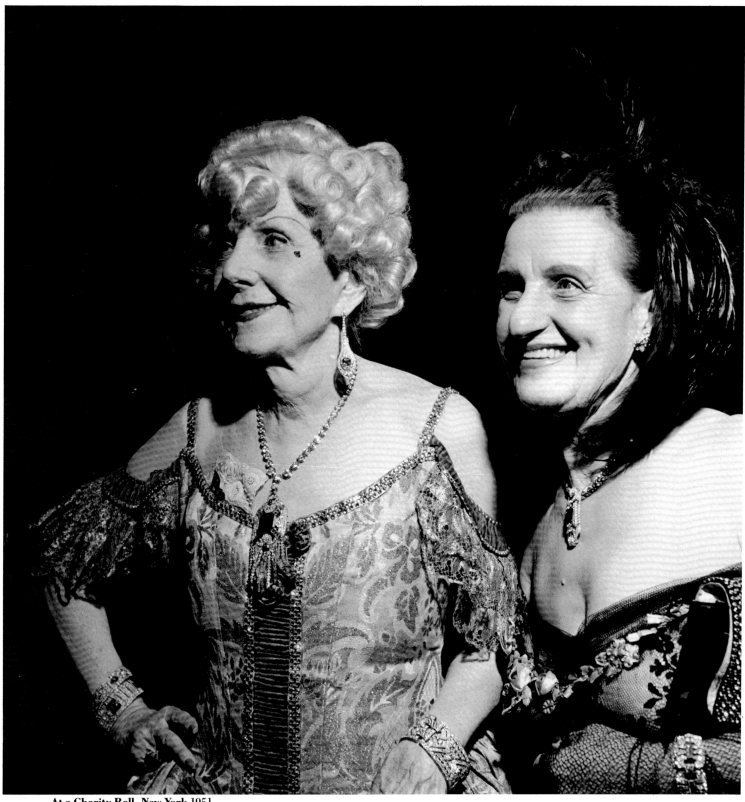

At a Charity Ball, New York 1951
Courtesy of Monah and Alan Gettner

HELEN LEVITT

Born 1918. Influenced by the work of Henri Cartier-Bresson and Walker Evans, Helen Levitt became a street photographer, showing a world she came to know well with perception, tenderness and elegant choreography. Since the 1940s Levitt's pictures have been held in great esteem by her colleagues. She currently now photographs in colour and stands as one of the most highly regarded recorders of city life.

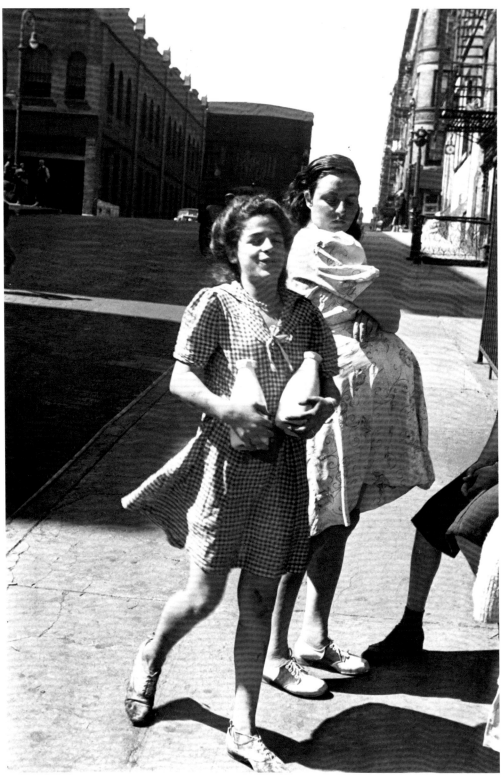

No title, c.1945
Courtesy of the artist

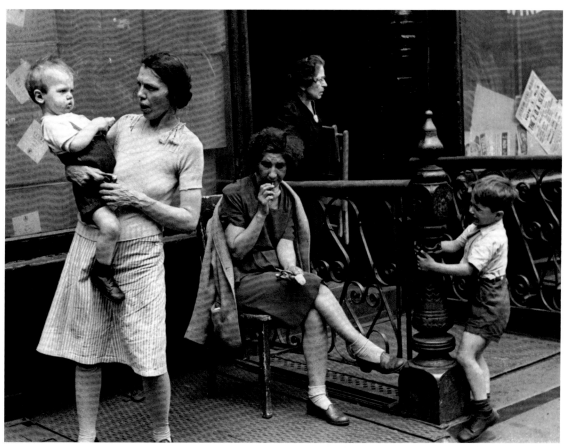

No title, c.1945
Courtesy of the artist

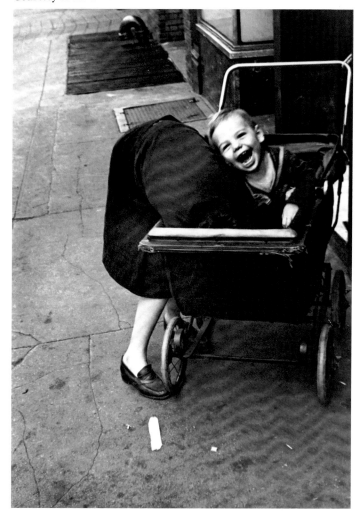

No title, c.1942
Courtesy of the artist

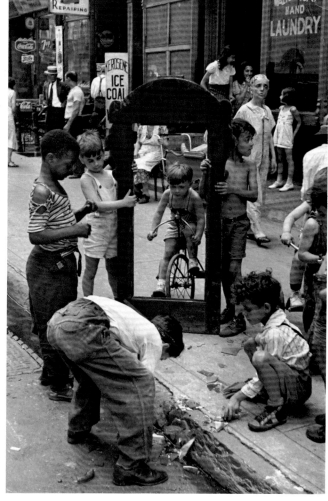

No title, c.1945
Courtesy of the artist

MORRIS ENGEL

Born 1918. Cited by François Truffaut as being instrumental in bringing the 'new wave' to French cinematography, Engel is best known for his film work, which began with Paul Strand in 1939. As a still photographer, trained in the disciplines of The Photo League, he worked a New York beat, documenting the city and its people for himself, for the newspaper PM and for a wide range of American magazines. His film Little Fugitive won the Silver Lion at the Venice Film Festival in 1953 and the same year received an Academy Award Nomination.

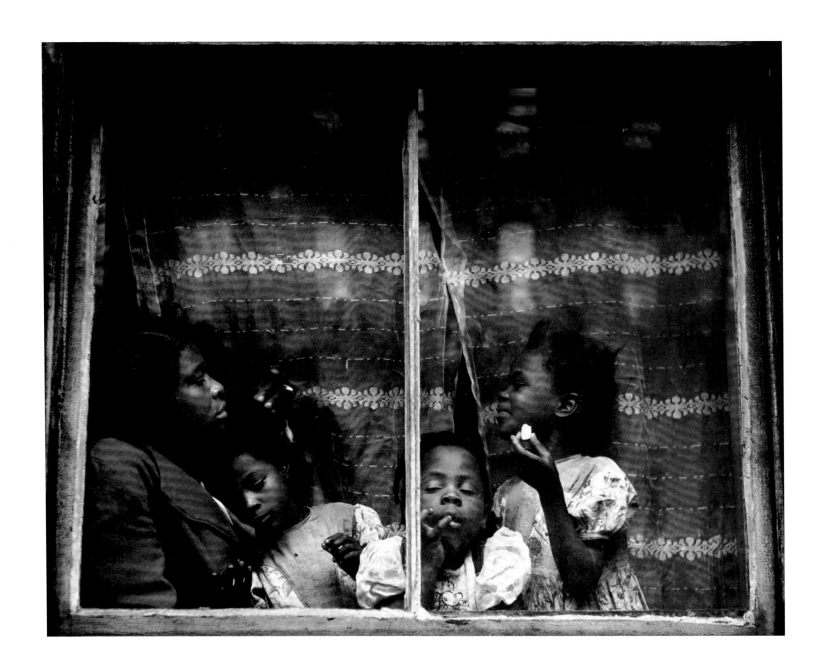

Rebecca, Harlem, New York 1947
Courtesy of the artist

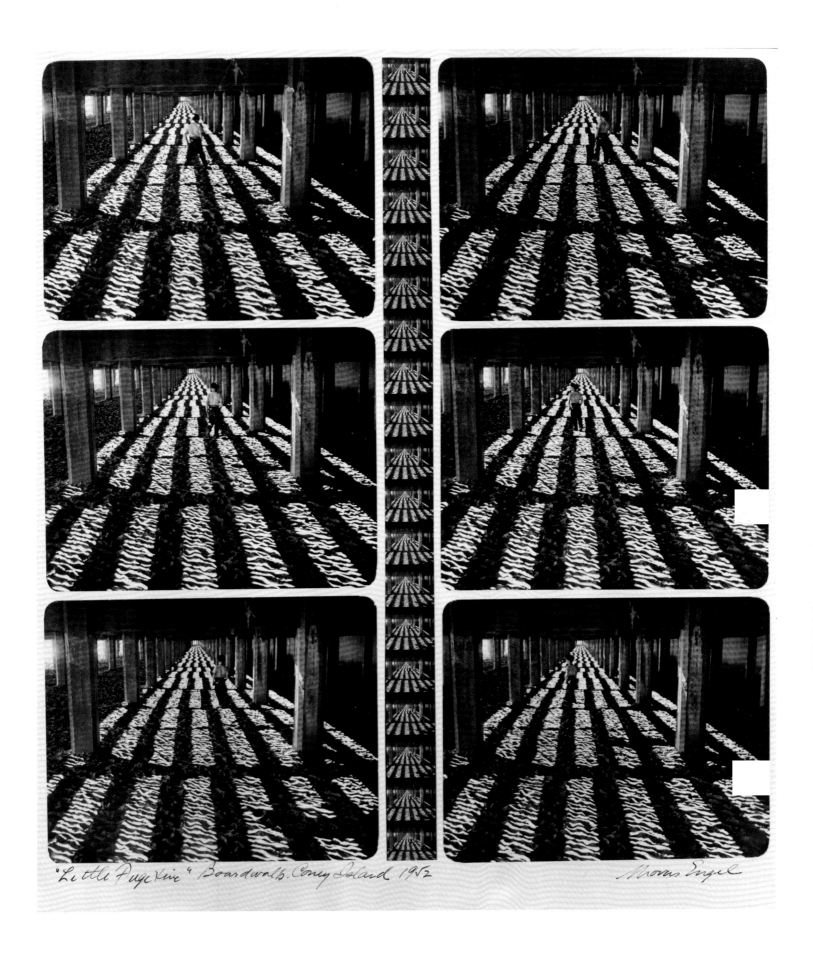

Under the Boardwalk, Coney Island, New York from the film **Little Fugitive,** 1952
Courtesy of the artist

RUTH ORKIN

Born 1921. Died 1985. Co-director and writer with Morris Engel on the films
Little Fugitive and Lovers and Lollipops (1955), Orkin is more often associated with
her work for magazines such as Life and Look. In 1959 she was voted one of the
'Top Ten Women Photographers in the US' in recognition of her humanistic,
often intimate and always sensitive vision.

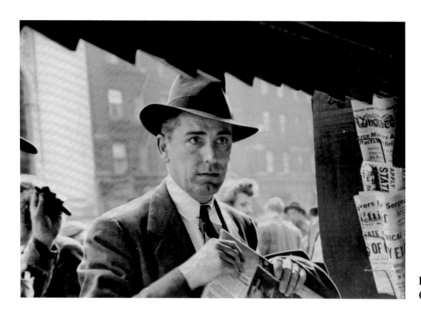

Portrait of Man Buying Newspapers, 14th Street at 8th Avenue, New York 19
Courtesy of the artist

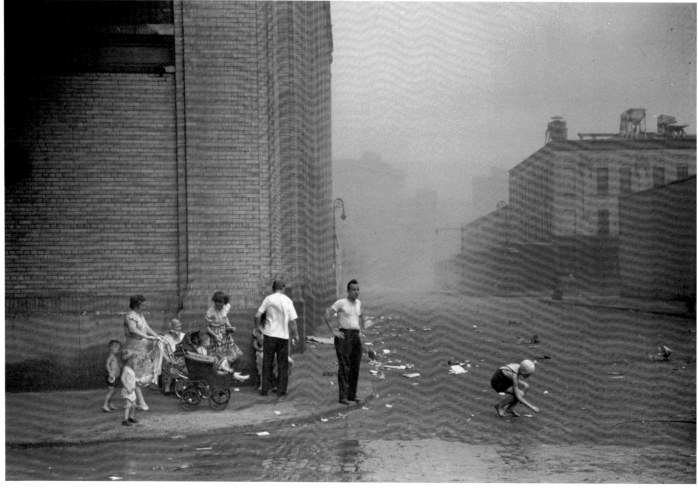

Sandstorm, Greenwich Village 1949
Courtesy of the artist

JEROME LIEBLING

Born 1924. As documentary photographer, film-maker and teacher, Liebling has a lifetime involvement with visual communication. Like many concerned photographers of his generation he was schooled in the traditions of 'straight' photography via The Photo League and has gone on to refine those values.

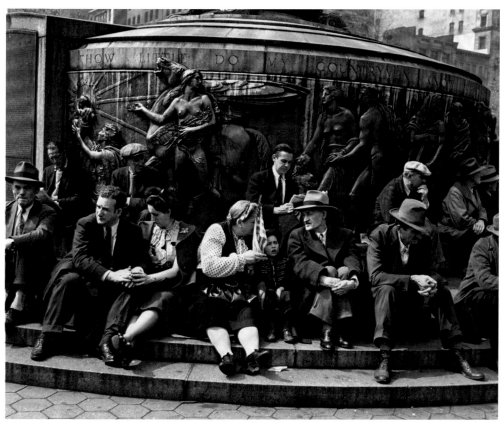

Union Square Park, New York 1948
Courtesy of the artist

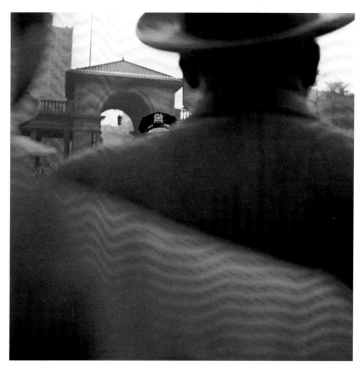

Union Square Park, New York 1948
Courtesy of the artist

JOHN GUTMANN

Born 1905. Now Professor Emeritus at San Francisco State University, where he taught photography from 1938-73, Gutmann first came to America in 1933. He transposed many of the progressive visual attitudes of his native Germany to picture-making in America, where he was able to see as an outsider and pick up the unconscious clues to American thinking he found on public display. He describes his fields of interest as 'photo-journalism, documentary, surrealism, symbolism, human interest and serial photography'.

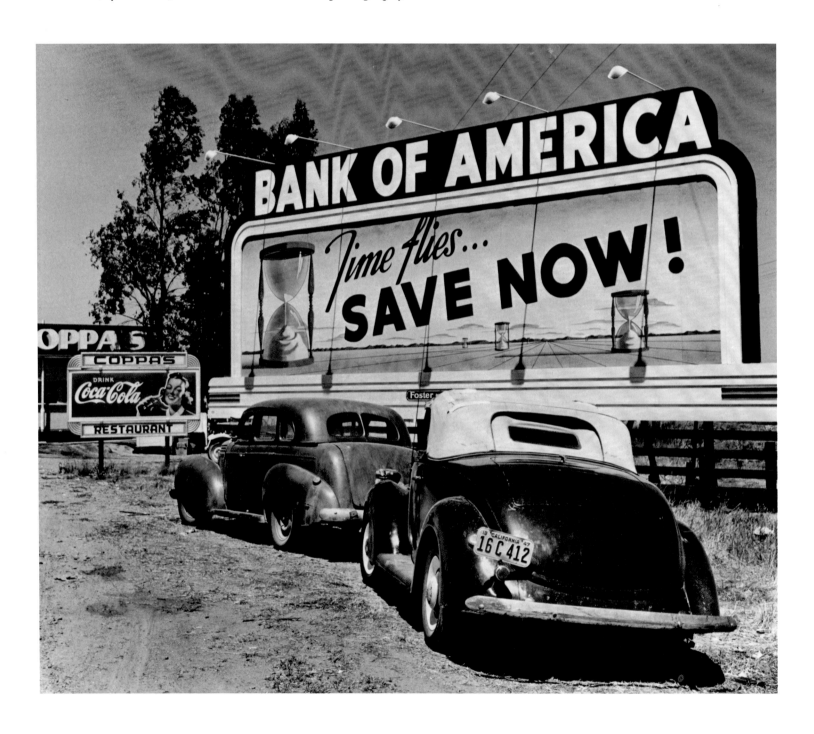

Time Flies ... Save Now! 1947
Courtesy of the Fraenkel Gallery

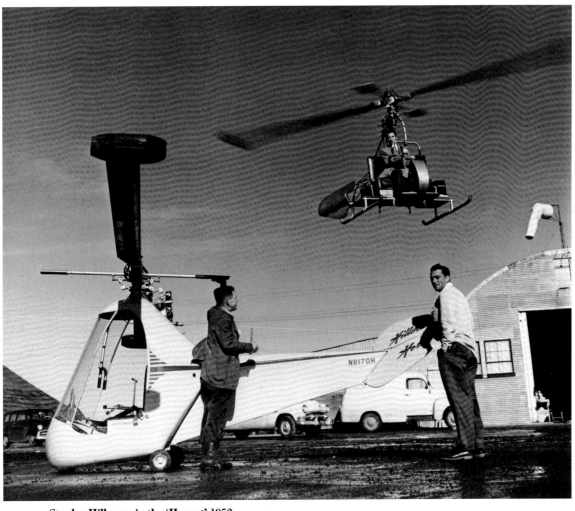

Stanley Hiller up in the 'Hornet' 1952
Courtesy of the Fraenkel Gallery

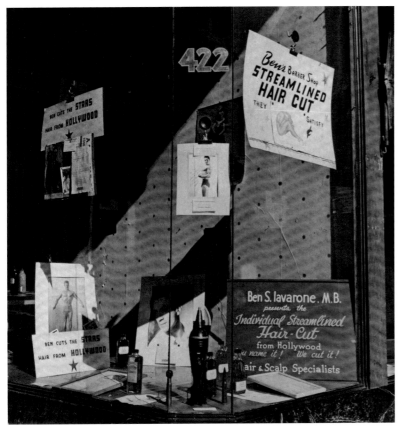

Ben's Barbershop Window, San Francisco 1946
Courtesy of the Fraenkel Gallery

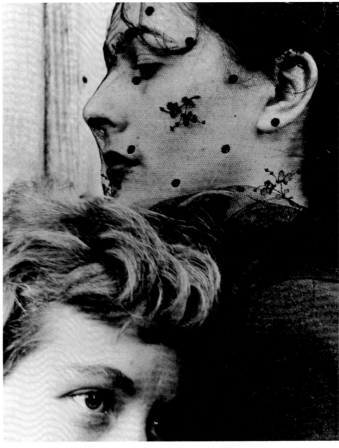

The Oracle 1949
Courtesy of the Fraenkel Gallery

IMOGEN CUNNINGHAM

Born 1883. Died 1976. Few photographers have inspired a more loving or lasting audience in America than Imogen Cunningham. Her career began in 1901, well before the birth of modernism, and continued unabated into the 1970s, thus spanning (in style and years) more than half the history of photography. Individual to the last, Cunningham was a friend and colleague of Ansel Adams and Edward Weston, a free-spirited bohemian and a monument to the growth of photography on America's West Coast.

Morris Graves 1950
Courtesy of The Weston Gallery

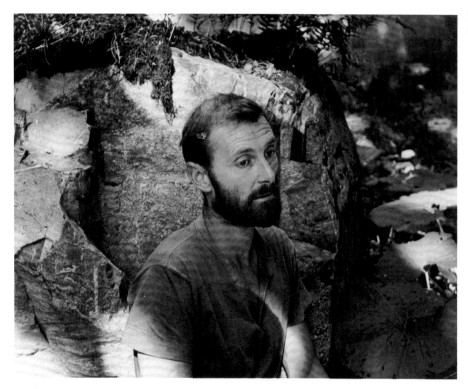

Tea at Fosters, San Francisco 1950
Collection of Joseph E. Seagram

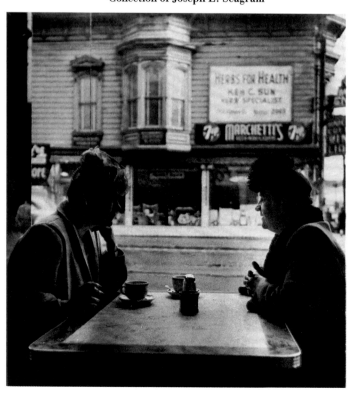

FREDERICK SOMMER

Born 1905. Architect, painter, composer, philosopher and photographer, Sommer remains an enigmatic, though highly-regarded figure in contemporary photography. Though he is frequently classified as a surrealist, his concerns have gone beyond those generally associated with that movement. In 1956 Minor White wrote: 'Frederick Sommer makes no concessions to the casual observer ... Consequently a superficial glance at his pictures reveals about as much as a locked trunk of its contents.' **In 1976 Sommer was quoted as saying:** 'You have to learn to take chances, you have to learn to appreciate juxtapositions, a set of things, a constellation of things in a way that you just happen to meet. You have to be flexible enough to see the possibilities.'

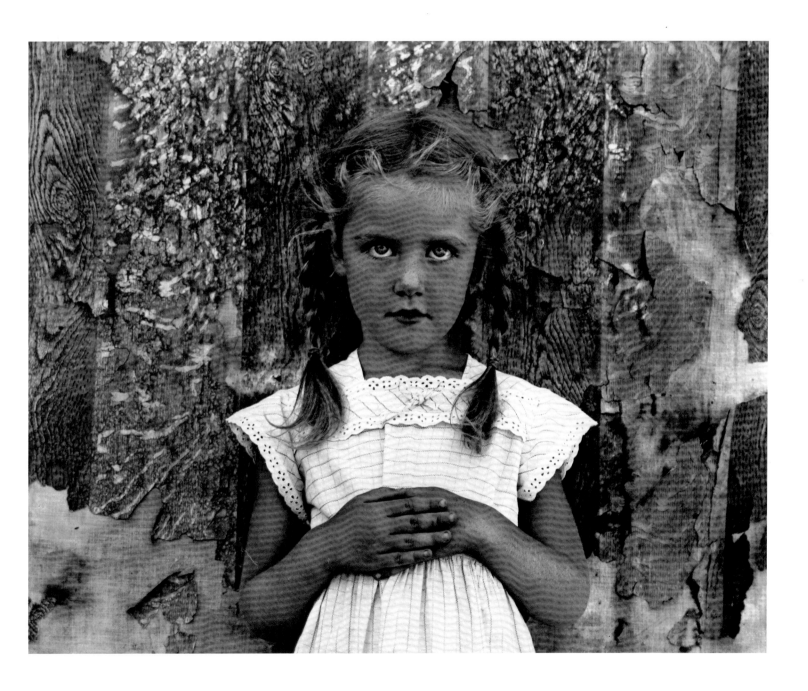

Livia 1948
Courtesy of Center for Creative Photography, Tucson

Circumnavigation of the Blood 1950
Courtesy of Center for Creative Photography, Tucson

Coyotes 1945
Courtesy of Center for Creative Photography, Tucson

Max Ernst 1946
Courtesy of Center for Creative Photography, Tucson

Arizona Landscape 1945
Courtesy of Center for Creative Photography, Tucson

JONATHAN GREEN

AMERICAN PHOTOGRAPHY IN THE 1950s

Two publications of the 1950s literally changed the look of subsequent photography. Jonathan Green, Associate Professor of Photography at Ohio State University, examines The Americans **by Robert Frank and** Aperture, **a quarterly journal edited by Minor White.**

At a time when the affirmative, humanistic vision of photo-journalists was being questioned, these two photographers began to authenticate a viable alternative. In acknowledging a widening division between picturing what is, and the image as a symbol, their vision was to dominate photography during the next decade.

'ANYBODY DOESNT LIKE THESE PITCHERS DONT LIKE POTRY, SEE?'

In **Mirrors and Windows**, the controversial photographic exhibition and publication of 1978, John Szarkowski of New York's Museum of Modern Art argued that the three most important events in American photography during the 1950s were the founding of **Aperture** magazine (1952), the organization of **The Family of Man** exhibition (1955) and publication of Robert Frank's **The Americans** (1959). These events were integrally connected. **The Family of Man** embodied a popular photographic sensibility; **Aperture** and **The Americans** evolved as a reaction to that sensibility. And **Aperture** helped foster the radical vision that ultimately made Frank's work available to America.

The Family of Man, important because the traditions of documentary expression and pictorial style that it upheld have dominated popular conceptions of photography, is discussed by Gerry Badger on page 13. **Aperture** and **The Americans**, though they differed from each other in intent and appearance, both had their roots in anti-establishment culture, a background antithetical to the popular tradition that produced **The Family of Man**. Both sprang from 'the underground' – the rise of the Beat movement and alternative culture.

The **Aperture** quarterly of the fifties was a quiet manifesto for the work of the metaphorical and expressionist photographer. Though thoroughly dominated by its editor, Minor White, through carefully chosen essays and photography it introduced alternatives to popular photographic aesthetics. **Aperture's** audience was small but the quarterly became the first significant critical forum of photography since Stieglitz's **Camera Work**. **Aperture** lacked **Camera Work's** urbanity, cosmopolitanism, sophistication, and cultural breadth, yet it did have a curious, at times adolescent, eloquent vitality.

Aperture's personality was the personality of Minor White. Where else could one find all rolled into one publication the finest possible photographic reproduction, White's eclecticism and gawky humour and Henry Holmes Smith's intellectual analysis; the historical perspective of the Newhalls and the aphorisms of White's alter ego, Sam Tung Wu; Lyle Bonge's

photographs made and viewed under the influence of mescaline; portfolios by Adams, Bravo, Bullock, Caponigro, Cunningham, Eisenstaedt, Hyde, Jones, Lange, Weston, Stieglitz, Siskind, Sommer, and Charles Wong; serious essays on photographic styles and schools and on the photographic consciousness; reviews of photographic books as well as of Boleslavsky's **Acting: the First Six Lessons** and Herrigel's **Zen in the Art of Archery**? Who else but White would dare to comment on **The Family of Man**, 'How quickly the milk of human kindness turns to schmaltz', call the prestigious **US Camera Annual**: 'the juke-box level of American taste', and describe Cartier-Bresson's post-1947 photographs as examples of 'the journalistic photograph out of context that drifts into the travelogue'? Who else would use such a colophon as 'Reading photographs requires so much salt that we like to get pickled before we start'? Or follow one issue's serious editorial on recapturing innocence of vision with an editorial in the next issue on the need for gravestones that 'disintegrate beautifully'? What other publication would place such a personal ad: 'For photographers who wish an overhaul of their seeing habits Minor White is available for individual instruction ...'? And only White could have published such an outraged, uncomprehending reader's protest to his whole endeavour: 'And this preciousness – this is the thing above all ... I want to spend my life fighting against ... The high flown language, the collector in inverted commas, the beautifully framed engraving, the postage stamp size; all kinds of snobbery; these are the things I want killed dead ... Your magazine to someone not living on the West Coast or Eastman House looks more than a little parochial.'

White was committed to the advancement of photography both as an art and as a medium of personal growth and expression. He was determined by trial and error, philosophical exchange, discussion and debate to develop a theory of photography that was relevant to his own time. The theory he developed would not be one of style and form, but would be centred, as it had been for his mentor, Stieglitz, around the central issues of expression. The final form of the image was of

less importance than its evocative meaning. White set out to define the nature of photography's emotional content and to discover methods by which that content could be perceived. **Aperture** moved ahead quickly to crystallize White's maturing ideas about the intentions of the photographer and the function of photography. Two major ideas emerged. The first was that photographs could be 'read'. The second was that photography could serve as a fitting medium for psychological and spiritual contemplation.

Aperture's stand on 'reading' photographs was developed in a series of articles, editorials, and reproductions. The quarterly's major concerns were well expressed by some of the titles of these articles: 'Photographing the Reality of the Abstract', 'The Subconscious of the Camera', 'The Masks Grow to Us', 'Image, Obscurity and Interpretation', 'Substance and Spirit of Architectural Photography'. What emerged from these articles was a series of premises by which a photograph would be 'read'. First, a photograph's meaning is not exhausted by mere identification of its subject matter. A photograph's significance lies deeper than that which can be comprehended by an immediate response. This first tenet contradicts the popular notion, in White's words, **'that any picture that cannot be totally grasped in less than 1/100th of a second is needlessly obscure, private, meaningless.'** 'The lay public, Henry Holmes Smith wrote, **'is utterly blinded by identification. If they can identify a subject, they are satisfied that the photograph has communicated all its secrets'.**

Second, a photograph is not different from, but is closely related to, other forms of aesthetic experience. From the beginning, **Aperture** was committed to appropriating for photography the same seriousness of purpose and interpretation that had been reserved for the other arts.

Third, a photograph, like any work of art, is a complex whole composed of similes, metaphors, symbols, and forms that refer both to the visual world and to the perceptions and feelings of the photographer. A photograph differs from work in the other arts chiefly in the manner in which it is produced, not in its inherent meanings and intentions nor in the consciousness of the individual who made the image. The primary aesthetic values of insight, intuition, control of form, and personal expression are as much a part of photography's birthright as the inherently photographic virtues of documentation and description.

Fourth, a photograph may be understood as a new experience. There is no necessary relationship, link, or memory between the object photographed and the meaning of the finished print. This premise so boldly contradicted the documentary tradition that it was taken to be a credo for abstraction and photographic expressionism. **'Social needs,'** Frederick Sommer wrote, **'are not central to the problems of photography as an art.'**

Fifth, the accidental photograph may reveal the world in a new way. For White, the unfailing, mechanical nature of the recording process could be used as **'automatic writing,'** which when carefully scrutinized had the possibility of **lifting the veil from the surface of familiar objects ...'**

Sixth, and last, the viewer's experience of a photograph could be translated from the realm of visual thinking into that of verbal expression. The experience of art was communicable in words. White shared the poet's belief that words could make one see more clearly. It was on this premise that the possibility of 'reading' photographs rested. Though White had a mystical turn of mind, he never patronized the ineffable. A translation of some sort could always be found. Even the most extreme and

unusual experiences could be communicated. On his deathbed, a few moments before his heart stopped, White asked his last visitor, 'Do you have any questions?' He wanted and was willing to tell all.

To many of **Aperture's** own readers, and certainly to the popular photographer who wholeheartedly accepted the ethos of **The Family of Man,** the direction that White and the quarterly were taking, particularly in **The Way Through Camera Work** – an issue offering an esoteric, internalized answer to the popular aesthetic – must have seemed strangely obtuse, cultic, and anti-establishment. For **The Way Through Camera Work** was not only intellectually shocking to the conservative high culture of the fifties, it was also a distinct departure from the styles and manners sanctioned by complacent popular opinion. Though **Aperture** always stayed to the right of that thin line between respectable culture and the underground, between comprehension and obscurity, its roots go back to the same sources that spawned the alternative cultures of the fifties, particularly the Beat movement.

White's relationship to Stieglitz is always rightly emphasized. Yet his closest contemporary spiritual allies in the fifties were the same as Robert Frank's: the major Beat poets – Kerouac, Ginsberg, and Snyder – and the older members of the San Francisco and West Coast intellectual community – Kenneth Rexroth, Alan Watts, Gerald Heard, Christopher Isherwood, Aldous Huxley, Mark Tobey, and Morris Graves – who for years had been interested in Oriental religions and had been continually pursuing the contemplative life. Though **The Way Through Camera Work** appeared after White had left San Francisco for Rochester, its origins stem from the Oriental teachings that had long established themselves in California. It was not based on the European idea of active intelligence, but on the Oriental tradition of passive intuition.

Aperture itself was just as surely a product of the San Francisco renaissance and bohemian ambience as Ferlinghetti's City Lights publications. **Aperture** was one of the little magazines of the fifties, which, together with **Big Table, Chicago Review, San Francisco Review, Contact, Origin, Choice, Yugen, Black Mountain Review, The Jargon Society, Neon,** and **Evergreen Review,** gave America its first indication that something radical in thought and action was occurring beneath the surface of respectable culture. When this finally broke into the open its practitioners were called 'the Beats'.

The Beats used the rough experience of life itself as the confessional medium for a new vision; **Aperture** used photography as the medium that could seek out the truths and essences that lay behind the accepted culture of the fifties. Both **Aperture** and the Beats, in their own way, stood for an art of revelation, of individuality, of loud or quiet protest, of message, of beatitude.

The sources to which **Aperture** and the Beats turned were identical. Kerouac read D. T. Suzuki's essays on Buddhism, Zen stories, **The Life of Buddha** by Ashvagosa, Dwight Goddard's **Buddhist Bible.** Ginsberg followed Buddhist Sutras, Yoga precepts, Vedic hymns, Chinese philosophy, and the Tao. Neal Cassady read Gurdjieff and Ouspensky.

While White himself seems to have stayed on the sidelines of the avant-garde, **Aperture** sympathetically parallels its concerns. It is Siskind, Callahan, and Sommer, photographers who broadly supported the new art, who make the personal ties. The painter Hugo Weber during the fifties was a close friend to both Kerouac and Callahan. The old Cedar Bar in New York became the hang-out for Siskind and the Abstract

Expressionists as well as for Ginsberg, Corso, Seymour Krim, and occasionally Kerouac. And some of these men might also have been found at Helen Gee's Limelight coffee house, the first and most important New York photographic gallery in the fifties. One of the leading sympathetic critics of Abstract Expressionism, Harold Rosenberg, wrote the introduction to Siskind's first monograph. And the Six Gallery, one of the initial homes of Abstract Expressionism in San Francisco, became the place where Ginsberg first read **Howl** and launched the Beat movement. Black Mountain College hosted or published Siskind, Callahan, Jonathan Williams, Kerouac, Ginsberg, Burroughs, Snyder, and many more of the major poets, musicians, and painters of the vanguard.

Through **Aperture,** and through the discoveries that White made in these other contexts, it is clear he was looking for a Tao of photography: the way to see clearly beyond the superficial, the intellectual, the pictorial. For him, the Tao became the essence of philosophy and photography. For Robert Frank, linked in time and cultural environment, the physical facts spread out along the American roadway generated the very shape and content of photography. For both White and Frank it is the Tao – the Way, the Road – that becomes the primary word and symbol: **The Way through Camera Work** and **On the Road.** Frank, like the Beats, was a traveller. He had spent most of the ten years preceding 1955 moving from country to country, peering and photographing from the windows of moving cars and trains, seeing reflections of humanity in shop windows, monuments, and public signs and in the movement of people on the street and in parades. Frank was bound neither by political nor visual constraints. He was on the road, always on the move. He was the archetypal stranger, the carefully observant onlooker.

The shock of self-recognition that O'Sullivan and Brady had given America with their photographs of the Civil War and that Walker Evans had produced with his photographs of the thirties would now be repeated in Frank's work. '**Robert Frank, Swiss, unobtrusive, nice,**' the observation is from Jack Kerouac's famous introduction to **The Americans,** '**with that little camera that he raises and snaps with one hand he sucked a sad poem right out of America onto film, taking rank among the tragic poets of the world.**'

Frank had come to the United States first in 1947. By 1953 he was part of the New York avant-garde circle. He had met Walker Evans, Herbert Matter, Willem de Kooning, Franz Kline, and Allen Ginsberg. Nevertheless, Frank seems not to have known Kerouac's unpublished, yet already mythologized work when he made his cross-country trip of late 1955 and 1956. Nor did he know Ginsberg's **Howl,** which was written in the fall of 1955 and was not published until a year later. Kerouac's **On the Road** would not finally see print until late in 1957. It was not until 1958, after the Paris edition **Les Américains** appeared, that Frank met Kerouac and asked him to write the introduction to the American version of his book. '**I don't think that I traveled on the Beats' path,**' Frank remarked recently, '**but it seems we've heard each other.**'

Frank's America was that visual environment known, loved, and despised by these men who took the term *beat,* which originally meant '**poor, down and out, dead beat, on the bum, sad, and sleeping in subways**' – the definition is Kerouac's – and elevated it first to a gesture of defiance and then to a virtue and a prophecy. Theirs was the invisible America of the fifties. It was the hidden country. It had neither the pathos of the dust bowl, the glamour of Hollywood, or the scientific determinism demanded by Cold War politics. America at times seemed thoroughly foreign to them. Frank voiced both his own and the Beats' sentiments when he remarked in 1958: '**I should imagine, though I've never been to Russia, that America is really more like Russia, in feeling and look, than any other country in the world … the big distances, the faces, the look of families traveling.**'

This was not exactly what any red-blooded American would want to acknowledge in the midst of the Cold War and in the wake of McCarthyism. But it was the scruffy world that lay by the side of the road, and Frank was determined to put it down as he saw and felt it.

Paradoxically, through **Aperture,** White helped foster what little climate of acceptance there was initially for Frank's vision of America. But White failed to understand that Frank, just as surely as Callahan, Siskind, and he himself, had abandoned the public document for private vision. '**My view is personal,**' Frank stated, and with this simple acknowledgement rejected the same iron-clad tradition of the American documentary essay that had repelled White, Siskind, and Callahan.

'**The old going road … trucks, cars, poles, roadside houses, trees, signs, crossings.**' These words from a Kerouac description form the essential iconography repeated again and again in the work of the Beats. It can be found in Frank and many of those who came after him. It is the barren American landscape Ferlinghetti saw in **Starting from San Francisco:**

> Later again, much later,
> one small halfass town,
> followed by one telephone wire
> and one straight single iron road
> hung to the tracks as by magnets
> attached to a single endless fence,
> past solitary pumping stations,
> each with a tank, a car, a small house, a dog,
> no people anywhere …

It is the vision of madness, speed, and the road seen in Ginsberg's **Howl:**

> who barreled down the highways of the past journeying
> to each other's hotrod-Golgotha jail-solitude watch or
> Birmingham jazz incarnation, who drove crosscountry
> seventy-two hours to find out if I had a vision or you had
> a vision or he had a vision to find out Eternity …

And it is the public metaphor for what Kerouac, like Whitman, had proposed as '**the noble ideal American open-mind sensibility, open road, open energy**'.

More than this, the road and the automobile took on hieratic meaning. '**What is the meaning of this voyage …?**' Ginsberg asks in Kerouac's **On the Road.** '**What kind of sordid business are you on now? I mean, man, whither goest thou? Whither goest thou, America, in thy shiny car in the night?**' Frank's answer to Ginsberg's question is given in the same tone in which it is asked: it is given in distinctly religious terms. **The Americans** shows the quest for the values of the ideal life translated and relocated in commercial advertisements, on billboards, and in store windows at the roadside. The sacred has become totally secular. In **The Americans,** the spirit, the quest, tawdry advertising, and the road have become one. Religious rites have been usurped by public signs. The world of spirit exists only in the world of things: *SAVE* proclaims the giant sign standing amid the silent, worshipping gasoline tanks at Santa Fe; *Awake!* headlines the magazine proffered by the evangelist in the business suit in Los Angeles; *Remember Your Loved Ones 69 cents* hawks the sign above the rows of Styrofoam crosses and plastic wreaths in the department store

in Lincoln, Nebraska; *Christ Died For Our Sins* announces the card taped to the back of a shiny Chevrolet in Chicago. The few moments of genuine energy Frank perceived within America were distinctly un-American. They came from a world beyond conventional expectations and attitudes, beyond the narrow alternatives offered by the establishment's culture. They came from the vitality of America's sub-cultures and counter-cultures. There is more human intensity, joy, meditation and grief in the photographs of blacks than in the photographs of whites. There is more feeling emanating from the omnipresent jukebox than from the entertainments of high culture. And the cocktail parties and restaurants of the rich are sterile compared to the sometimes desolate, sometimes violent, sometimes dream-like eateries of railroad stations and corner drugstores. **'Anybody doesnt like these pitchers dont like potry, see?'** Kerouac challenged. **'Anybody dont like potry go home see Television ...'** The dichotomy was absolute. The vigour in Frank's world is distinctly Beat.

It was Frank's genius and good fortune – as it had been Stieglitz's half a century earlier – to revitalize American photography by way of the European tradition. It was Frank who cross-bred native facts and the optimistic idiom of Walker Evans and the early Strand with the tougher, ironic *verité* of Atget, Salomon, Kertész, Brassaï, Brandt, and Cartier-Bresson. He brought to photography Kerouac's definition of the new American poetry: **'The discipline of pointing out things directly, purely, concretely, not abstractions or explanations, wham wham the true blue song of man.'**

Almost every major pictorial style and iconographical concern that will dominate American straight photography in the late sixties and throughout the seventies can be traced back to one or more of the eighty-two photographs in **The Americans**. The work of White, Callahan, and Siskind virtually – but not entirely – used up the potential inherent in Stieglitz's concept of equivalence. Frank's photographs, on the other hand, laid the groundwork for endless experimentation. The list of major photographers who go back to White, Siskind and Callahan is surprisingly short, but the list of those who derive from Frank is impressive and continually growing. Even Callahan's recent work owes something to Frank's vision.

Frank's cross-country pilgrimage will be repeated time and time again. The picaresque view of America from the road will appear in Lee Friedlander's **The American Monument** and **Self Portrait**, Charles Harbutt's **Travelog**, Burk Uzzle's **Landscapes**, Danny Lyon's **The Bike Riders**, Nathan Lyons's **Notations in Passing**, Michael Becotte's **Space Capsule**, Steve Fitch's **Diesels and Dinosaurs**, as well as in the work of many of the Photo-Realist painters.

Frank's images of the starlets at movie premières and the opening of the New York City Charity Ball are matched before his time only by the caustic photographs of Weegee. But it was through Frank, not Weegee, that a series of critical, sometimes compassionate, more often cruel, descriptions of people in public places found their way into the mainstream of American photography. Echoes will turn up in Friedlander's party photographs, Mark Cohen's close-ups, and Winogrand's **Public Relations**. And in Frank's dime-store cowboy, New York transvestites, sardonic Jehovah's Witness, and dolled-up older Miami Beach couple lies the basis for Diane Arbus's world.

Specific Frank photographs will sometimes be quoted directly. His isolated tv set in the deserted luncheonette has become an obsessive image of depersonalization. It will be found again in the portfolios of Friedlander, Davidson, Meyerowitz, Winogrand, and Mertin. And Frank's image of violence on the drive-in movie screen in Detroit is pushed to unbearable intensity by Friedlander. Here America's cold fascination with the automobile and death becomes acute. Anonymously peopled cars line up to watch on the outdoor screen the most traumatic car ride of all: John Kennedy's final motorcade through Dallas.

Most significantly, Frank's willingness to seek radically new ways to present the relationship between content and form, style and subject, marked an end in serious photography to popular notions of composition and subject matter. Just as White, through **Aperture**, had initiated a new and aggressive method of photographic interpretation, so Frank, in **The Americans**, initiated a tradition dedicated to a most aggressive exploration of the structuring of visual information.

JONATHAN GREEN
Photographer, writer, teacher and historian, Professor Green has contributed broadly to photography in America. At one time an Associate Editor of **Aperture** he is author of four books on photography, the most recent of which is a critical history from 1945 onwards. As a picture-maker his work has been widely published and is in collections in America and Europe. ★ P.T.

II.
1950-60

LEON LEVINSTEIN

Born 1913. Leon Levinstein is one of the few truly amateur photographers to appear in this collection: he always photographed for love, not money. Photography became his private passion after his discharge from the US Army in 1945. Trained as a graphic artist, he spent his free time taking pictures on the New York streets. His first solo exhibition, at the Limelight coffee shop and gallery, was in 1956. Levinstein has been included in ten Museum of Modern Art shows, including The Family of Man and The Photographers' Eye.

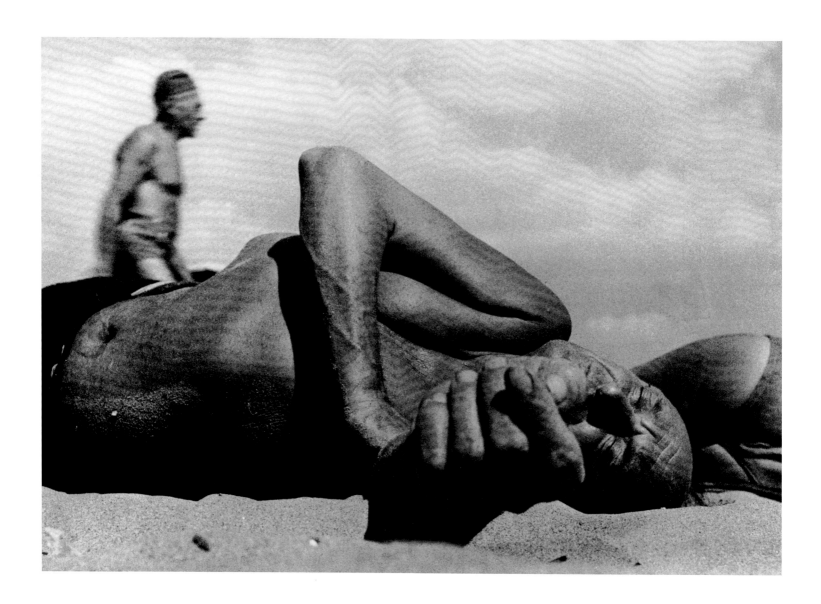

Untitled c.1955
Courtesy of the artist

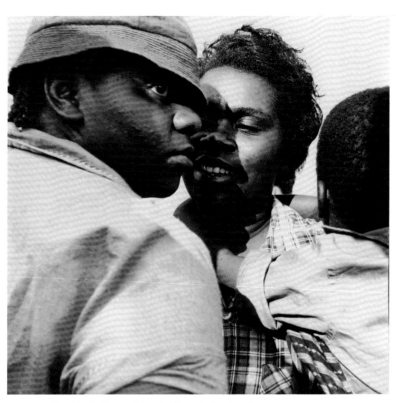

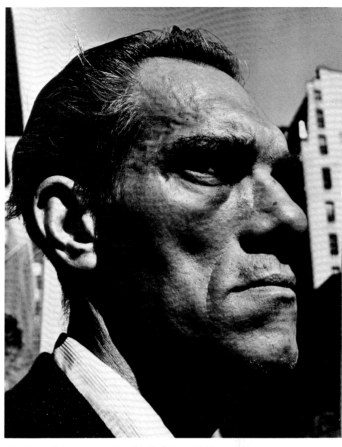

Untitled, Coney Island, New York c.1958
Courtesy of the artist

Untitled, 5th Avenue, New York City c.1959
Courtesy of the artist

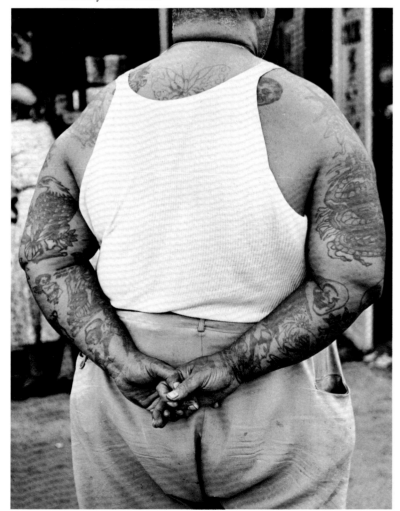

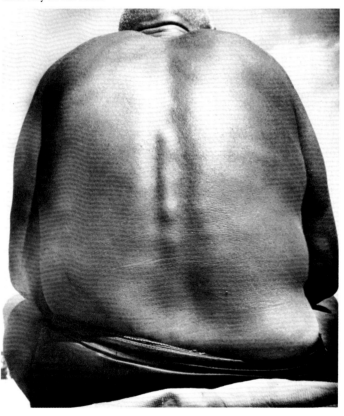

Untitled, Coney Island, New York c.1956
Courtesy of the artist

Untitled, Coney Island, New York c.1958
Courtesy of the artist

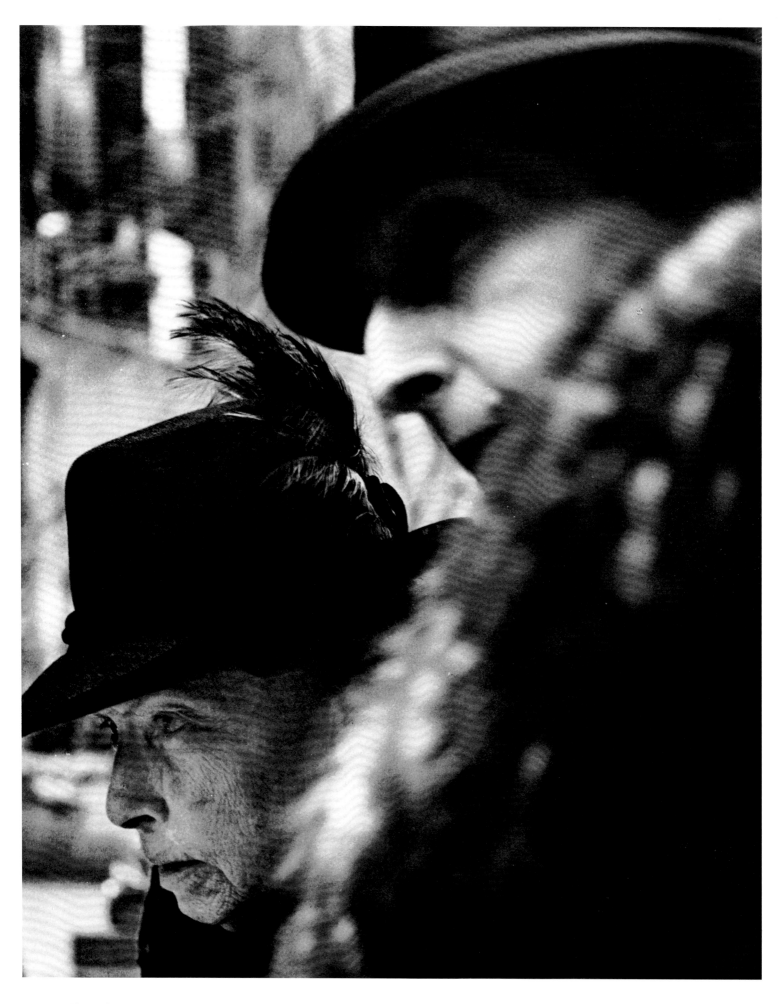

Untitled, Rockefella Center Skating Rink, New York City c.1959
Courtesy of the artist

ROBERT FRANK

Born 1924. Frank brought to bear on American image-making a radical, European sensibility derived from his Swiss origins. In the process he changed his adopted country's attitude to what could be pictured and how a photograph might look and feel. He has been more influential than any other photographer of his generation. He fought conventions of content and pictorial organization with a loose, elliptical view that spoke of mounting doubt at America's drift towards mindless affluence, Frank's pictures in The Americans (1959) exploded photo-myths of passive observation, exchanged them for personal reaction and thus opened new avenues for photography. In 1958 he began to make films, the best known (though little seen) being a documentary on The Rolling Stones tour of America in 1972 called Cocksucker Blues.

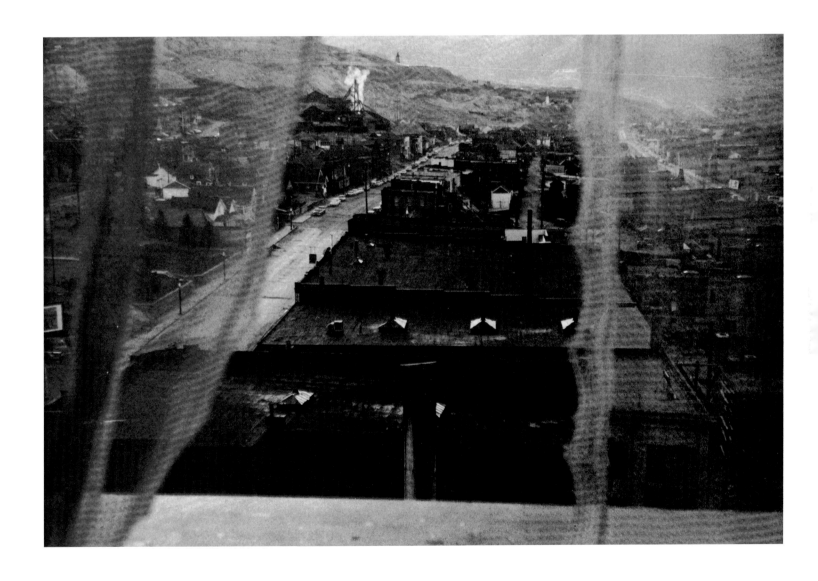

Butte, Montana 1956
Courtesy of The Weston Gallery

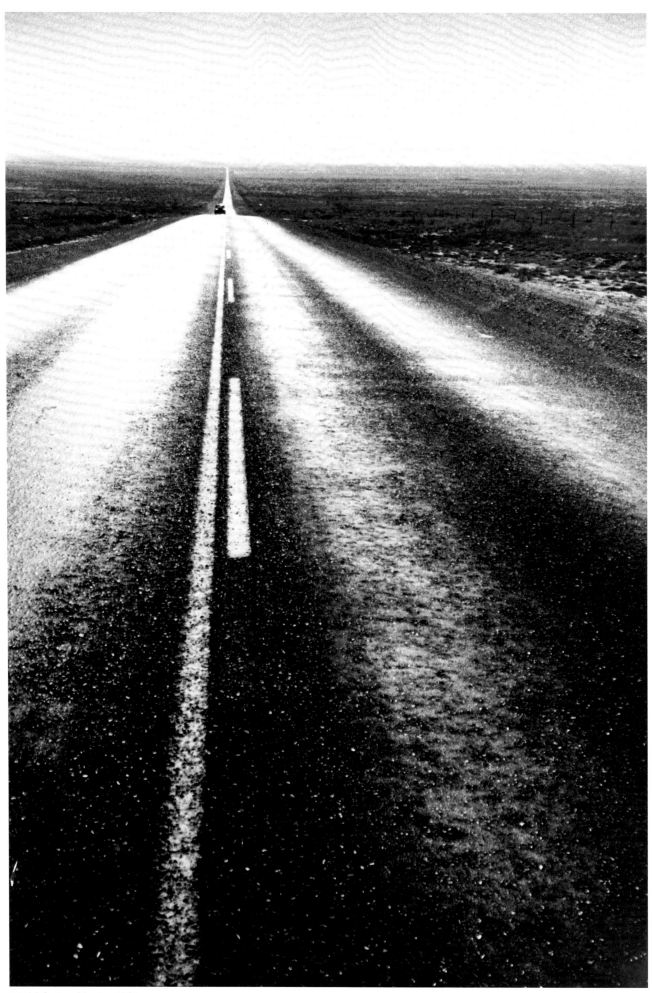

US 285, New Mexico 1956
Courtesy of The Weston Gallery

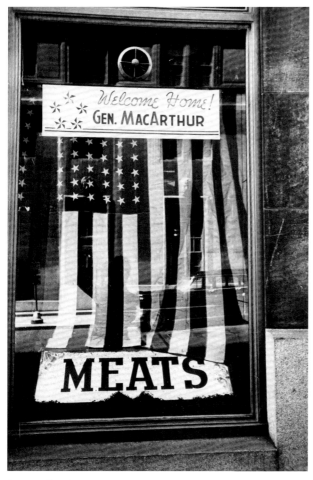

New York 1951
Collection of Peter Steil, Raymond B. Gary & Bowen McCoy

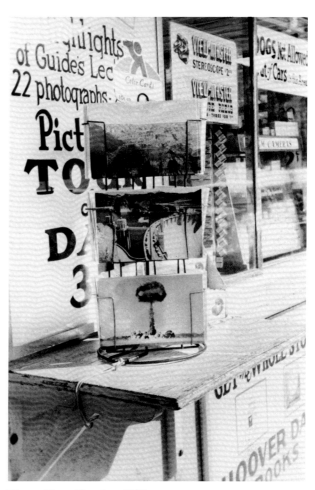

Hoover Dam, Nevada c.1955
Collection of Peter Steil, Raymond B. Gary & Bowen McCoy

Political Rally, Chicago 1956
Courtesy of The Weston Gallery

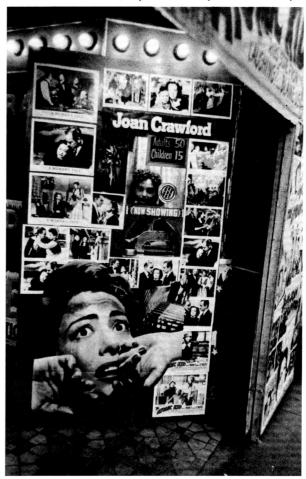

Detroit c.1955
Collection of Peter Steil, Raymond B. Gary & Bowen McCoy

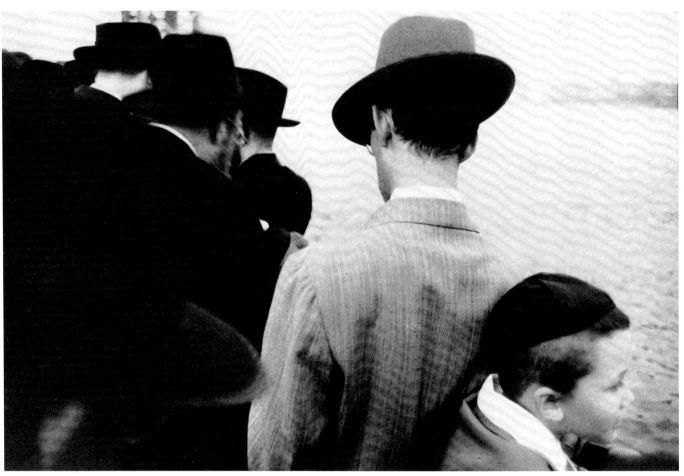

Yom Kippur, East River, New York 1956
Courtesy of The Weston Gallery

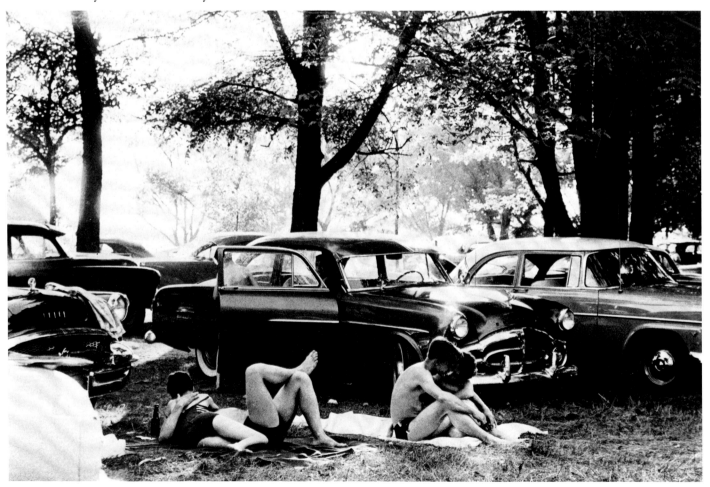

Ann Arbour, Michigan 1956
Courtesy of The Weston Gallery

W. EUGENE SMITH

Born 1919. Died 1978. Remembered and revered for his essays made for Life magazine, Smith was seen publicly as the quintessential photo-journalist. Dedicated, passionate and fiercely committed, he battled for recognition of a photographer's ideological beliefs, vision and intelligence against the whims of desk-bound editors. He was a champion of human causes photographing a troubled world and always seeking an affirmation of life and the basic dignity of people. Smith was enormously influential in style and journalistic approach. He is credited with lifting the photo-essay out of magazine illustration, lending it power and credibility as an independent means of communication and establishing the photo-journalist as a major contributor to the dissemination of ideas before television gained supremacy.

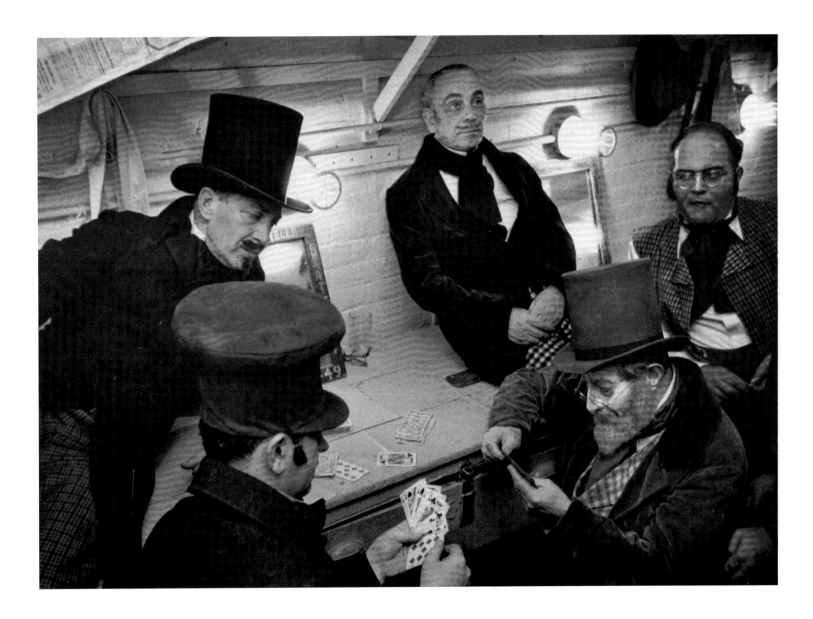

Metropolitan Opera series 1952
Courtesy of the Center for Creative Photography, Tucson

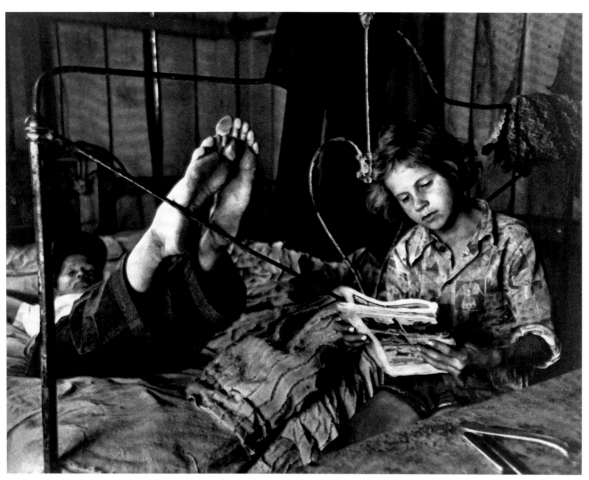

Migrant Worker series 1953
Courtesy of the Center for Creative Photography, Tucson

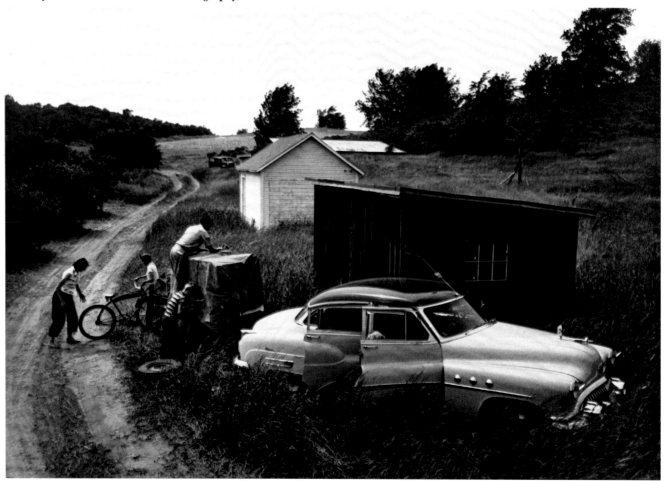

Migrant Workers series 1953
Courtesy of the Centre for Creative Photography, Tucson

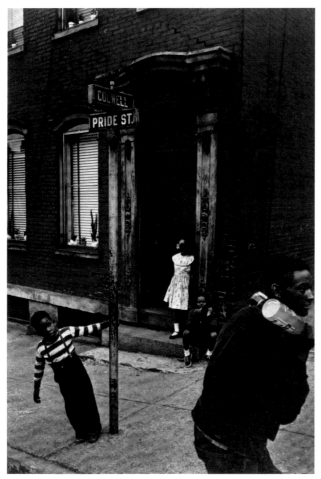

Pittsburgh series 1955-6
Courtesy of the Center for Creative Photography, Tucson

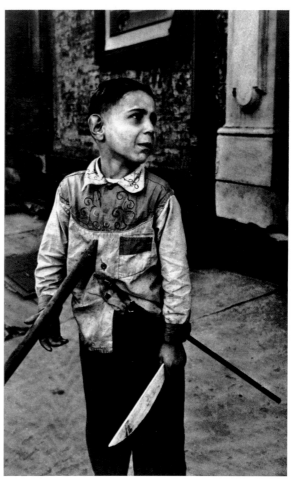

Pittsburgh series 1955-6
Courtesy of the Center for Creative Photography, Tucson

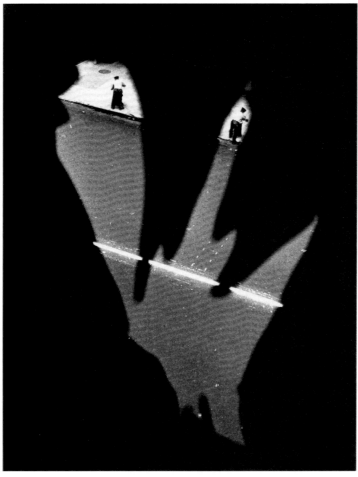

As From My Window ... I Sometimes Glance series 1957-8
Courtesy of the Center for Creative Photography, Tucson

Country Doctor series 1948
Courtesy of the Center for Creative Photography, Tucson

DAN WEINER

Born 1919. Died 1959. Like so many of his contemporaries, Weiner was
a product of The Photo League where he learned of the possibilities open to a
street photographer in New York City. He became a photo-journalist noted for his
visual agility and fascination for people. He died in a plane crash when on
assignment. Of him Walker Evans (a mentor) wrote: 'There have been a few
serious, gifted hands working in photography, since its beginnings. Dan Weiner was
one of them.'

East End Avenue, New York 1950
Courtesy of Sandra Weiner

The Plaza Hotel, New York 1950
Courtesy of Sandra Weiner

East End Avenue, New York 1950
Courtesy of John Benton-Harris

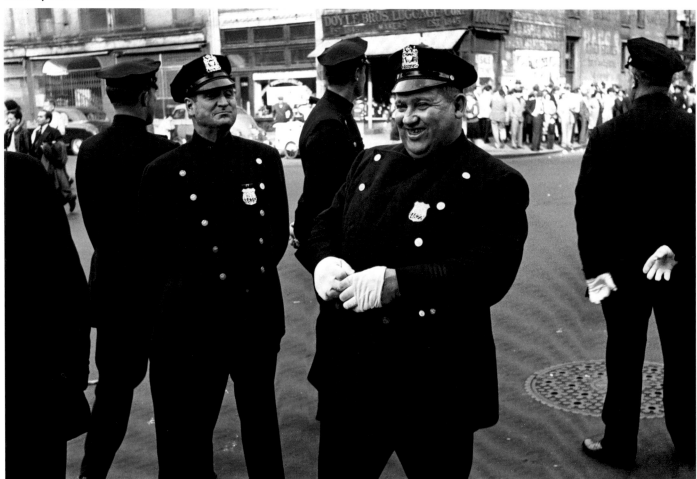

May Day, New York 1948
Courtesy of John Benton-Harris

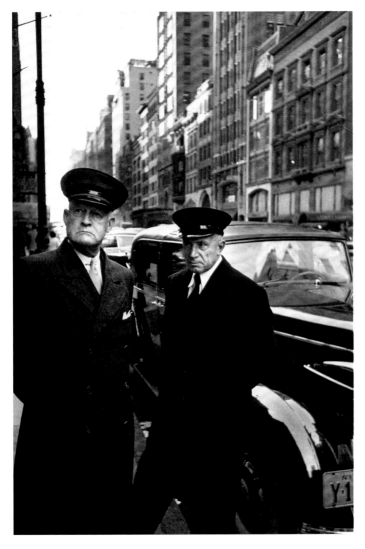

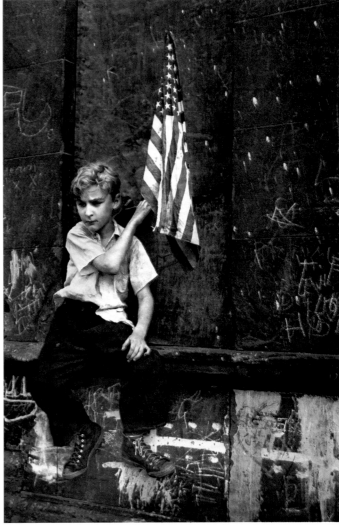

Chauffeurs, The Plaza Hotel, New York 1950
Courtesy of Sandra Weiner

New York 1948
Courtesy of Sandra Weiner

ROY DECARAVA

Born 1919. An early supporter of photography outside its commercial functions, DeCarava gained conspicuous success in both camps. As a working photographer he sold pictures to Sports Illustrated, Life, Look and Time; on the personal front he founded a New York gallery in 1954, worked towards ending discrimination against black photographers, and made pictures that evidenced sharp eyes and a concern for personal truths.

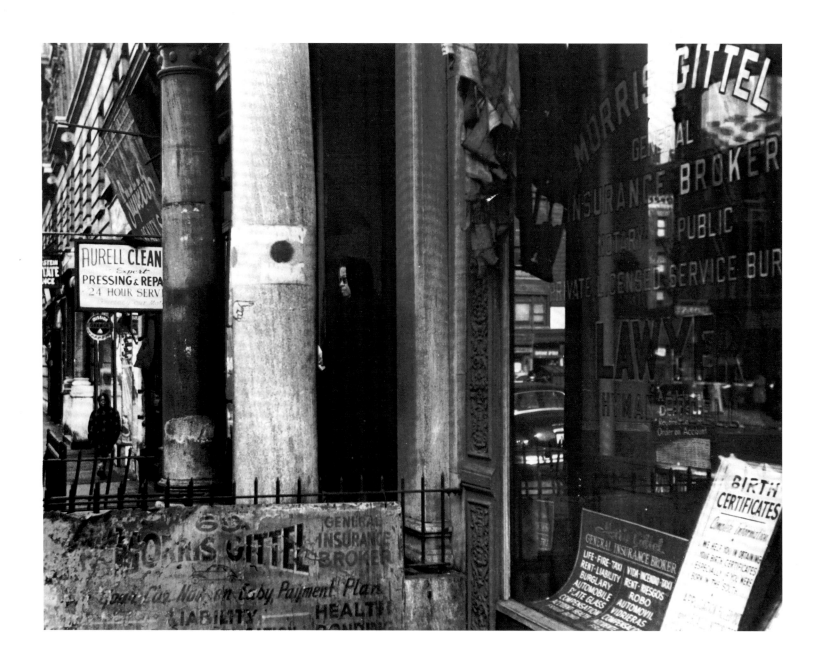

Gittel's, New York 1950
Courtesy of the artist

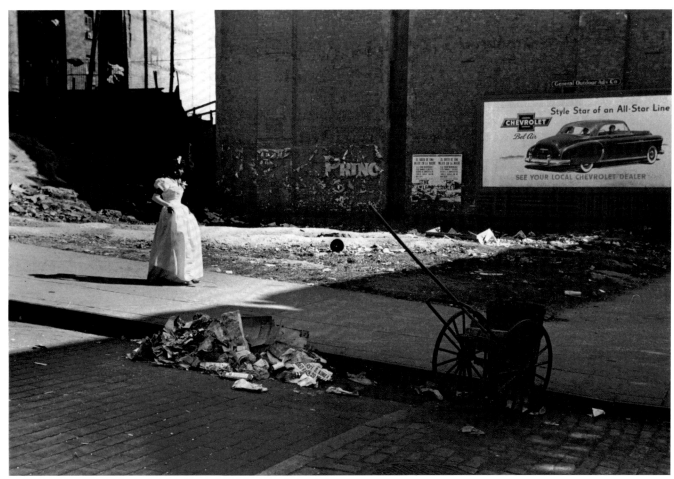

Graduation, New York 1949
Courtesy of the artist

Hallway, New York 1953
Courtesy of the artist

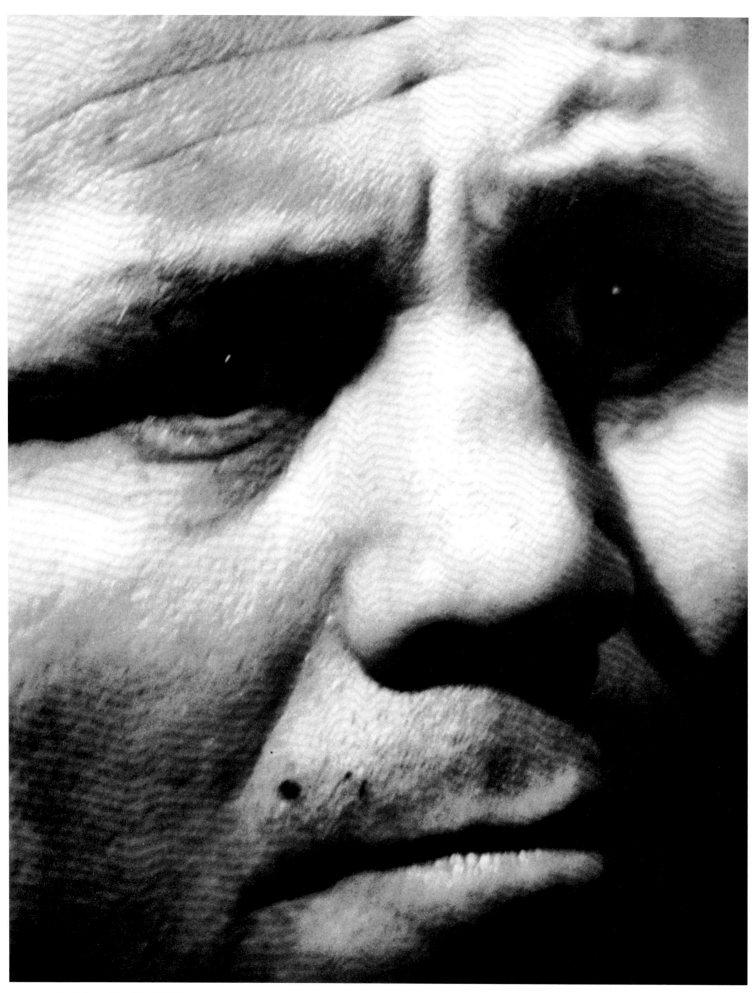

Ex-fighter, New York 1961
Courtesy of the artist

LISETTE MODEL

Born 1906. Died 1983. It is difficult to imagine contemporary American photography without Lisette Model. Her blunt, confrontational pictures brought success when she worked for Harper's Bazaar. Later, as a teacher, she had a profound influence — Diane Arbus was her most prominent pupil. Many others sought her out as a tutor in private classes and those she gave at New York's New School for Social Research.

Fashion Show, Hotel Pierre 1957
Collection of the Sander Gallery

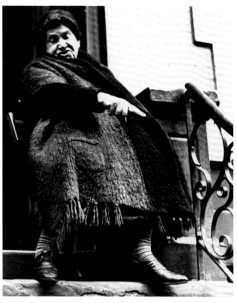

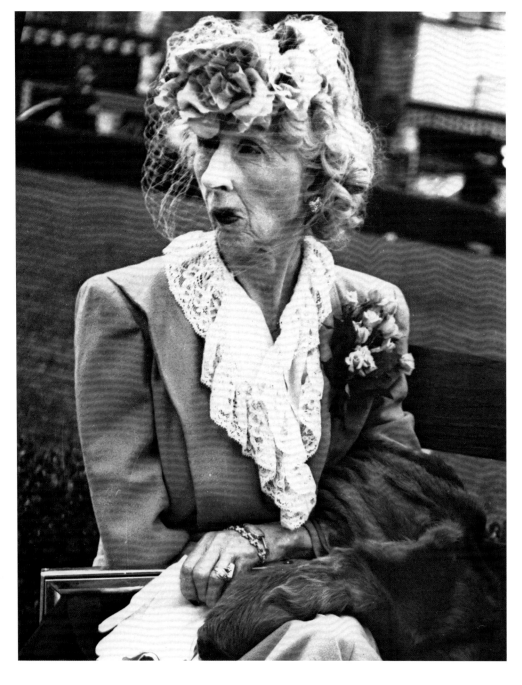

Lower East Side, New York c.1950
Collection of the Sander Gallery

San Francisco 1947
Collection of the Sander Gallery

LOUIS FAURER

Born 1916. Louis Faurer, whose subject-matter and sensibilities made him a native-born parallel to his friend Robert Frank, disappeared from the photographic scene for years at a time while he earned his living. There were some sightings of his personal works, but it was not until 1978 that he truly emerged as relevant to photography's recent history. In 1979 Faurer wrote: 'My eyes search for people who are grateful for life, people who forgive and whose doubts have been removed, who understand the truth, whose enduring spirit is bathed by such piercing white light as to provide their present and future with hope.'

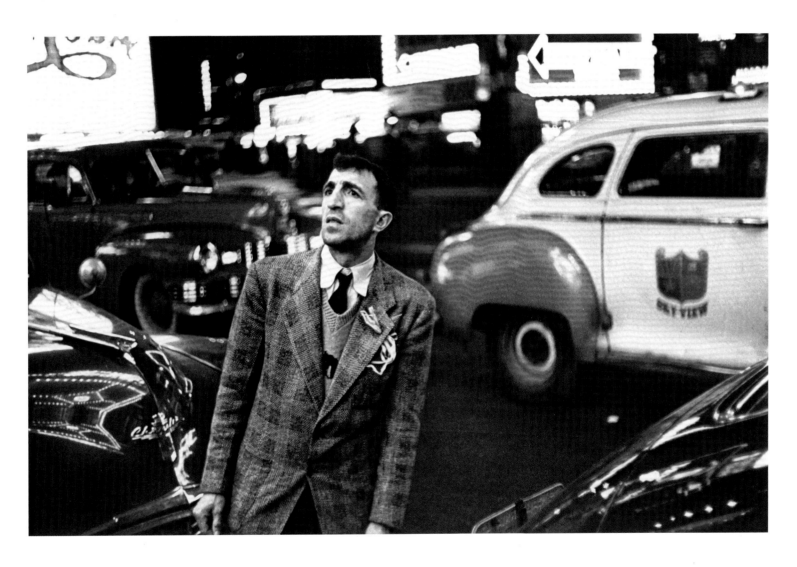

New York 1950
Collection of the Light Gallery

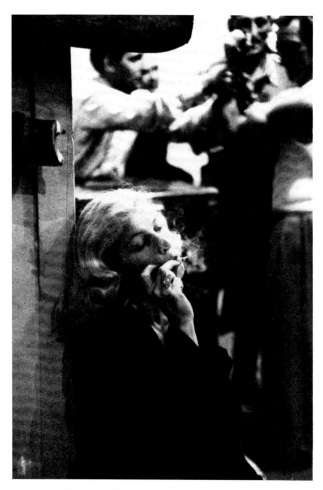

Circus Performers, New York 1947
Courtesy of Sarah Cross

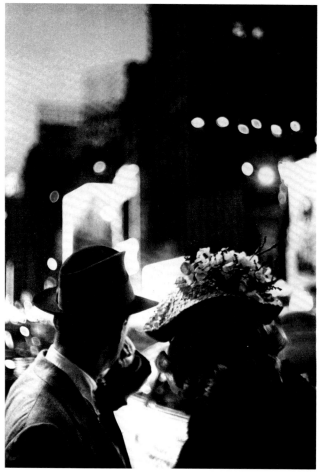

Times Square, New York 1949
Courtesy of the artist

Freudian Handclasp 1948
Courtesy of the artist

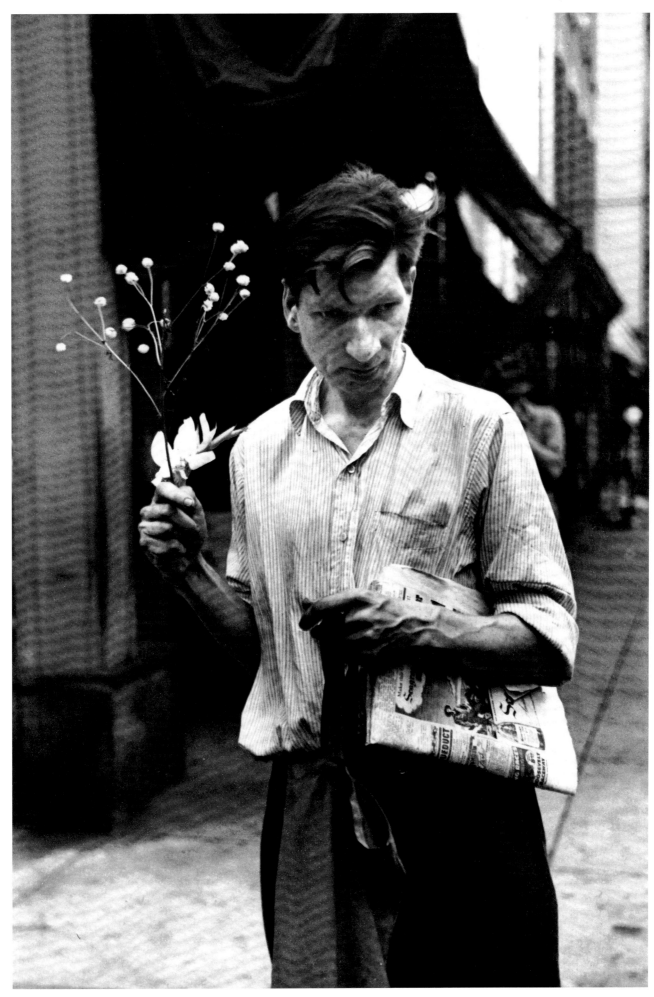

Eddie 1948
Courtesy of the artist

WILLIAM KLEIN

Born 1928. In 1965 Klein gave up his contract with Vogue **magazine as a fashion photographer in order to make films. He was very successful. He had already left painting to take up photography. Now he photographs again. Life is Good and Good for you in New York Trance Witness Reveals was the full, satirical title of his book that rocked the photographic world in 1956. In it he questioned all the medium's rules and found answers that helped alter the face of photography.**

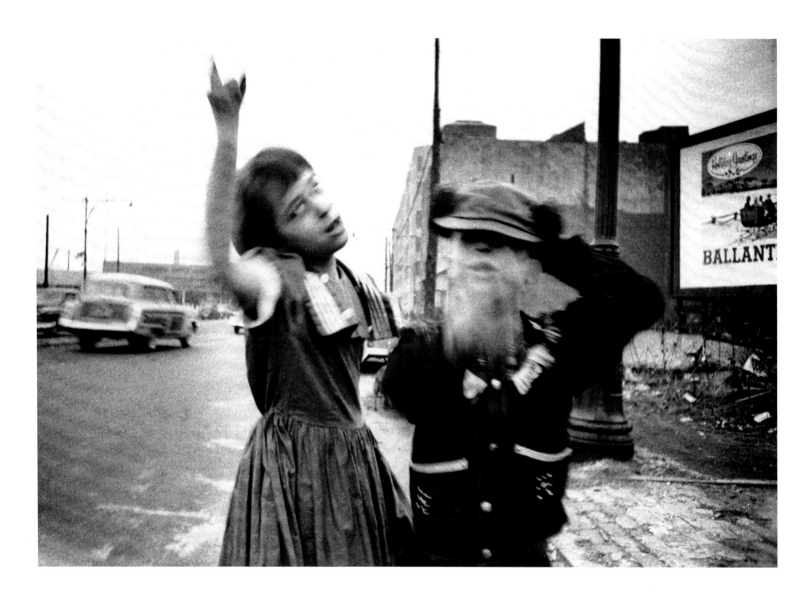

Dance, Brooklyn 1954
Courtesy of the artist

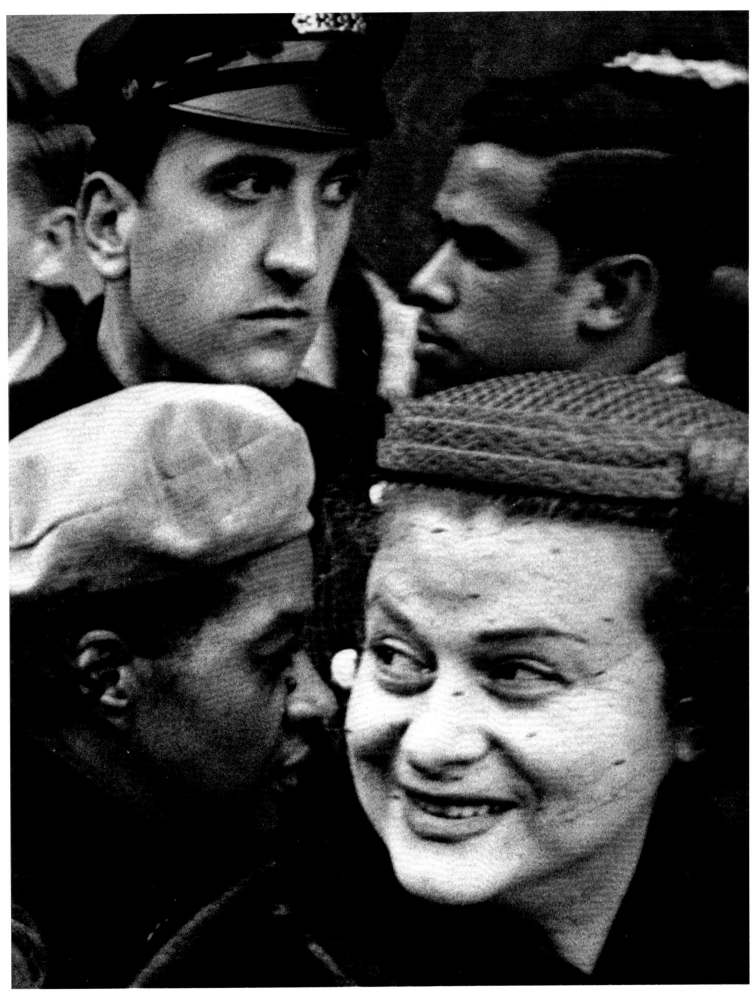

Four heads, Broadway 1954
Courtesy of the artist

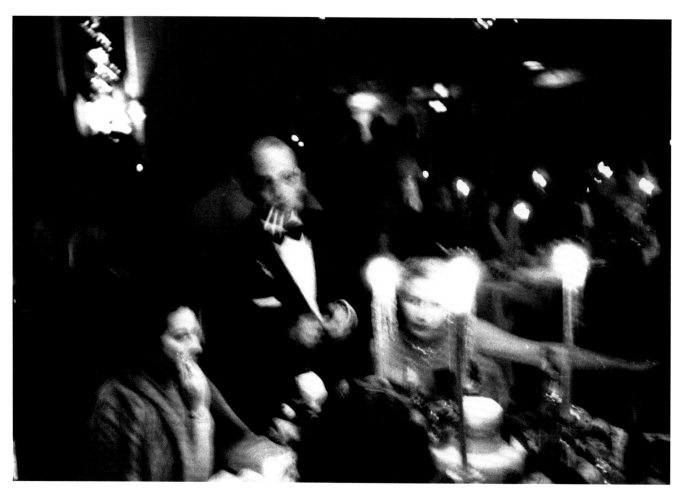

Charity Ball, Waldorf Astoria 1955
Courtesy of the artist

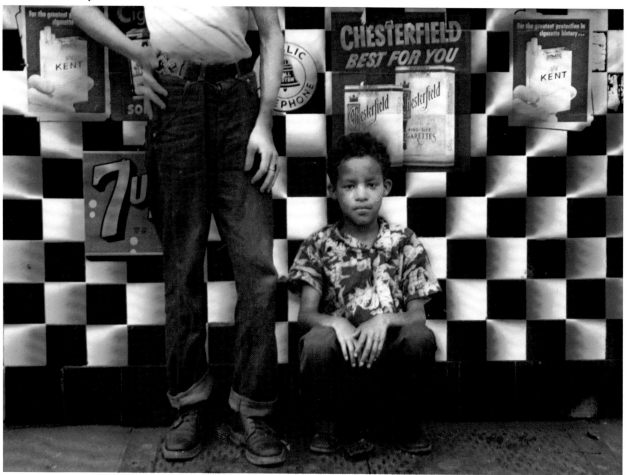

Candy Store, New York 1954
Courtesy of the artist

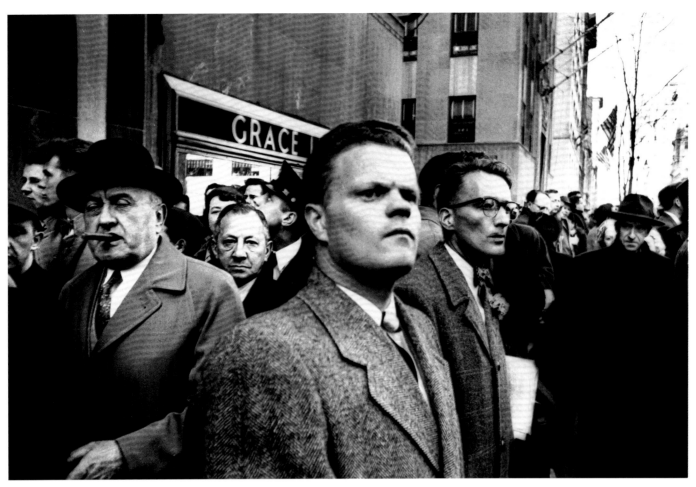

St Patrick's Day, 5th Avenue 1955
Courtesy of the artist

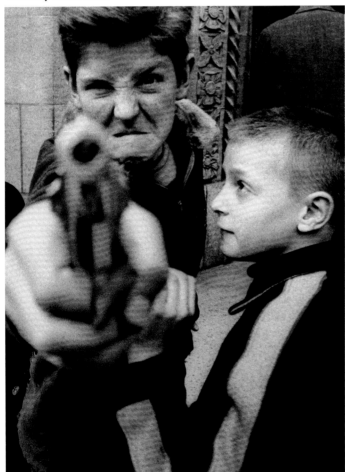

Mini-gang, Amsterdam Avenue 1955
Courtesy of the artist

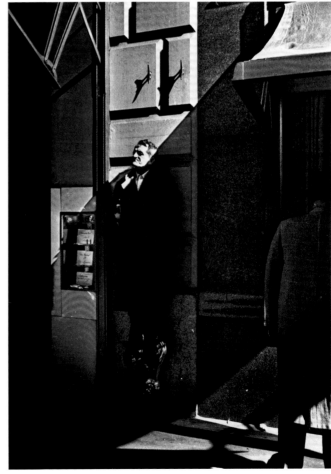

Severed head, 5th Avenue 1955
Courtesy of the artist

ARNOLD NEWMAN

Born 1918. As a portrayer of the great and good, Newman has few peers. His spare, stylized pictures seem equally respected by magazine art directors and museum gallery directors. Thus, unlike many of his contemporaries, Newman makes little division between personal and commercial work. He has pictured leading personalities in American life, from Presidents to photographers, with equal craft and telling composition.

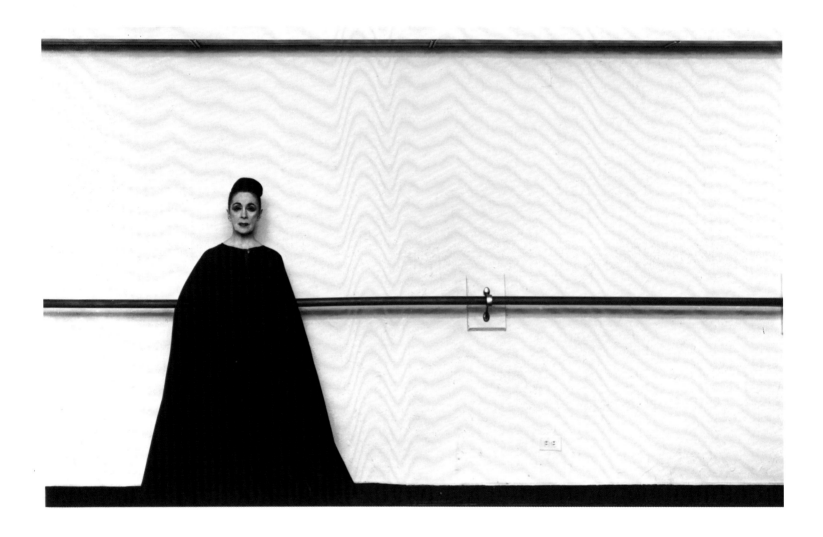

Martha Graham, New York 1961
Courtesy of the artist

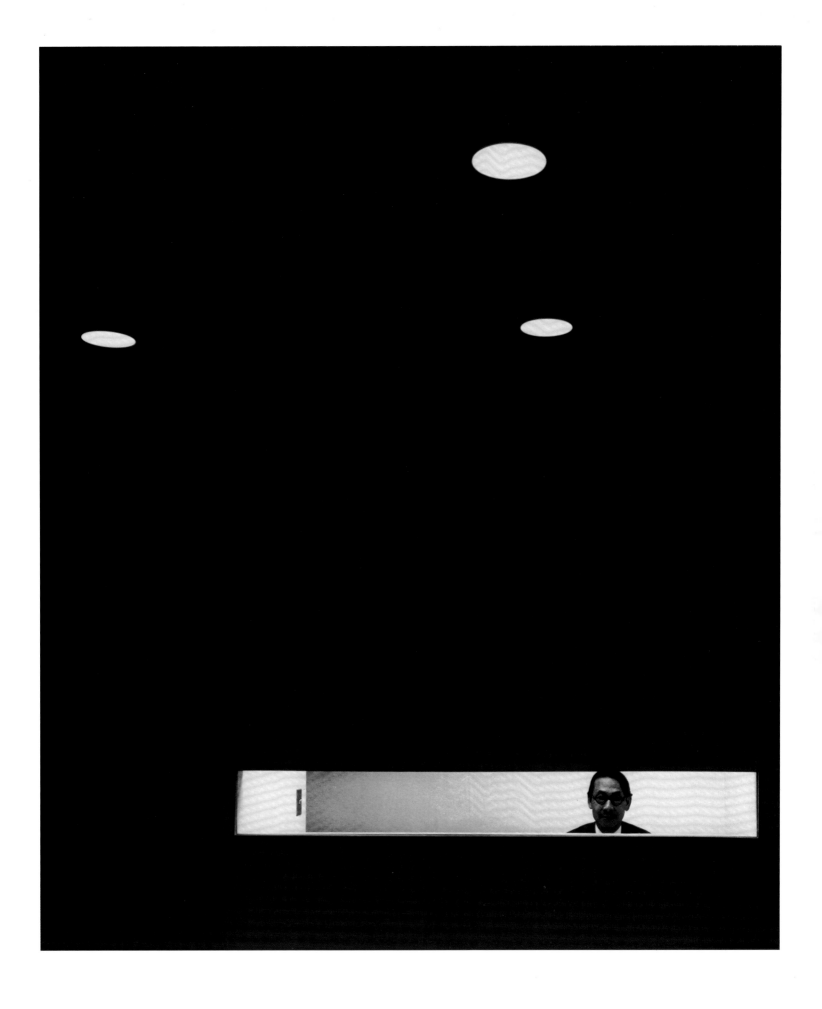

I.M.Pei, New York 1967
Courtesy of the artist

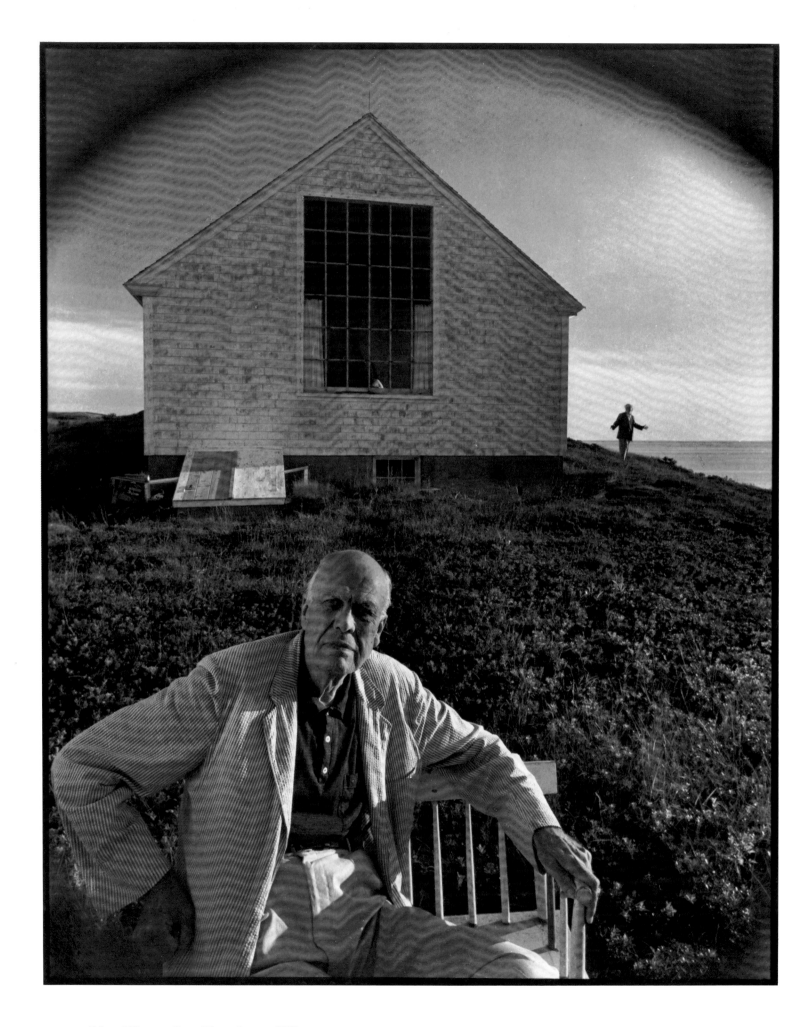

Edward Hopper, Turo, Massachusetts 1960
Courtesy of the artist

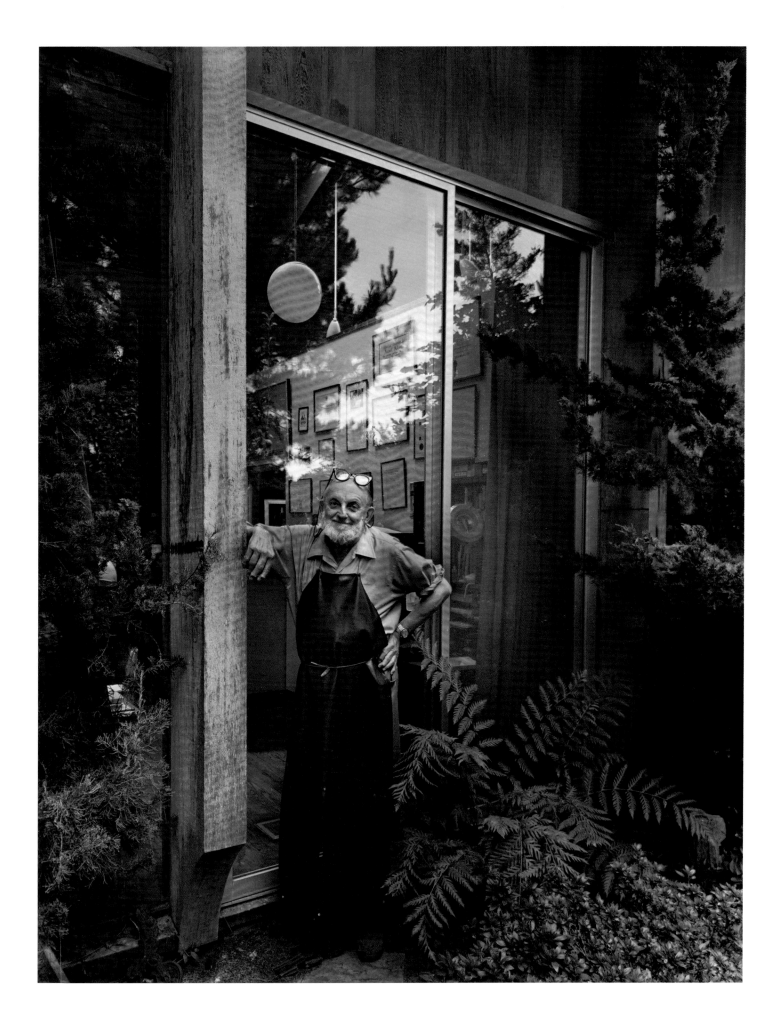

Ansel Adams, Carmel, California
Courtesy of the artist

IRVING PENN

Born 1917. Regarded by professional colleagues as a photographer worth emulating but impossible to equal, Penn brought an exquisite sensibility to the way in which subjects can be transformed by a controlled camera. His working method involves simplicity, dedication, consummate technique and total adherence to the idea of looking. Difficult to classify, he has worked successfully as a portrait, fashion, advertising and still-life photographer. To each he has lent a timeless sense of adventure.

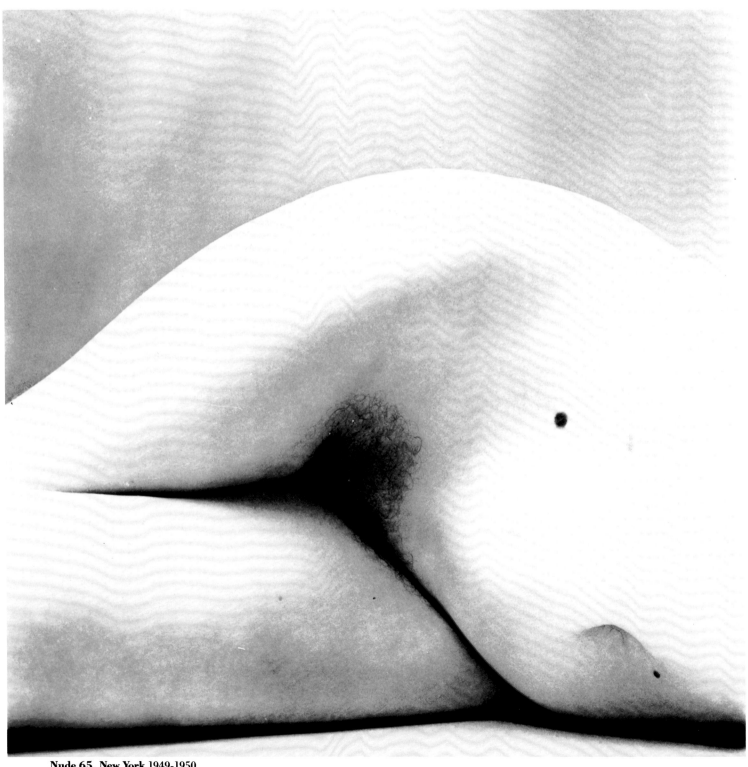

Nude 65, New York 1949-1950
Collection of Robert Forbes

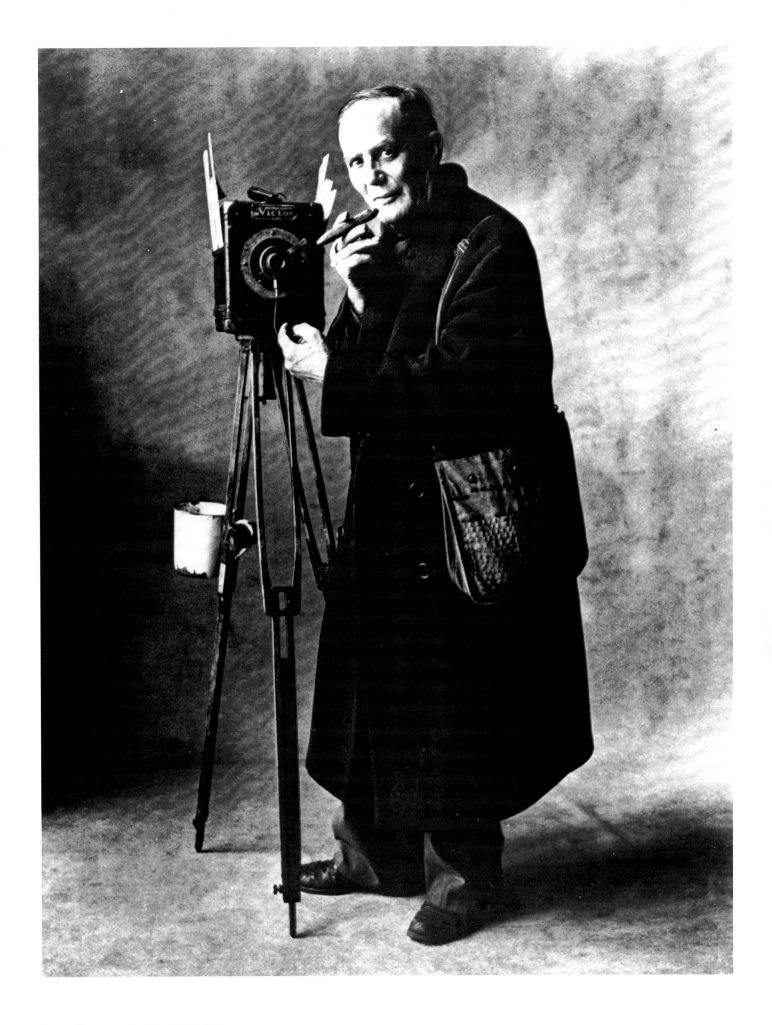

Street Photographer, New York 1951
Collection of Robert Forbes

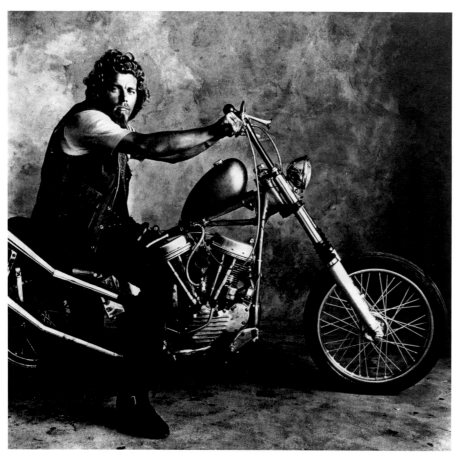

Hell's Angel, San Francisco 1967
Collection of Robert Forbes

Camel Pack, New York 1975
Collection of Robert Forbes

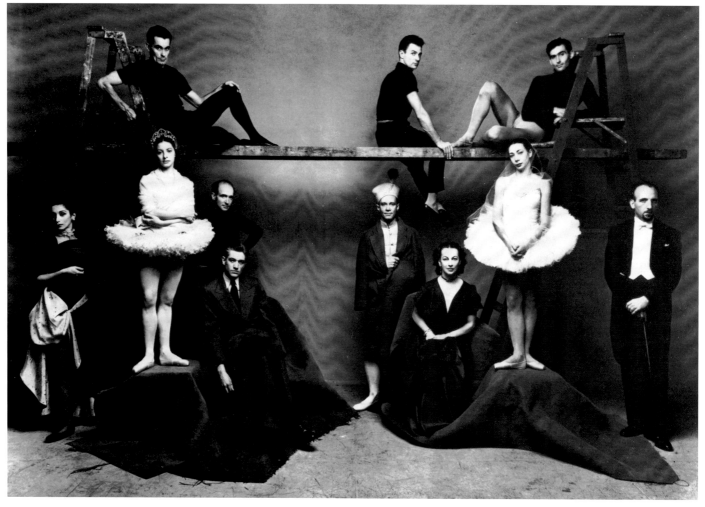

Ballet Theater, New York 1947
Collection of Robert Forbes

AARON SISKIND

Born 1903. Beginning as a Photo League documentarian, Siskind took photography into abstract realism and convinced two generations of its power to transcend subject matter. One of the first to make teaching a relevant profession for photographers, he influenced more than two decades of students at the Chicago Institute of Design and the Rhode Island School of Design, while continuing to make pictures that addressed new and pertinent visual issues.

Chicago 25 1957
Courtesy of the artist

Chicago 1960
Courtesy of the artist

Chicago 16 1957
Courtesy of the artist

Chicago 1949
Courtesy of the artist

Urapan 1955
Courtesy of the artist

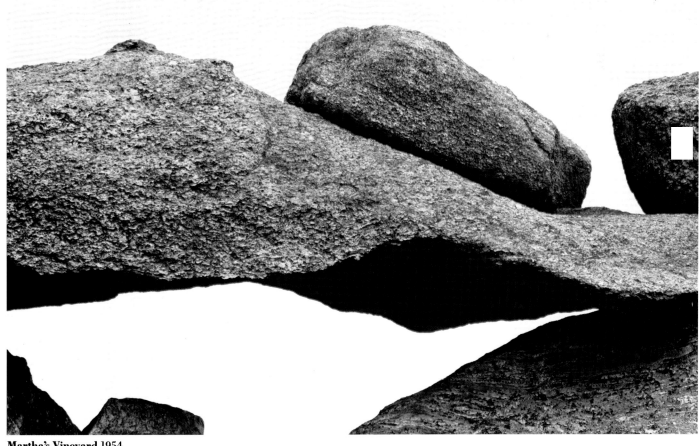

Martha's Vineyard 1954
Courtesy of the artist

WYNN BULLOCK

Born 1902. Died 1975. A musician, singer, commercial photographer, teacher and endless experimenter, Bullock used classic techniques in an avant-garde way. His work has come to represent West Coast photography at its most philosophic. Bullock searched for complex, symbolic meanings, writing of the need for 'new symbols ... that expand our minds so that we may be more at home in this scientific and terrifying age'.

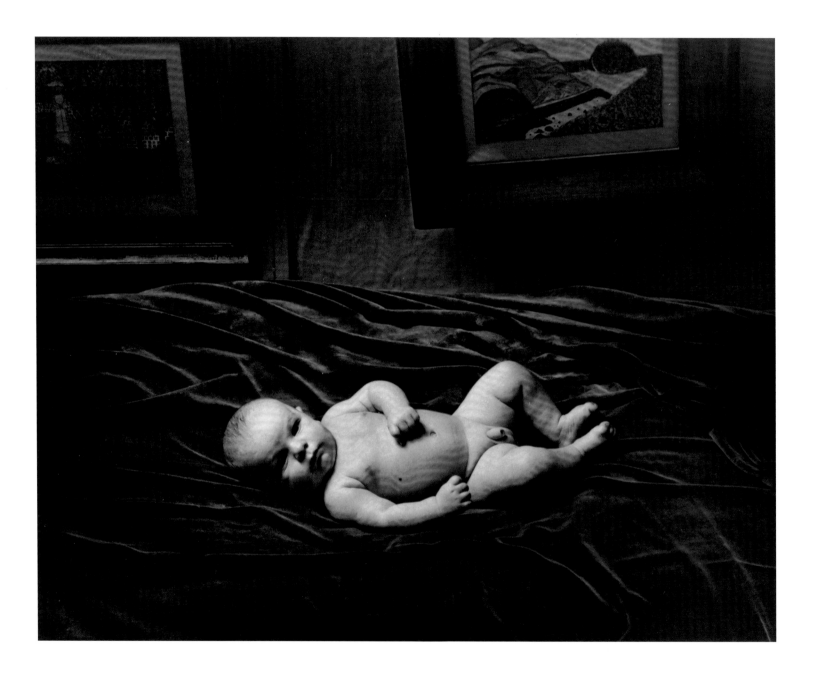

Stefan 1954
Courtesy of the Wynn and Edna Bullock Trust

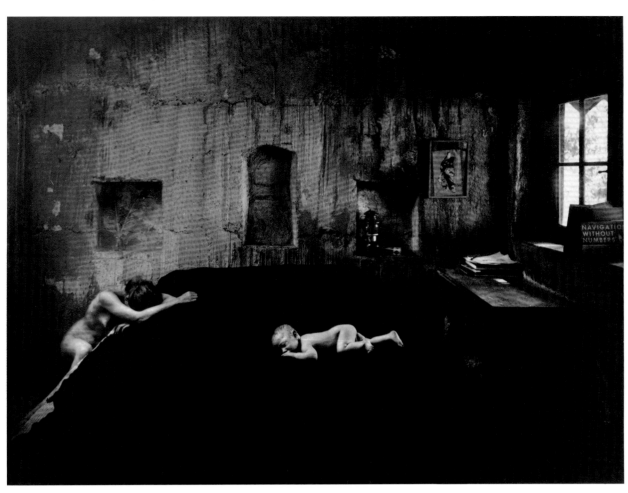

Navigation without Numbers 1957
Courtesy of the Wynn and Edna Bullock Trust

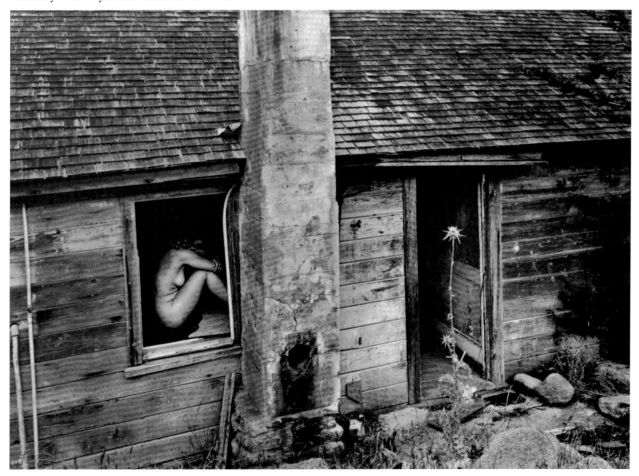

Woman and Thistle 1953
Courtesy of the Wynn and Edna Bullock Trust

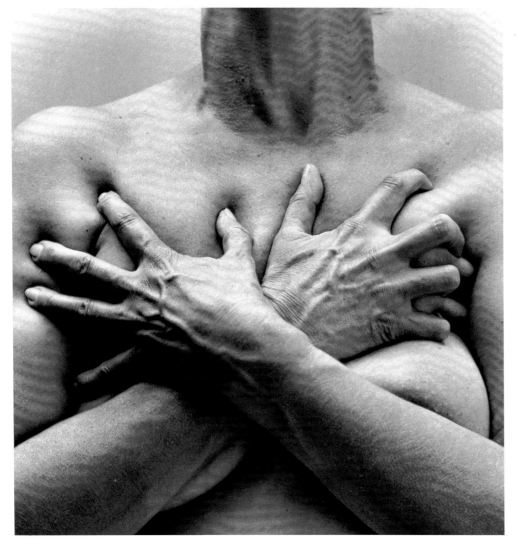

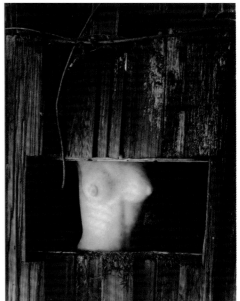

Edna 1956
Courtesy of the Wynn and Edna Bullock Trust

Torso in window 1954
Courtesy of the Wynn and Edna Bullock Trust

HENRY HOLMES SMITH

Born 1909. Smith used the properties of photo-chemistry to produce camera-less images born of the imagination. These became his hallmark as a photographer. An intellectual champion of the medium at a time when magazine photographers ruled, he wrote more, and more profoundly, than any of his generation, so becoming a spokesman for that medium's acceptance into a broader visual arena. As a teacher, too, he left his mark — Jerry Uelsmann is a notable pupil.

Untitled 1946
Collection of Russ Anderson

PAUL OUTERBRIDGE

Born 1896. Died 1958. Outerbridge was an iconoclast whose astonishing photographs from the 1920s and 1930s were allied to the explorations of the European Cubists into ways of representation, but who nevertheless maintained their absolute verity as products of the camera. Largely unknown are pictures he made towards the end of his life, when he used a 35mm camera — in itself a bold step for a photographer noted for precise studio images — to make photographs of a kind unknown to his contemporaries. Had they been discovered earlier they would have been unreadable, almost. Not until the 1970s was the avant-garde to adopt a similar colour-code and pictorial method.

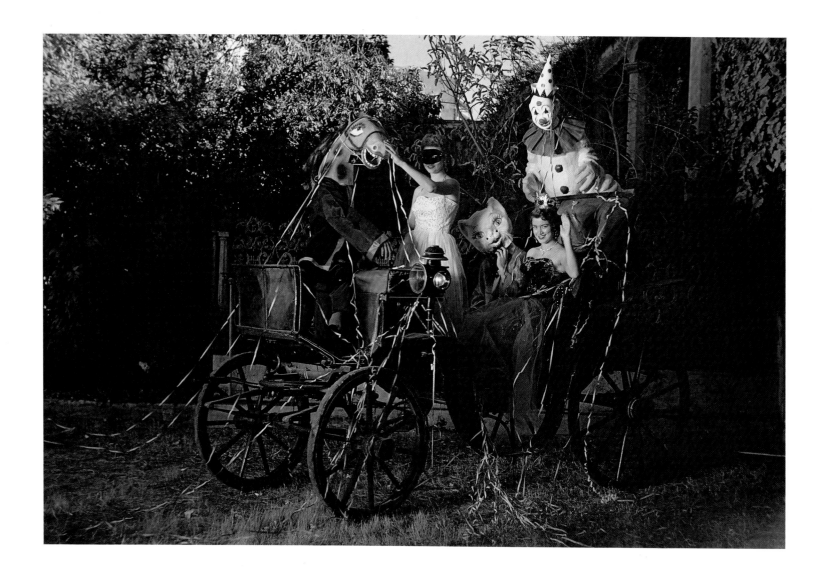

California 1950s
Courtesy of Graham Howe

CLARENCE JOHN LAUGHLIN

Born 1905. Laughlin, a fantast from New Orleans, has produced some of the more extraordinary works in American photography. Influenced by French symbolists and Baudelaire he developed visions of a gothic, psychic, decaying universe. 'I especially want made clear,' he said, 'that I am an extreme romanticist – and I don't want to be presented as some kind of goddamned up-to-the-minute version of a semi-abstract photographer.'

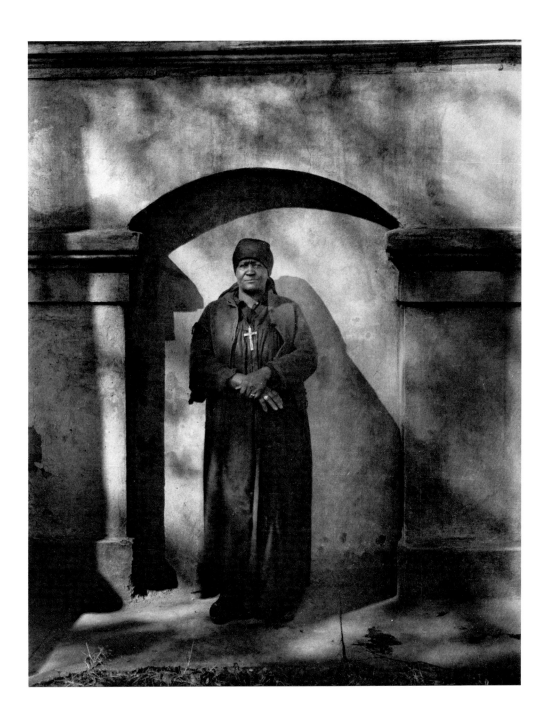

'Mother' Brown 1945
Courtesy of A Gallery for Fine Photography

Final Paradise for Dead Birds 1951
Courtesy of A Gallery for Fine Photography

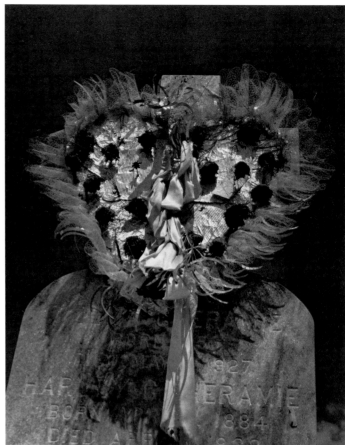

The Insect-headed Tombstone 1953
Courtesy of A Gallery for Fine Photography

The Radiator as a Hand, the Headlight as a Gaping Fish 1960
Courtesy of A Gallery for Fine Photography

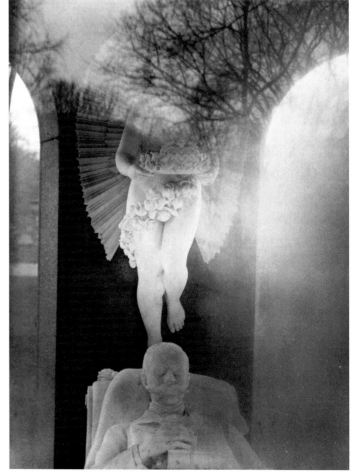

A Vision of Dead Desire 1954
Courtesy of A Gallery for Fine Photography

100

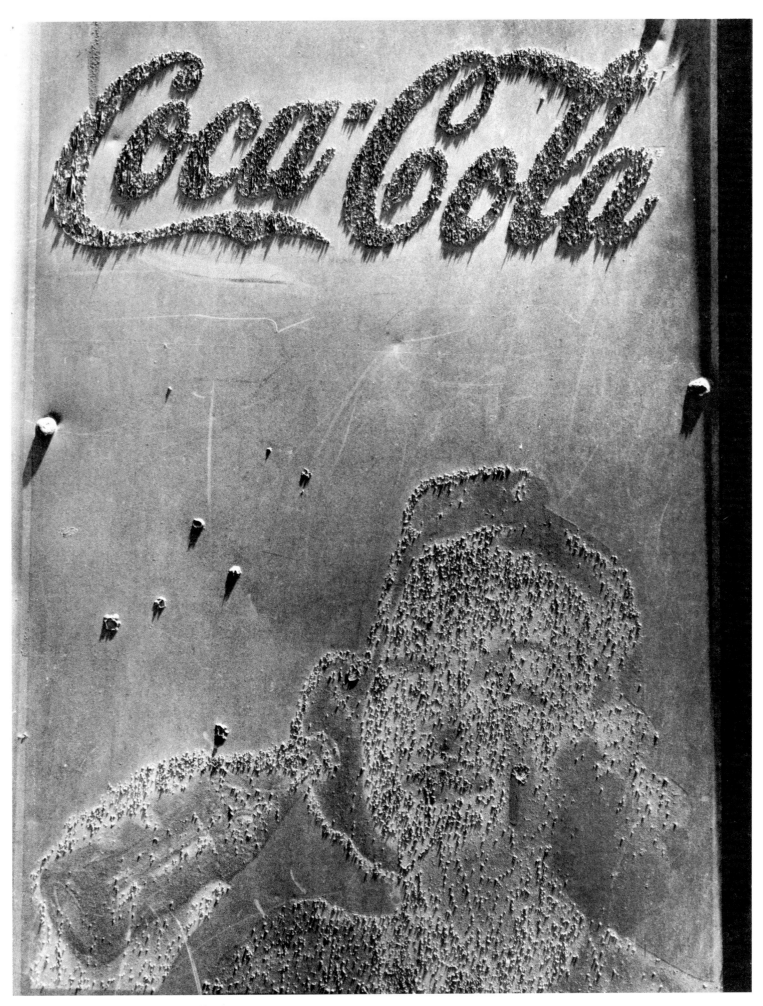

The Spectre of Coca-Cola 1962
Courtesy of A Gallery for Fine Photography

HARRY CALLAHAN

Born 1912. Like his friend and teaching colleague Aaron Siskind, Callahan has exerted considerable influence over American photography. Initially employed to join Moholy-Nagy's Chicago Institute of Design, he combined careers in teaching and image-making and encouraged students to follow his lead into new, often experimental ways of photographing. The first photographer to represent his country and medium at the Venice Biennale (1978), Callahan is regarded as one of the most important living photographers of the twentieth century.

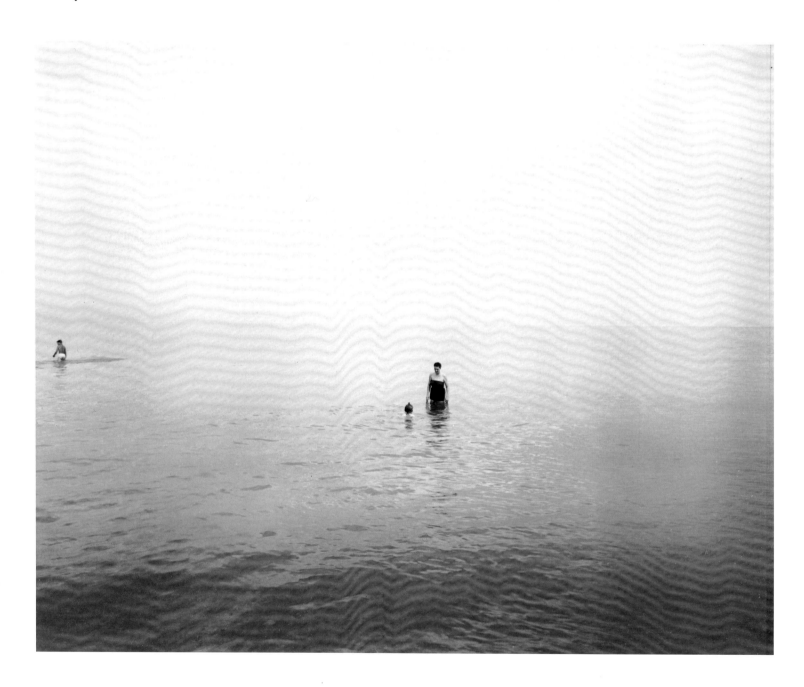

Lake Michigan 1953
Courtesy of the artist and Pace/MacGill Gallery

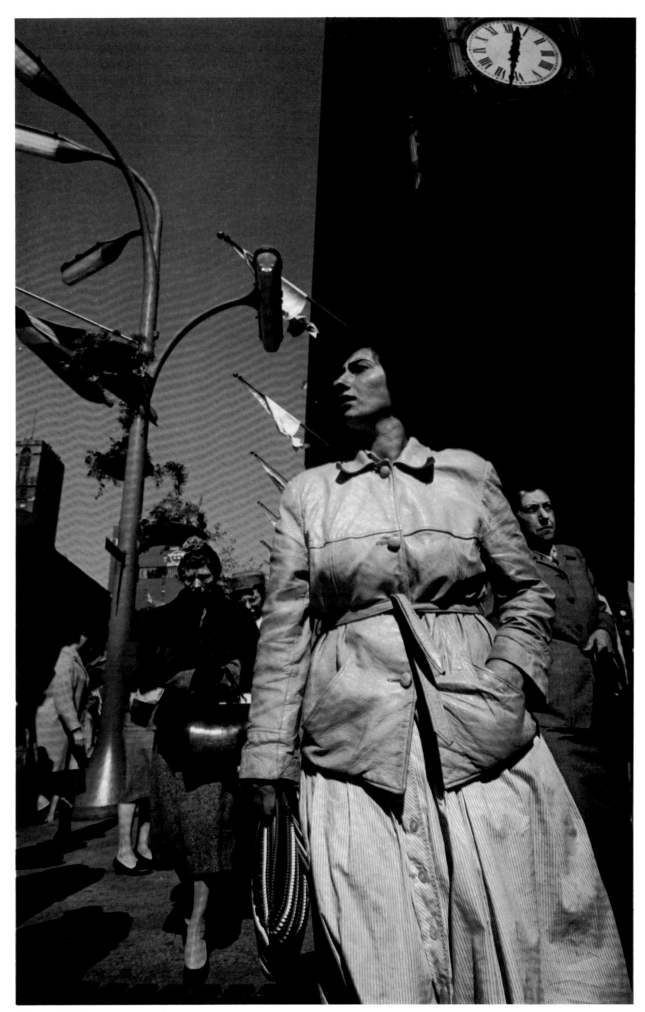

Chicago 1961
Courtesy of the artist and Pace/MacGill Gallery

Eleanor, Chicago 1953
Courtesy of the artist and Pace/MacGill Gallery

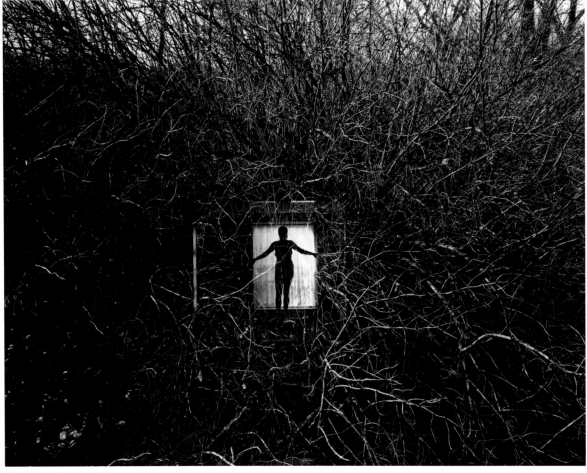

Eleanor, Chicago 1951
Courtesy of the artist and Pace/MacGill Gallery

Chicago c.1949
Courtesy of the artist and Pace/MacGill Gallery

Providence c.1962
Courtesy of the artist and Pace/MacGill Gallery

Collage c.1956
Courtesy of the artist and Pace/MacGill Gallery

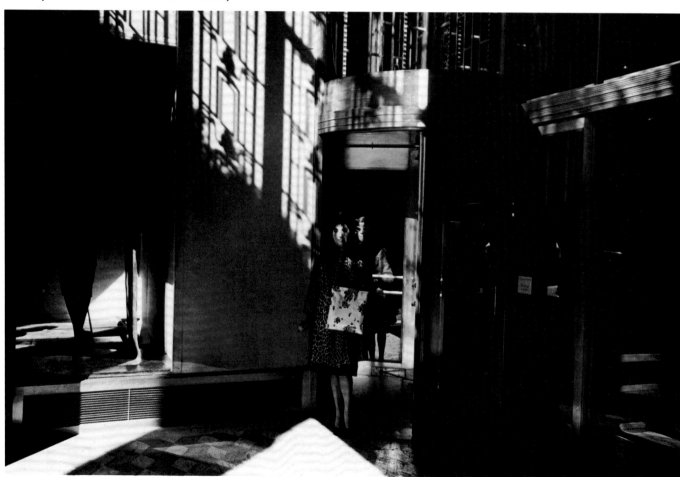

New York 1962
Courtesy of the artist and Pace/MacGill Gallery

BRETT WESTON

Born 1911. The second son of Edward Weston, Brett has continued his family tradition as a photographer. He has a harder-edged, more abstract style than his father's. Through it he was successful in establishing a personal vision, recognized in America in 1928 and Europe in 1929 when he featured in the influential Film und Foto exhibition in Stuttgart. An early Modernist, he went on to explore form and texture in a manner uniquely allied to camera-vision.

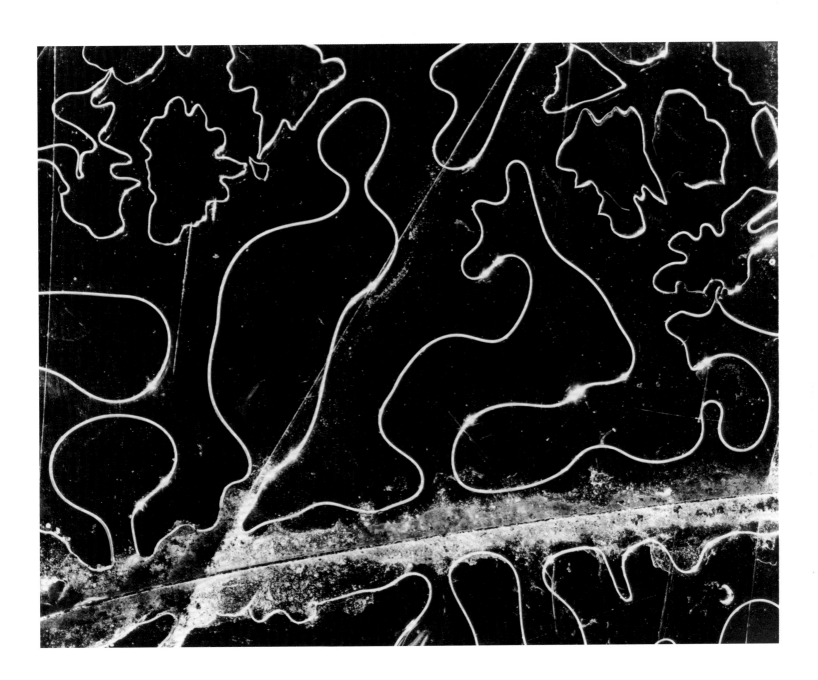

California 1955
Courtesy of The Weston Gallery

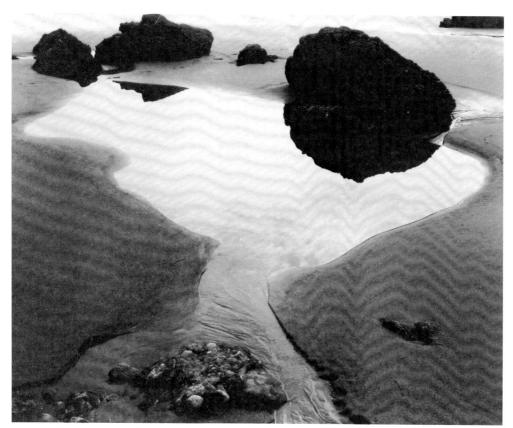

Santa Monica 1961
Courtesy of The Weston Gallery

Mono Lake 1956
Courtesy of The Weston Gallery

Scotland 1960
Courtesy of The Weston Gallery

Carmel 1952
Courtesy of The Weston Gallery

MINOR WHITE

Born 1908, Died 1976. As a direct link to earlier work by Alfred Stieglitz which examined photography's metaphorical possibilities, White was fundamental to the medium's expansion in the 1950s and 60s. A friend of Edward Weston and Ansel Adams, he brought many outside philosophical influences to bear on his teaching and photography, both based on notions that the photographer and his images are one. He was founder-editor of Aperture and a frequent contributor to intellectual, philosophic and historical debates concerning photography. In this way White brought many to the realization of photography's place within the spectrum of new art.

Sequence 16 – Sound of One Hand Clapping 1959
Courtesy of the Minor White Archive, Princeton University

110

BILL JAY

THE ROMANTIC MACHINE:
THOUGHTS ON HUMANISM IN PHOTOGRAPHY

As photography's character shifted from descriptions of a broadly understood external world to works implicitly self-referential, photographers became more aware of how they might transform reality. Supported by a massive growth in photo-education, the medium's introduction to an art world hungry for newness and its increasing status in museums, an object photographed became more important than the object itself. Humanism, that direct and positive record of mankind, no longer seemed appropriate to a photography whose future seemed certain.

Bill Jay argues for its relevance at a point where the old values seemed all but extinguished.

Throughout its history, photography has been defined, analyzed and categorized; its images segregated into movements, style, camps, and ideologies; their contents 'read' as equivalents, metaphors or allegories. Debates have raged over functionalism versus expressionism, symbolism versus representationalism, objectivity versus subjectivity, pictorialism versus purism, and a variety of other 'antagonisms' that all essentially encompass the same points of disagreement. Photographs are used, misused, described and discussed by specialists from psychology, psychiatry, sociology, anthropology, architecture, history, literature, film, behavioural science and every other discipline to which a name has been given. Even within that esoteric, élitist fraternity of university educators in photography, the medium is approached, and students' work assessed from a bewilderingly diverse set of standards. The result is chronic confusion over the nature of the medium.

Such confusion is inevitable while we persist in clinging to two basic misconceptions about photography. Firstly, it is a misconception to believe that photographic styles and movements have played any significant role in the development of the medium. Secondly, it is a misconception to assume that photography can be understood from the appearance of the image. Each of these statements deserves expansion.

Photography of merit is, and always has been, a mixture of antithetical concerns and styles of equal value. At any point in time many widely different styles and attitudes have produced a plethora of diverse images, all of which could be considered as having merit. No period in the medium's history has been stamped with the look of a single, dominant movement. Stylistic movements, when they have existed, have not played such crucial roles in the development of photography as they have in painting. Efforts at defining photography, at any period, in terms of a manifesto or a group's dictatorial style have always been short-lived – and widely different stylistic movements have always coexisted, reasonably amicably, simultaneously. Indeed the arch-protagonists of different styles often professed their admiration for each other. As Susan Sontag has written: **'What is most interesting about photography's career … is that no particular style is rewarded: photography is presented as a collection of simultaneous but widely differing intentions and styles, which are not perceived as in any way contradictory.'**

We can push this point further into the body-photographic. At this level it hits a nerve: any attempt at defining photography by the appearance of the image, and that alone, is futile at best, dangerous at worst. Yet what a picture looks like is the basis of practically all photographic criticism today.

Yet an understanding of photography based on image appearance is confusing to say the least. Nothing is more disconcerting than to discover that stylistically disparate images seem to be stating identical messages, or that two images of almost identical appearance are diametrically opposed in goals. Photography is damned inconvenient; imagine the dismay of a mother sparrow who builds a nest to protect her eggs, only to find that one hatches into a cuckoo. In the same way, it is natural to build structures in which to house the photographers' products according to 'species' but we must be aware that, all too often, there might be a stranger among the siblings. Such 'exceptions' are great in number. So how do we deal with such a multiplicity of ambiguities? In the past critics and historians have either ignored the 'cuckoos,' or built yet another critical structure into which they can be squeezed.

The work of Diane Arbus is a case in point. Since her images did not fit comfortably into any category in common use (a cuckoo in a nest of sparrows), critics, like the mother bird, flew in confusing circles, seemingly powerless to prevent this strange offspring from wrecking the structure of the nest. Even today, a smart student can wreck a teacher's carefully woven argument by asking: what about Diane Arbus? Her photographs are certainly documents of reality, but the assumption that they are mere transcriptions of reality leaves no room for the Gothic power of her pictures. But if they are 'art,' where does the hand and mind of the artist encroach upon the blatant flash-in-the-face approach of a newspaperman recording a traffic accident? The questions are endless; the answers few – if we look only at the surface of the prints.

What a photograph looks like tells us precious little about its meaning. For a more complete answer we must delve deeper and take a dive of faith beyond the print's appearance into the realm of concept and precept. At this level, the issues

are clear. It seems to me that there are two basic attitudes worth considering, neither of which is based on the appearance of the photographic image: Naturalism and Humanism. Let me admit that both words are unsatisfactory because of connotations borrowed from other associations, but they will suffice, once defined for this specific context. The naturalistic photograph states what is. The humanistic photograph states what could or should be.

NATURALISM

If it is true that the early experience of art was its ability to project the viewer's mind away from the earthbound, material facts of everyday life into the realm of the spirit, it is interesting that the symbolic function of image-making took a decidedly materialistic turn during the Renaissance. Suddenly, in the early fifteenth century, a new type of vision, a different function of art, occupied man's mind: the desire to organize the appearance of nature in terms of the human figure, systematically to reconstruct in two dimensions familiar objects and views with exactitude. For the first time, the artist's concern was to reveal the objective appearance of reality. As da Vinci wrote in the **Codex Urbinas: The most excellent painting is that which imitates nature best and produces pictures which conform most closely to the object portrayed.**

It is no coincidence that da Vinci describes a mechanical drawing device in his notebooks, or that mechanical and lenticular aids to the artist increased in popularity as the need for accurate transcriptions of reality became more firmly rooted. It is in the Renaissance, as opposed to the 1830s, that the value of the camera obscura became apparent. But the introduction of photography was the culmination of art's aspirations since the Renaissance. The dream of transfixing the three-dimensional outer world on to a two-dimensional surface without the intervention of the human hand was realized. It is not surprising, therefore, that during the 1840s and 50s there was no debate concerning the art-nature of photography – it was automatically, almost by definition, a fine art. The mere transcription of reality was enough; the prosaic document was Art. Early photographic literature is full of expressions of wonder that such an automatic recording of the minutiae of the real world was possible. Witness the enthusiasm of Jules Jannin, editor of the influential magazine **L'Artiste**, which was the mouthpiece to the avant-garde Romantic painters: **'Note well that Art has no contest whatever with this new rival [photography], ... It is the most delicate, the finest, the most complete reproduction to which the work of man and the work of God can aspire.'**★

The ability of the camera to transcribe reality so intently and accurately not only fulfilled an artistic quest, but also appeared at exactly the right moment in time to complement a cultural need. The *Zeitgeist* was there. All the pieces that made up the jigsaw of photography were available for several decades before the medium's invention. Johann Zahn, a monk in Wurzburg, described several types of neat, functional and sophisticated camera obscura in 1685. Yet the puzzle was suddenly completed by a dozen men in various continents, independently and simultaneously, in the 1830s. The cultural need that catalysed the introduction of such a documentation process was the urgent interest in the close observation of the facts of the material world. The early 1800s were marked by a surge of enthusiasm for categorisations, listings, statistics and data production. The Victorians were fanatical in their passion for collecting details of the physical world in such varying fields as astronomy, anthropology, physiology, physiognomy, botany,

geology and sociology. They wanted a sharp, clear, close-up of the physical world, its people, places and objects, seen not in its entirety but from a conglomeration of detail. No wonder that the miscroscope, telescope and camera were such indispensable tools of the age. Photography was born, raised and matured within this atmosphere of passion for facts. Photography was, and is, the ideal instrument for examination, for documenting what *is*. The Victorians were appreciative. The Mayor of New York, on examining a daguerreotype marvelled that: **'Every object, however minute, is a perfect transcript of the thing itself; the hair of the human head, the gravel on the roadside, the texture of a silk curtain, or the shadow of the smaller leaf reflected upon the wall, are all imprinted as carefully as nature or art has created them in the objects transferred...'**★

In the **Pencil of Nature** Fox Talbot recommended the examination of photographs with a magnifying glass which **'often discloses a multitude of minute details, which were previously unobserved and unsuspected.'**

Photography owes its origin to this desire for detail, for information, for a close up, impartial, non-judgemental examination of the thing itself. There is no doubt in my mind that the greatest social achievements of photography, even to the present day, have been in this naturalistic spirit. Our knowledge of the material world has been immeasurably enhanced, widened and deepened because of photographs and their all-pervasive abundance. As Sontag has written: **'to collect photographs is to collect the world.'** It might also be said: to make photographs is to reshape the world, because the camera sees no difference in significance between the sublime and the silly. In a photograph, a cup of tea is impressed with the same degree of value as the Grand Canyon. One can sense the bemusement, even slight resentment, in Fox Talbot's tone of voice when he acknowledged that: **'the instrument chronicles whatever it sees, and certainly would delineate a chimney-pot or a chimney-sweeper with the same impartiality as it would the Apollo of Belvedere.'**

This is both the power and the bane of photography, evident from its first decades when the prosaic and puny was viewed and respected as much as the exotic and ambitious. Since the daguerreotype, however, the problem has been compounded a billion fold. Indiscriminate recording has given us a catalogue of trivia that is impossible to understand in terms of value. The Victorian's desire for facts has come full circle: so many facts defy understanding. The result is a debasement of the idea of naturalism to a superficial attitude that has nothing to tell us about ourselves or the world. Now, the habit of collecting facts is more significant than the facts themselves.

With this thought in mind, it is interesting that one of the most potent movements in contemporary photography has been a return to the idea of naturalism in a pure, serious state. I am referring to New Topographics. When first given coherence as a style, at the International Museum of Photography in 1975 it immediately struck a responsive chord in many young photographers. The reason is not difficult to understand. Apart from the photographers' efforts to define their work in terms of art – ideas, the central core of their work is pure naturalism, taking off directly from the point at which photography intersected the nineteenth-century desire for facts and the Renaissance dream of pure representationalism. New

★ Newhall, Beaumont **The Latent Image**, Doubleday, New York, 1967.
★ op. cit.

113

Topographies – which could have been called Original Naturalism – defines the world as it is. Appearance is all. The photographers, significantly, refuse to make value judgements, either to praise or condemn the content of their work. The thing exits – therefore it is worth recording. The catalogue of the original exhibition contains brief quotations from several of the participating photographers. Phrases and words like: **'utilitarian'**, **'of the world'**, **'the photographer has set aside his imaginings and prejudices'**, **'pure subject matter'**, are typical and highly revealing.

All the photographers in this exhibition tended to use a static camera for their documentations, relying on a straight printing technique ensuring maximum image sharpness and tonal fidelity. But it would be a mistake to see this as a stylistic need or bond. The naturalistic photograph owes no such allegiance to the appearance of the image. As one example, I might contrast the appearance of their images with those by Garry Winogrand, who shoots fleeting moments with a miniature hand-held camera, distorting tonal values with flash, arbitrarily cropping reality with the frame, tipping the horizontal. Yet though so different in style, his photographs, by his own definition, are naturalistic. They record the subject as it is without moral judgements, with a cataloguing, sharply focused, objective detachment. He has said: **'I photograph to find out what something will look like when photographed.'**

This could be the perfect credo of the naturalistic photographer.

HUMANISM
The antithesis of the naturalistic attitude can be defined as the humanist approach to photography. The photographer is no longer recording what is, but what could or should be. Again, we must back-track into the past to find the path along which this idea developed, to before the Renaissance, when art was not imitation but an incantation. This early experience of art must have been imagery as ritual; a picture *of* a real object but *about* a separate idea embodied in that reality, which stood as a talisman or oracle for messages 'from another world'.

To the pre-Renaissance worshipper it did not matter whether or not the image over the altar was an accurate representation of the reality that was Jesus; no one cared. The quality inherent in the image was based not on factual accuracy but on its ability to focus attention on an idea or ideal. The function of the icon was, paradoxically, a widening of perception until the trivial details of daily existence seemed inconsequential compared to the individual's broad connection with the expanses of the spirit. As the essayist William Gass pointed out: **'A flashlight held against the skin might as well be off. Art, like light, needs distance ...'** The icon of Christ, like the humanistic photograph, is a visual aid towards, not an end product of, truth or meaning. And I, for one, find it most interesting and significant that photography, which fulfilled the naturalist's ideal, is the same medium that is performing the pre-Renaissance idea of images as expressions of the romantic spirit.

And here is the essence of humanistic photography. In order to make photographs that transcend 'what is', the photographers must make value judgements. In order to make value judgements he must have an all-pervasive personal code of values or ethics. In order to use this code of values he must make choices. In order to make choices he must be aware of the alternatives. In order to understand the alternatives he must have a sure knowledge of, and be constantly involved in, the nature of self. The humanistic photographer has a philosophy

or attitude to life based on his personal relationship with reality. This is the real subject of his photographs; they are about the photographer as a transmitter of messages through metaphor. Value judgements are essential to humanism; they are not essential to the naturalist's attitude.

Does this mean that the humanistic photographer is limited to fictional manipulations of reality? Not at all. It is possible, but admittedly difficult, to be a humanistic photographer in the tradition of realism and with a medium as rooted in representation as photography. Art, by which I mean literature and music as well as painting, has always been an indispensable process for communicating a moral idea. It merely means that the nature of photography, its dogmatic assertion of fact, makes the morality more difficult to achieve and communicate. The camera is not predisposed to be a romantic machine. But I would argue that the photographer who works from a position of moral volition, acknowledged or denied, produces a body of work which as a whole reveals the author's value judgements. For this reason it is next to impossible to gauge a photographer's intent from the appearance of a single image. In photography, quantity is as important as quality. It would be difficult for example, to deduce anything from a single Dorothea Lange photograph of, say, a bed in a sharecropper's cabin, except the literal fact, in a naturalistic vein, that the thing existed as depicted. Yet in the body of Lange's work, seen in quantity, the value judgements of the photographer become powerfully and abundantly evident. This one photograph therefore can be selected from the work as a single image, but only because it represents, is a reminder of, the value judgements inherent in the quantity of images produced by the one author.

Before misunderstandings occur, it is important to state that moral judgements should not be confused with didactic propaganda. Humanistic photography is not concerned with 'real life' and the rectitude of the world's problems in any direct way. In fact, didactic photography usually fails both as art and as propaganda, with a few notable exceptions such as Heartfield and Riefenstahl. Yet much of humanistic photography does seem concerned with the ills of society, and, to confuse the issue, the photographers themselves often state that the function of the image is to solve a specific problem. It has yet to be demonstrated to me that a photograph changes anything. Fiction more than fact is a potent force for direct social action or for changes in the nature of the audience's behaviour. Some degree of aloofness, a standing back, is necessary for humanistic art. Direct social action is not synonymous with humanism. The humanistic photographer is less concerned with the specific event or object, but more with his own value system, integrating and incorporating personal volition, value judgements and the generalized relationship of himself as a human being with the real world. It is this two-way, infinitely complex process that defines humanism, not a single picture of a specific event. A humanistic photograph therefore, is about both the photographer and the world simultaneously, the contact point being an object, the print, that signifies both value judgement and volition. Dorothea Lange made this point when she wrote: **'... the great photograph first asks, then answers, two questions. "Is that my world? What, if not, has that world to do with mine?"'**

Our minds and feelings are constantly scanning for 'meanings'. A 'meaning' happens when we compare two lots of experience, and suddenly understand something about them both. The naturalistic photographer sacrifices meaning for objective clarity. The humanistic photographer, it must be

admitted, is often working with one blurred image, either self or subject, and the position is even more dangerous, for the meanings are arrived at by guesswork or presumption.

The humanistic photograph, then, is about both reality and the mind, which, in unison, reveal value judgement. Subject matter alone is not enough. Take, for example, the well-known photograph by Don McCullin of a young Biafran mother, with starvation-swollen belly, attempting to suckle a doomed baby from shrunken milk-empty breasts. It might seem shocking to say so, but this is not a humanistic photograph *per se*. The subject belongs to a humanistic attitude and the image depicts an appalling fact. This mother existed. But the appearance of the image need not tell the truth. The photograph might or might not be didactic. I would doubt its value as propaganda, horrific as its story might be. The technique is naturalistic – a direct documentation of what is. There is no plea for help, merely a recognition that this woman happened to be in front of McCullin's camera at the moment of exposure. Humanistic photography is not specific – this woman and her baby are irrelevant as individuals, or even as representatives of all the sufferers of the Biafran war. But the point is sharpened by placing this photograph in the body of McCullin's work. Don McCullin is a humanist. He has a value system expressed through his medium, for which this particular print serves as a reminder. His talismans are conflict situations. Therefore it is not at all incongruous to see the photographs in a monograph, photography magazine or museum context, where quantity is possible.

As another example of a humanist, whose value judgements pervade his work, yet who works in a stylistic manner widely separated in the photographic spectrum from McCullin, I would mention Robert Heinecken. Even Heinecken's series of a Vietnam soldier carrying two severed heads, overprinted on to magazine advertisements, is not didactic. He has unequivocally stated that he is not interested in making direct political statements. **'If I really wanted to do something on the level of the society, I wouldn't be making pictures. I'd be acting in it more directly.'** Heinecken's work is astonishingly varied in terms of techniques, processes and subject matter – but as a whole his body of work is suffused with the artist's volition and value system. The moral ideal prevails. In one sense, of course, humanism in photography is always a political act since it disturbs the status quo. The photographer, by the very nature of his insistence on making value judgements, is anti-establishment and therefore radical.

Humanism in photography includes many types of people and their pictures. There are differences in the appearance of naturalistic photographs but the varieties are nothing like as extreme as in humanism, which encompasses both McCullin and Heinecken. In photographic criticism based on appearance, McCullin would be a photo-journalist with close affinities to a newspaper photographer. In humanistic photography, McCullin and Heinecken are bound much closer together than with any naturalistic attitude. Merely as a point of debate I would throw in the remark that this is the prime difference between New York street photographers, like Winogrand and Friedlander, and the European equivalent, such as Tony Ray-Jones. Although the style, manner and content of their pictures seem so similar, they are poles apart in attitude, which is a source of confusion in much analysis of their work based on what the work looks like. The differences are clear if the former are considered naturalistic and the latter humanistic.

If it is irrelevant to categorize photographs according to image appearance in terms of style, it is equally misleading to associate humanistic photography with specific types of subject matter. Slums, starving natives, the old, decrepit, insane and sick are not the prerogatives of the humanistic photographer. No subject is intrinsically a moral issue. Even the decision of the photographer to use ugliness, sickness, or sordidness as a prime motif is not necessarily volitional, based on a value system. In fact it is usually naturalism posing as humanism, and fooling most of the people, most of the time. For the same reasons, humanism should not be confused with sentiment. It is not, *a priori*, a moral or volitional issue to photograph mountain streams, picturesque nature, sublime mountains, pretty little girls in soft focus, and so on. Pictorialism appealing to sentiment is not implicitly romantic or humanistic. It is merely a stylistic device that determines the appearance of the image, and allows categorization of the photograph according to what the print looks like. While we are listing what humanism in photography is not, I would like to add another one. Humanism should not be confused with emotion, as opposed to naturalism's intellect.

Humanism in photography is not anti-intellectual. It cannot be. The ability, even need, of a photographer to project value judgements is not a mystical, instinctive feeling only attained by intuitive, non-rational insight. True, the existence of a value system can be felt, but it cannot be understood, and intelligently used, by vague hopes and wishes. To be productive and powerful the individual's sense of life has to be analysed and verified conceptually. Humanism in photography is an intellectual as well as an emotional endeavour. The two together, in perfect harmony produce quality. Making humanistic photographs is a thinking process, by definition, and does not belong to the 'if it feels good, do it' cult of the inarticulate.

The humanistic photograph is not defined by style, subject or sentiment, but by an all-pervasive value system that is implicit in the photographer and which permeates the body of work. It is a fulfilment of a need, not in the sense of resolving questions or preaching morals, but permitting the contemplation of abstractions about his relationship to life through the specific nature of photography. Such individualism cannot be easily defined, or even discussed, since each individual will present different value systems based on a myriad of complex interrelationships. It would be incongruous and silly to speak of a humanistic movement. Yet these photographs exist, and must be dug out of the stylistic categories defined for naturalists where they have been buried by critics.

Since all individuals will display different value judgements, it seems self-evident that sympathies with a photographer's work will be on the basis of similar value systems, rather than on stylistic compatibilities. This explains why a photographer can admire the work of another photographer from a widely different stylistic area. But there is a danger here. Agreement or disagreement with the attitude to life presented through the photograph is not an aesthetic concern or a valid method of establishing merit. The humanistic spirit is not determined by truth or falsehood. It is perfectly feasible to find oneself in conflict with the specific value judgements of the photographer, yet appreciate his or her humanism, as defined. John Heartfield is not a 'better' photographer because one might sympathize with his anti-Nazi attitude; Leni Riefenstahl is not a 'bad' photographer because of her pro-Nazi sympathies. In fact, humanists invite such disruptions in the critical approach due to their need to create ideals. Not being content with what is, the humanistic photographer is constantly striving for what should be, a forward motion that creates

exaggerations. The exaggerations will be heroes or anti-heroes, depending on whether or not the life attitudes of the photographer are in obvious agreement or disagreement with those of the viewer. Even with a seemingly naturalistic approach, there is no doubt that Diane Arbus was a humanistic photographer, except that her value judgements were both anti-heroic and contrary to the life attitudes of the majority. It is not truth or falsehood, agreement or disagreement, but an implicit view of life that is essential.

It is not the prime responsibility of humanistic photography to answer questions, give information, educate or provide moral guidance, no matter how intriguing the images might be as artefacts. Humanism in photography fulfils a more profound need for the photographer – the contemplation of abstractions. If naturalism provides answers, humanism asks questions. How deeply and efficiently the photographs deal with the problems is the nature of photographic merit, and a reflection on the stature of the photographer. Since the naturalistic attitude is to provide facts about what is, the problem is solved by a quantity of images that incessantly and systematically present data in a non-judgemental way. For this reason, it is not at all difficult to deduce that Joseph Deal is a better photographer in the pure naturalistic spirit than a real-estate photographer. This is merit by control of the medium. Francis Frith was a better photographer than most of his long-forgotten contemporaries largely because the sheer volume of his output is, in itself, an expression and affirmation of the naturalistic process. This is merit by quantity. Perceptive observations are in the nature of the medium. For this reason, even second-rate naturalism has a great deal to offer since information is carried by even a 'bad' photograph, or even by a remote machine without the intervention of the human controller, as witnessed by the astonishing images transmitted to Earth from Mars. The value of the naturalistic photograph is in the reproduction of the specifics and the photographer can be judged by the accuracy with which the information is restated. That is the essence. All else is sugar on the pill.

There is no such leniency in humanism. The photographer's value judgements are deemed valid if they are evident; if they remain unexpressed the work is a misshapen parody of a bad naturalistic photograph. Photography is kind to naturalism, and cruel to the romantic humanist. There are very few humanists in photography which is a medium that was born in an atmosphere of naturalism and is, by its very nature, conducive to facts rather than philosophies. Then there is the feeling that photography does not, as a medium, attract many philosophers – or has not done so to date. I am not pessimistic about this point. Humanists might be rare among the numbers of people who call themselves photographers, but they account for a disproportionately large number of those who are at the cutting edge of the medium in any generation.

BILL JAY
An *émigré* to America in 1972, Jay had been a persuasive voice in British photography during the 1960s when he edited **Creative Camera** and **Album** magazines and published five books. Now he studies and teaches the history of photography at Arizona State University, where he is an Associate Professor. Four more books of his have been published in America, most recently a volume of his photographs of photographers. Jay's essays and articles appear from time to time in the **British Journal of Photography**. ★ P.T.

III.
1960-70

ANDRE KERTESZ

Born 1894. In 1937 Kertész carried his singular way of seeing from
Paris to New York, where he has lived and worked since. Working primarily in a
lyrical, interpretative, documentary style he has been an influence on younger
photographers since 1925 — Henri Cartier-Bresson is an example. Kertész
brought a newness to American photography and even now, in his nineties, he
continues to make pictures that surprise and delight his audience.

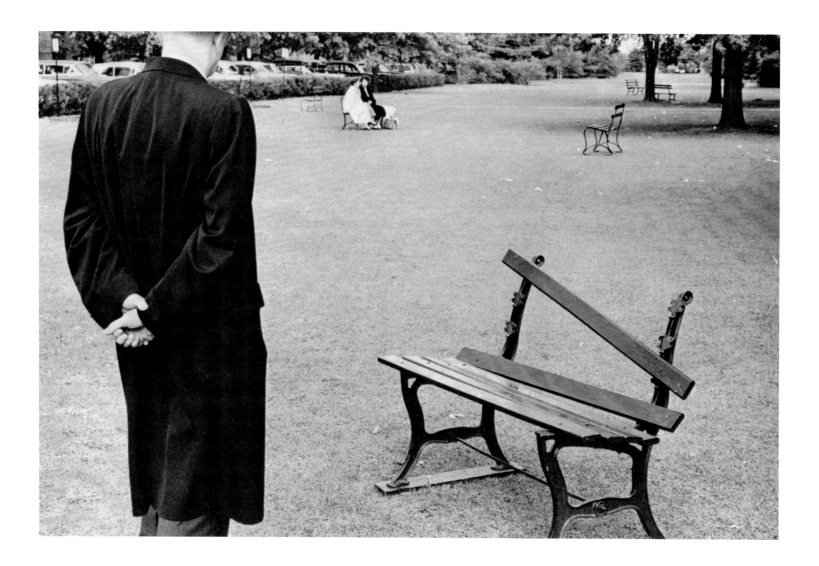

Broken Bench, New York 1962
Courtesy of the artist

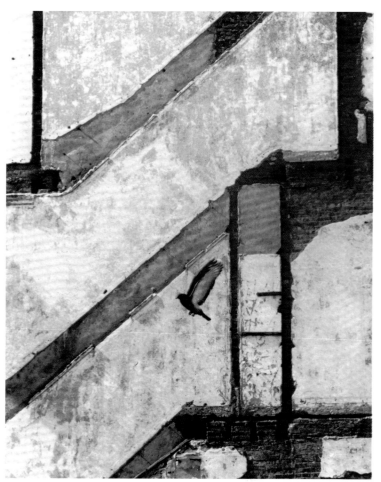

Landing Pigeon, New York 1960
Courtesy of the artist

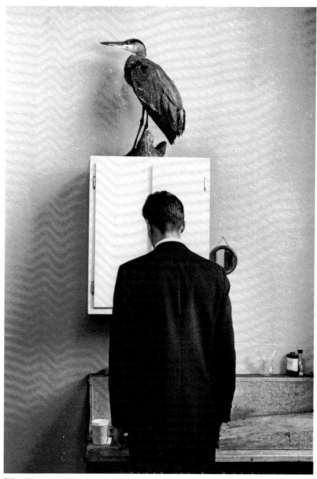

The Heron, New York 1969
Courtesy of the artist

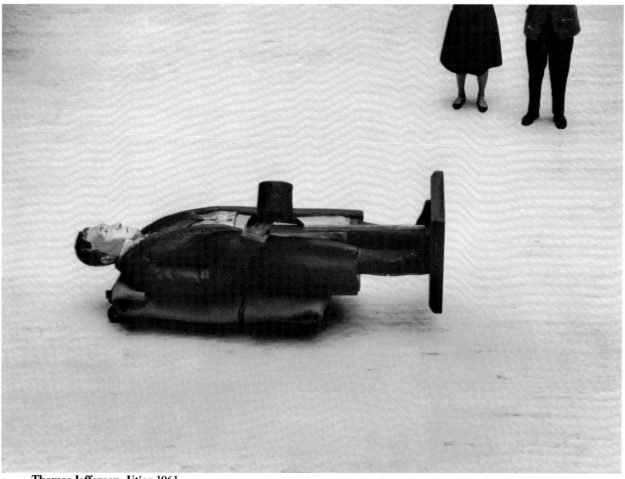

Thomas Jefferson, Utica 1961
Courtesy of the artist

DANNY LYON

Born 1942. The early sixties saw the rise of photographers who acquired the visual values of their journalistic predecessors and modified them to accommodate personal and social commitments. Lyon was prominent in this movement, first as a supporter of civil rights, then as a recorder/participator in youth culture. He went on to make one of the most telling documents of prison life. He is still active as a photographer and film-maker, his early work remaining a testament to an era of changing social awareness.

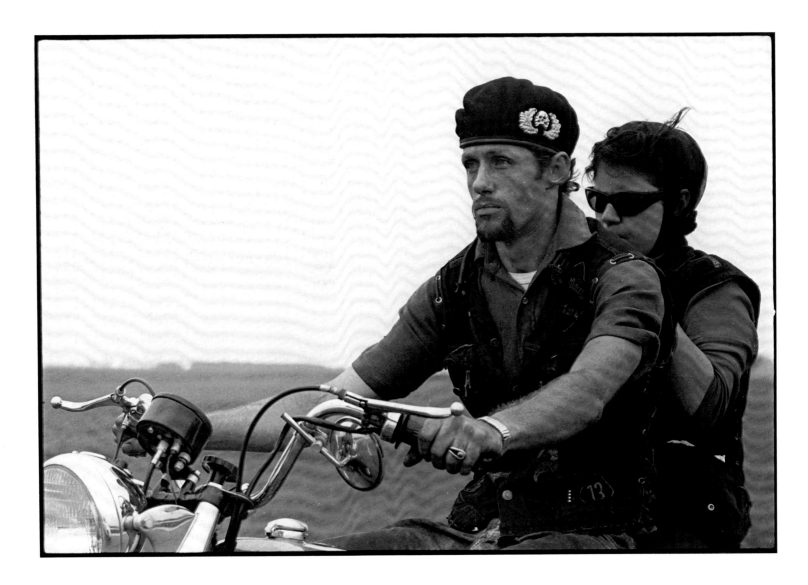

Cal and Eileen 1966
Courtesy of the artist and Magnum Photos Inc.

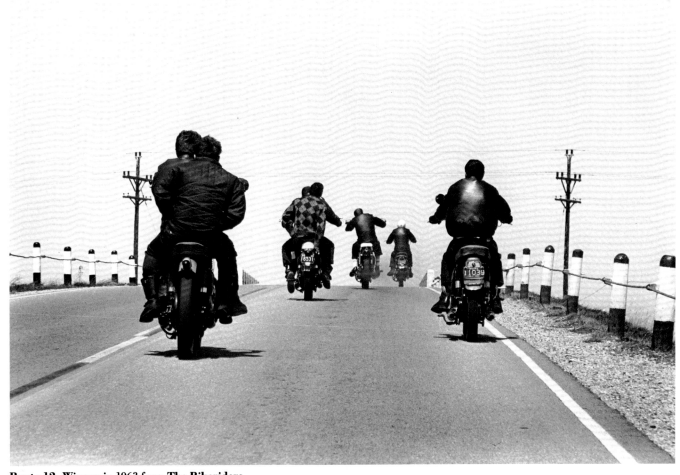

Route 12, Wisconsin 1963 from **The Bikeriders**
Courtesy of the artist and Magnum Photos Inc.

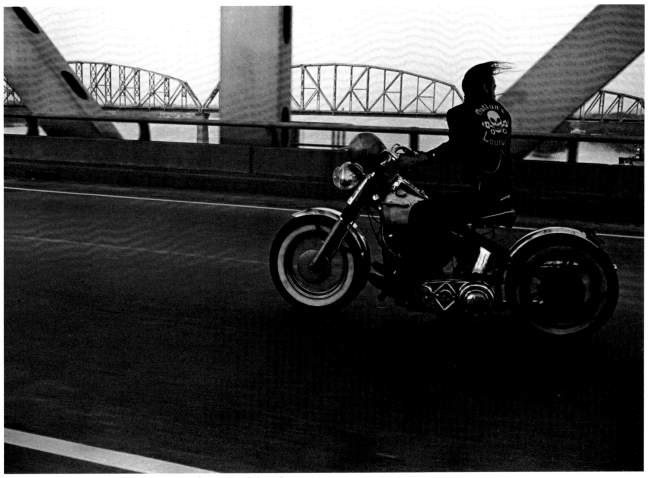

Crossing the Ohio, Louisville from **The Bikeriders**
Courtesy of the artist and Magnum Photos Inc.

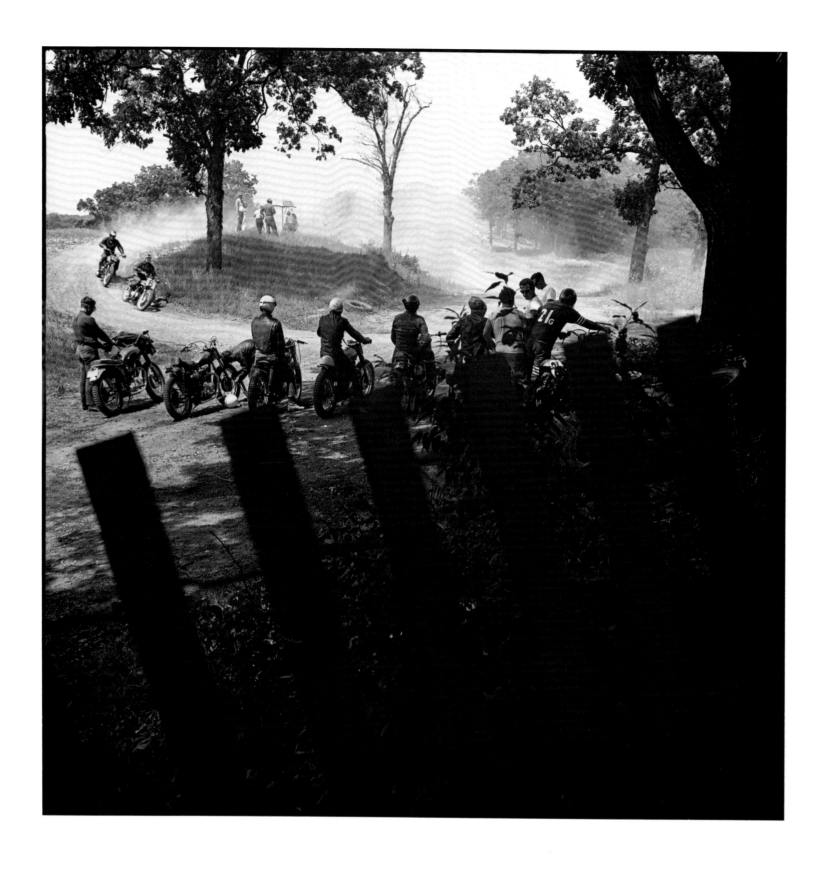

Scrambles Track, McHenry, Illinois, 1966
from **The Bikeriders**
Courtesy of the artist and Magnum Photos Inc.

LEONARD FREED

Born 1929. 'Concern' became a public issue during the mid-1960s, particularly concern for the rights of minority groups. Freed, successful as a magazine photographer, took pictures that showed his support for the disadvantaged. Like several of his colleagues he saw his role as contributing to the nation's conscience, and strove to make visual eloquence a lever for change.

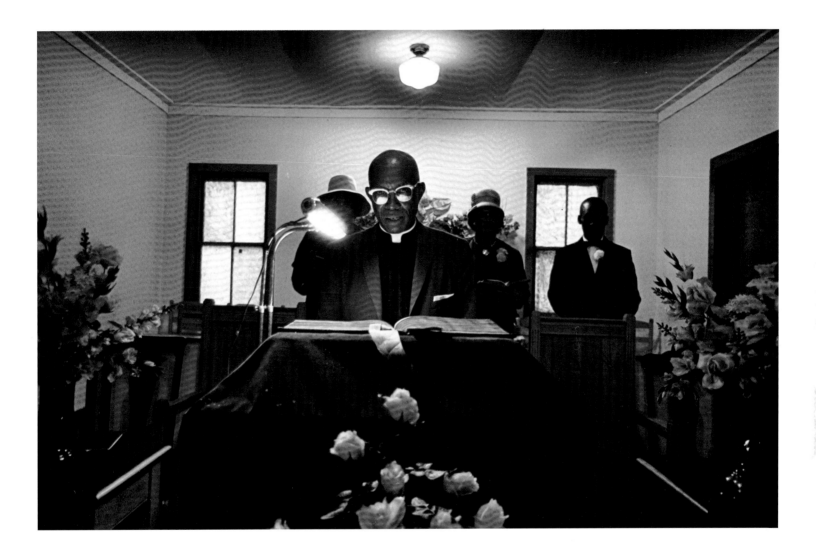

South Carolina 1966
Courtesy of the artist and Magnum Photos Inc.

123

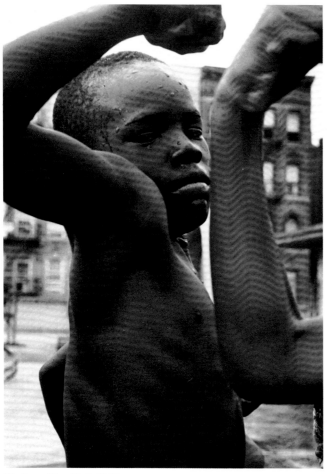

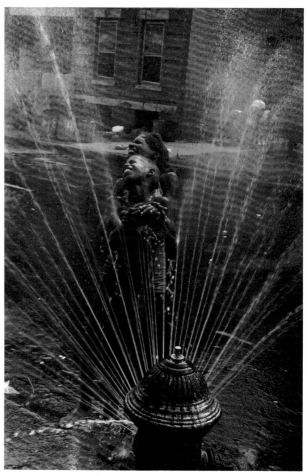

Harlem, New York 1967
Courtesy of the artist and Magnum Photos Inc.

Harlem, New York, 1967
Courtesy of the artist and Magnum Photos Inc.

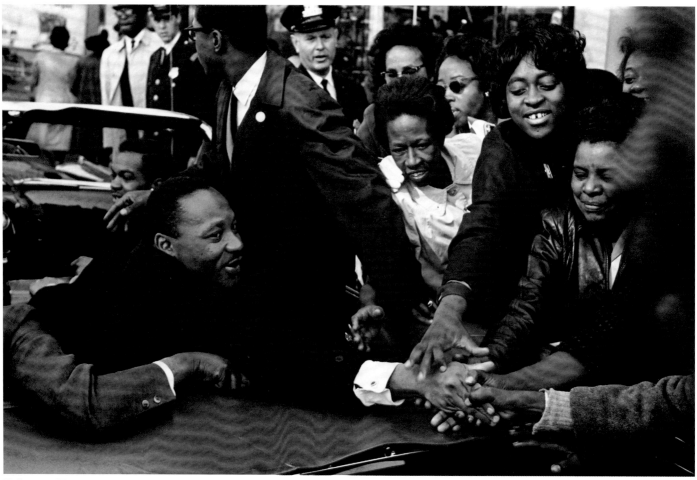

Baltimore Maryland undated
Courtesy of the artist and Magnum Photos Inc.

GARRY WINOGRAND

Born 1928, Died 1984. Winograd began as a freelance photo-journalist and advertising photographer, but rapidly found his most rewarding assignments to be those he set himself. A fast-moving street photographer who delighted in the complexities, banalities and bizarreness of urban life, he used intelligence, wit and his camera in roughly equal measures to make some of the most influential and frequently imitated pictures of the 1960s. Winograd's stated motive, that he photographed to see how things looked when they had been photographed, can be seen to have inspired a generation.

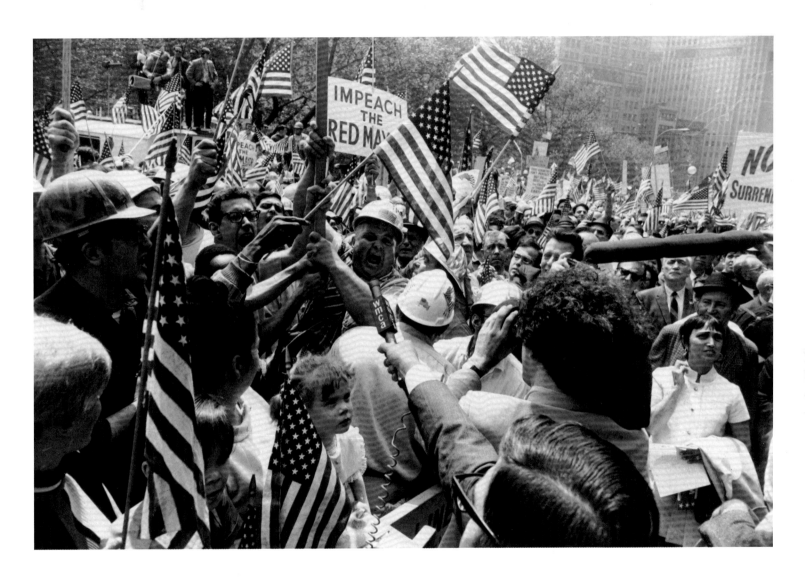

Hard Hat Rally, New York 1969
Courtesy of the Fraenkel Gallery and the Garry Winogrand Estate

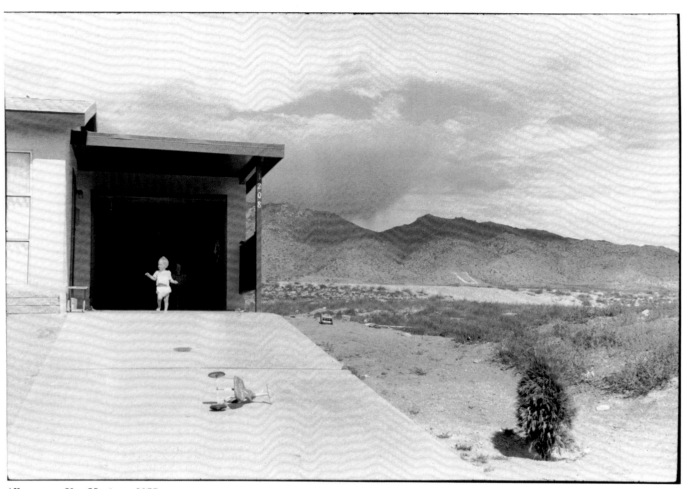

Albuerque, New Mexico c.1957
Courtesy of the Fraenkel Gallery and the Garry Winogrand Estate

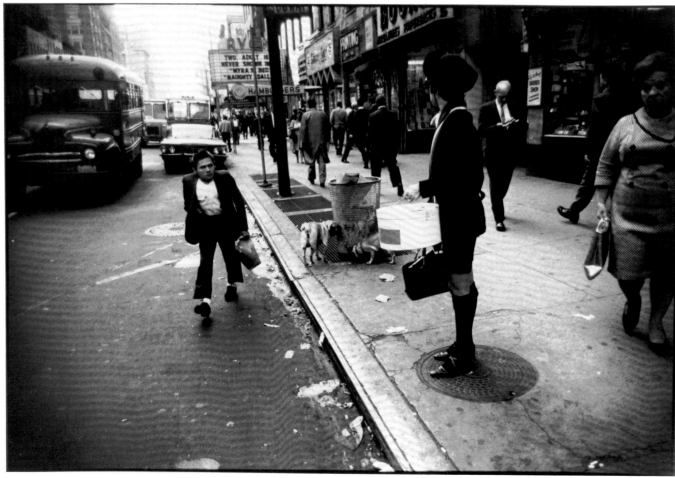

New York undated
Courtesy of the Fraenkel Gallery and the Garry Winogrand Estate

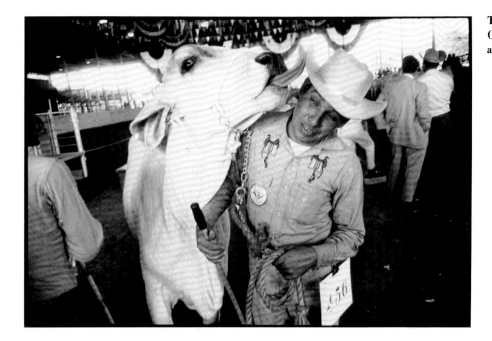

Texas undated
Courtesy of the Fraenkel Gallery
and the Garry Winogrand Estate

New York c.1967
Courtesy of the Fraenkel Gallery
and the Garry Winogrand Estate

San Marcos, Texas 1964
Courtesy of the Fraenkel Gallery
and the Garry Winogrand Estate

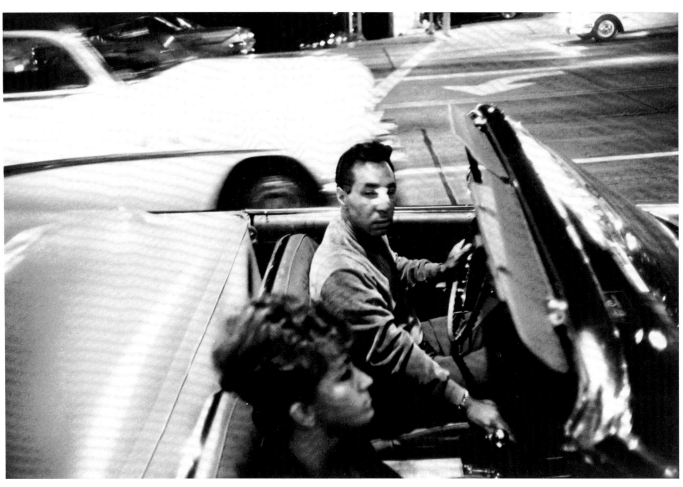

Los Angeles 1964
Courtesy of the Fraenkel Gallery and the Garry Winogrand Estate

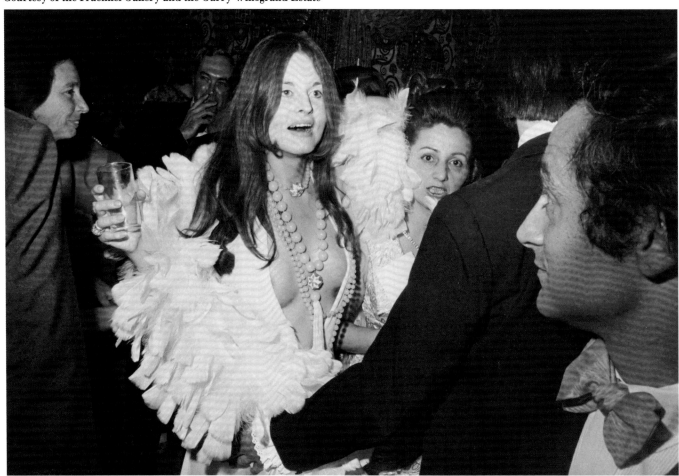

Centennial Ball, Metropolitan Museum, New York 1969
Courtesy of the Fraenkel Gallery and the Garry Winogrand Estate

ELLIOT ERWITT

Born 1928. A successful advertising photographer and film-maker, Erwitt is more often associated with the pictures he takes for himself. His hallmark is humour, a rare quality in photographs that are taken seriously. He finds it in unexpected juxtapositions and chance encounters.

Miami Beach 1962
Courtesy of the artist and Magnum Photos Inc.

Pasadena 1963
Courtesy of the artist and Magnum Photos Inc.

New Haven 1955
Courtesy of the artist and Magnum Photos Inc.

New York 1953
Courtesy of the artist and Magnum Photos Inc.

CHARLES HARBUTT

Born 1935. Harbutt is a distinguished photo-journalist. He also produces personal pictures which explore his psychological and emotional experiences while examining what is photographic about photography. Over a hundred of these were brought together in Travelog (1973) — a radical, non-narrative book based entirely on visual syntax.

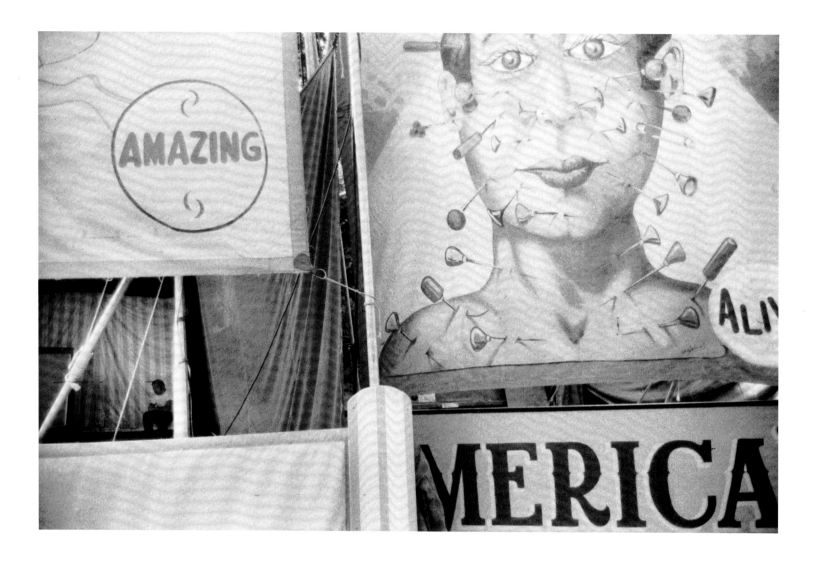

Great Barrington, Massachusetts 1978
Courtesy of the artist and Archive Pictures Inc.

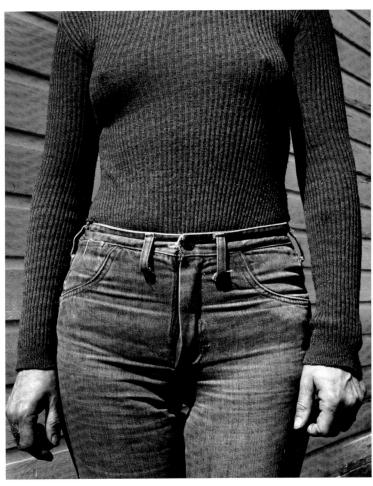

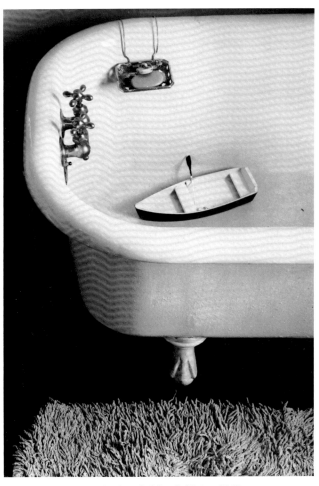

Torso, Stone Ridge, New York 1972
Courtesy of the artist and Archive Pictures Inc.

Bathtub with Boat, Cushing's Island, Maine 1968
Courtesy of the artist and Archive Pictures Inc.

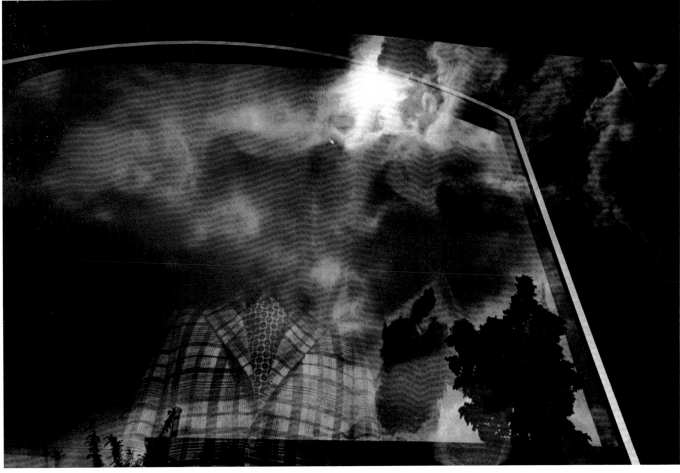

Window, Kalamazoo 1970
Courtesy of the artist and Archive Pictures Inc.

NATHAN LYONS

Born 1930. Lyons is a pivotal figure in photography and a tireless activist for its welfare. He spent much of the 1960s at George Eastman House (now the International Museum of Photography), Rochester NY. There he developed an important series of exhibitions and publications before leaving to create the Visual Studies Workshop, an advanced learning, publications and exhibition centre. In 1962 he helped found the Society for Photographic Education and was its first chairperson. Lyons's pictures, Notations in Passing (1974), deal with his investigations into perceptual experience.

From Notations in Passing a series begun in 1962
Courtesy of the artist

From **Notations in Passing** a series begun in 1962
Courtesy of the artist

From **Notations in Passing** a series begun in 1962
Courtesy of the artist

From **Notations in Passing** a series begun in 1962
Courtesy of the artist

LEE FRIEDLANDER

Born 1934. Like his close friend, Garry Winogrand, Friedlander began as a freelancer. He is now established as one of America's major artists, most closely associated with picturing the 'social landscape': linking together discontinuous fragments of urban ambiguity and lending them first coherence and then a suprising grace. As well as photographing the street, Friedlander has made portraits, photographed trees and flowers and American monuments. His complex pictorial strategies are frequently based on punning with a camera, and are informed by acuity, intelligence and visual elegance.

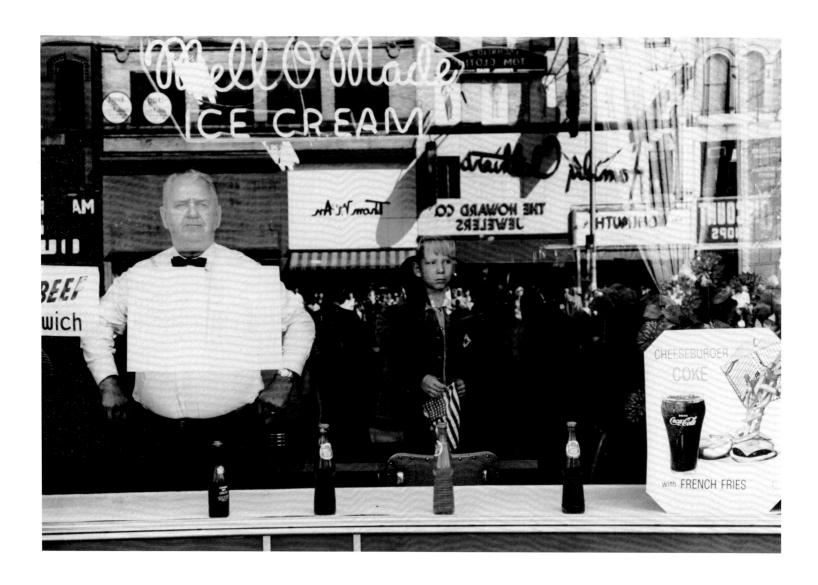

Newark, New Jersey 1962
Courtesy of Zabriski Gallery, New York & Paris

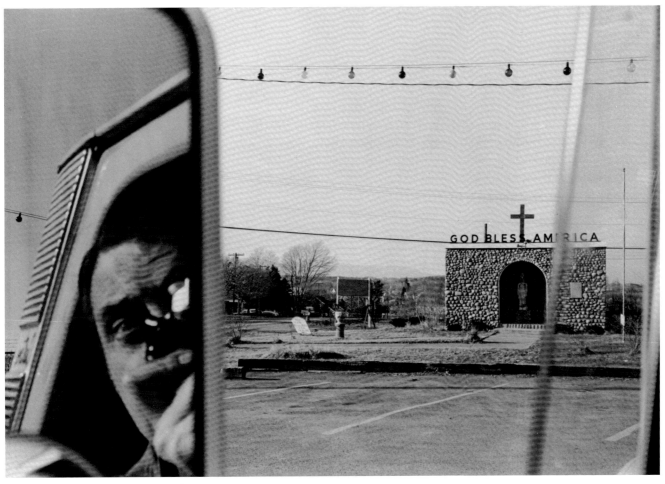

Route 9W, New York, 1969
Courtesy of Zabriski Gallery, New York & Paris

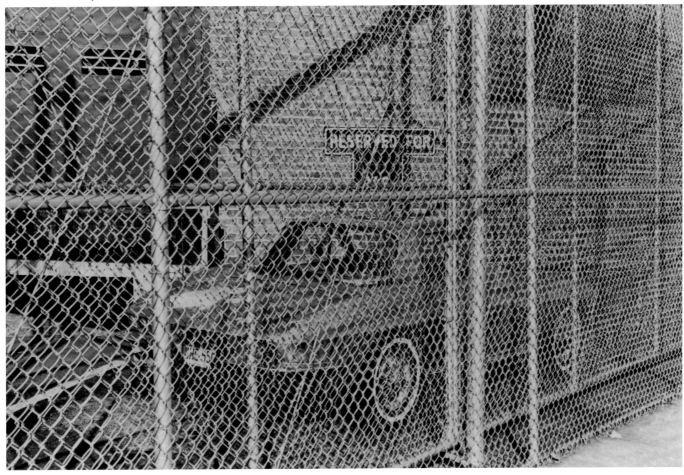

New York City 1963
Courtesy of Zabriski Gallery, New York & Paris

137

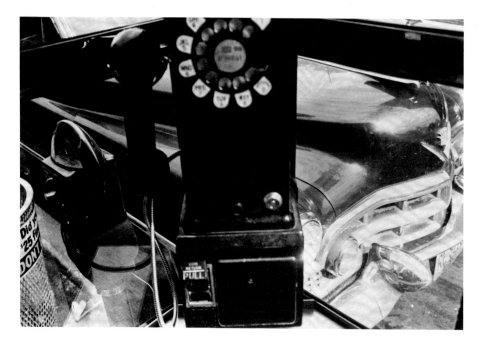

New York 1963
Courtesy of Zabriski Gallery, New York & Paris

New York 1963
Courtesy of Zabriski Gallery, New York & Paris

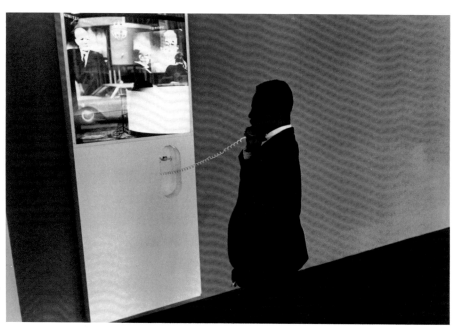

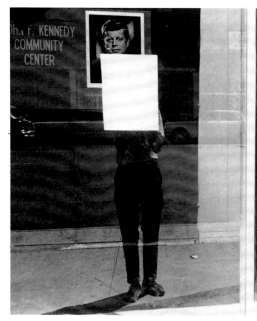

Colorado 1967
Courtesy of Zabriski Gallery, New York & Paris

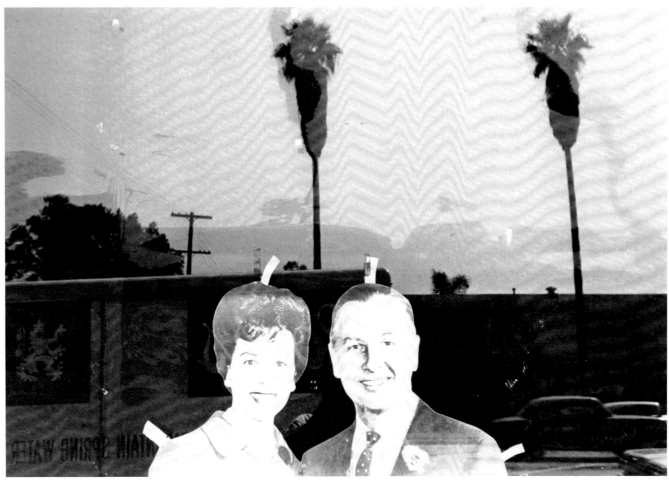

Los Angeles, California 1965
Courtesy of Zabriski Gallery, New York & Paris

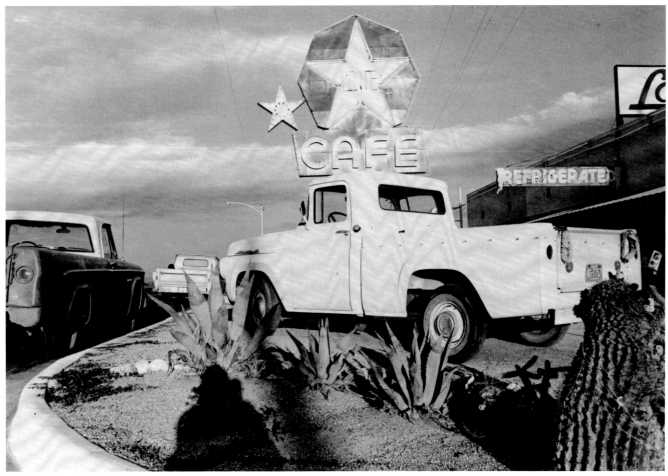

Texas 1965
Courtesy of Zabriski Gallery, New York & Paris

139

BRUCE DAVIDSON

Born 1933. Recognition of how the act of photographing affects the ways in which images are read is well shown in Davidson's work from this period. With the informal intimacy of a small, hand-held camera, he first produced moving essays in the tradition of W. Eugene Smith. He exchanged this discretion for frank formality when he took a large-format view camera, flash and a tripod into East 100th Street, the 'worst' block in New York City. His project began in 1966, went on for two years and allowed for no 'candid' pictures. When the finished photographs were exhibited at the Museum of Modern Art, Davidson invited his subjects to the show.

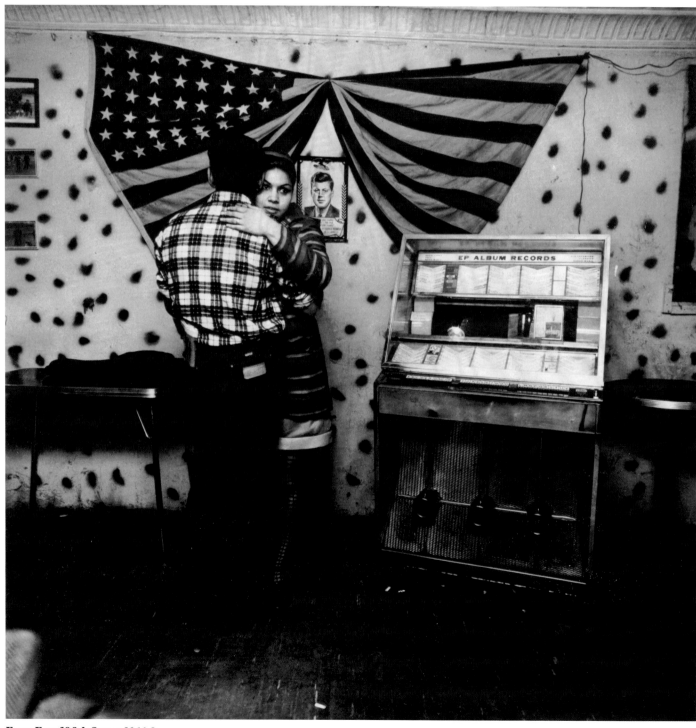

From East 100th Street 1966-8
Courtesy of the artist and Magnum Photos Inc.

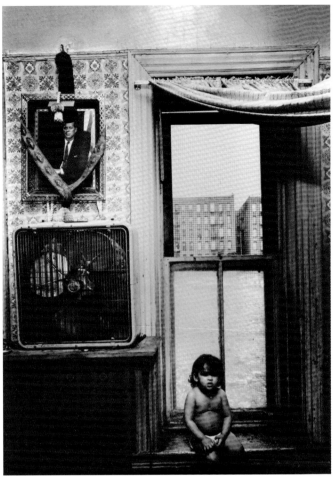

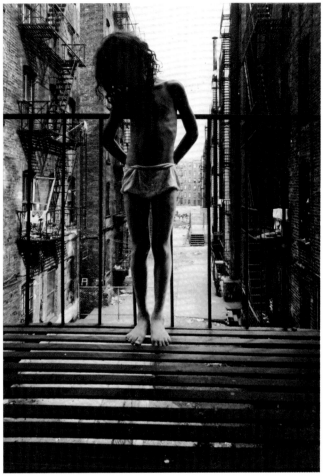

From East 100th Street 1966-8
Courtesy of the artist and Magnum Photos Inc.

From East 100th Street 1966-8
Courtesy of the artist and Magnum Photos Inc.

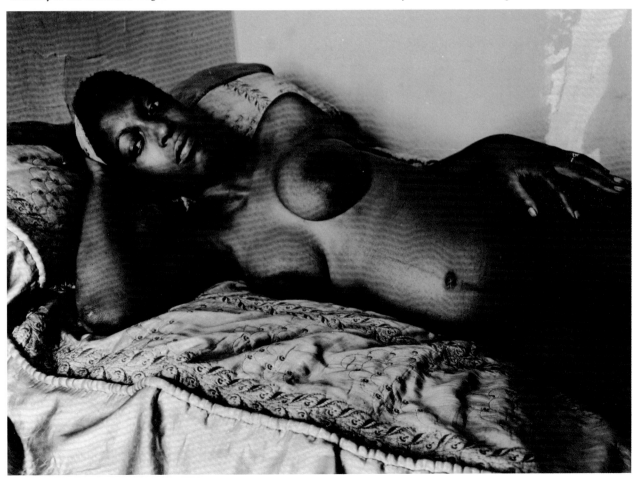

From East 100th Street 1966-8
Courtesy of the artist and Magnum Photos Inc.

RAY K. METZKER

Born 1931. A student of Callahan and Siskind, Metzker developed formalism in photography by considering its repeatability and concepts of the frame surrounding each image. In 1967 he wrote: 'Where photography has been primarily a process of selection and extraction, I wish to investigate the possibilities of synthesis.'

Spring Tingle 1980
Courtesy Laurence G. Miller Gallery

Parking Pavilion 1983
Courtesy Laurence G. Miller Gallery

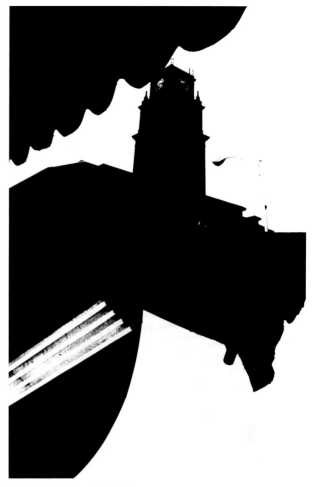

Double-Frame, Philadelphia 1968
Courtesy of Laurence G. Miller Gallery

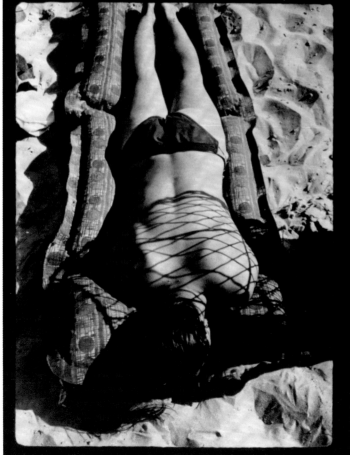

Couplet, Atlantic City 1968
Courtesy of Laurence G. Miller Gallery

ART SINSABAUGH

Born 1924. Died 1983. Interviewed for the book Landscape: Theory
**(1980), Sinsabaugh went on record as saying: 'I don't give a damn about the
landscape tradition in art.' It seems an appropriate remark from a man whose
work is rooted in transforming the world's appearance by making photographs.
Sinsabaugh used a massive camera to make much of his work. It lends a
wonderful delicacy to the minutiae contained in his sweeping vision.**

New Hampshire Landscape, No. 21 1969
Collection of the Victoria & Albert Museum, London

144

New York Landscape, No. 2 1969
Collection of the Victoria & Albert Museum, London

New Hampshire Landscape, No. 22 1969
Collection of the Victoria & Albert Museum, London

Illinois Landscape, No. 2 1970
Collection of the Victoria & Albert Museum, London

JERRY UELSMANN

Born 1934. In the early 1960s photography found a new power base in an expanding educational field. One result was images that ignored any direct commercial influence. Uelsmann took such photographs. He took his cue from nineteenth-century practice and made prints composed of several negatives. They are clearly fantasy but believable, almost, because they employ the medium's realism. His synthetic universe is part playful, part psychological, and wholly his own.

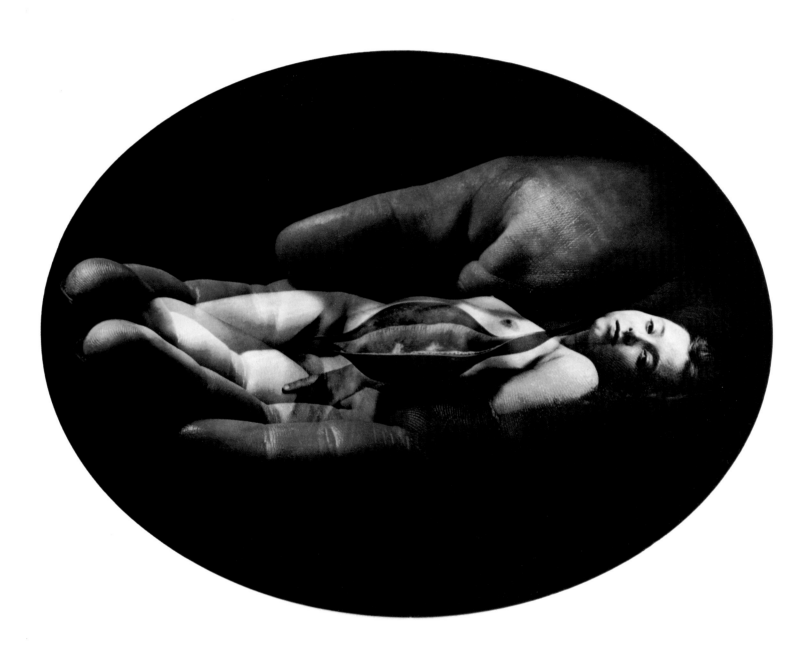

1972
Courtesy of The Weston Gallery

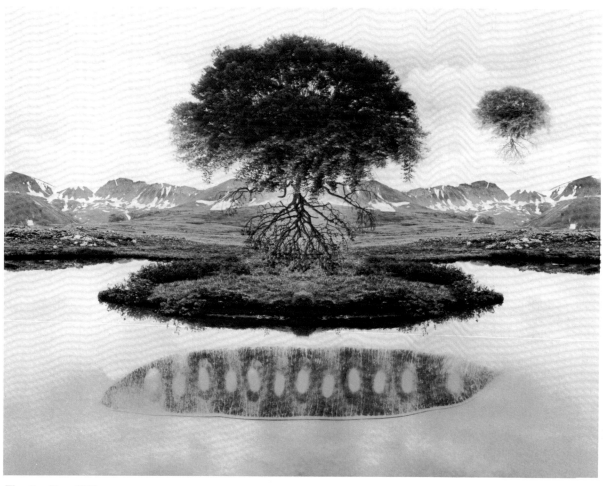

Floating Tree 1969
Courtesy of The Weston Gallery

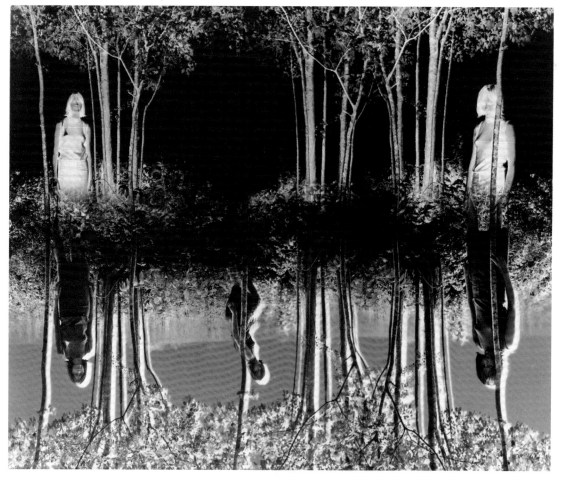

Small Woods Where I Met Myself 1967
Courtesy of The Weston Gallery

1968
Courtesy of The Weston Gallery

PAUL CAPONIGRO

Born 1932. Like many of his peers, Caponigro has great affinity with music, which he studied before photography became dominant in his life. From Minor White, his teacher, he acquired a sense of the importance of the natural order in establishing man's spiritual basis. In 1975 he looked back at his work to date and wrote: 'All that I have achieved are these dreams locked in silver. Through this work it was possible, if only for brief moments, to sense the thread which holds all things together. The world, the unity of force and movement, could be seen in nature.'

Apple, New York 1964
Courtesy of the artist

Kalamazoo, Michigan 1970
Courtesy of the artist

Kalamazoo, Michigan 1970
Courtesy of the artist

Woods, Redding, Connecticut 1970
Courtesy of the artist

Woods, Redding Connecticut 1968
Courtesy of the artist

Frost, Window No. 2, Ipswich, Massachusetts 1961
Courtesy of the artist

Newton, Massachusetts 1960
Courtesy of the artist

DIANE ARBUS

**Born 1923. Died 1971. Arbus was once a fashion photographer; then
she came upon a world that had previously been private territory for its
participants. Like Friedlander and Winogrand in the 1960s she proved influen-
tial in her curiosity about a 'personal' America. Hers was composed of 'things
which nobody would see unless I photographed them'. Arbus lifted a stone and her
audience recoiled at what her unflinching gaze saw underneath it. They were
fascinated — at a safe distance — to see her looking. Arbus was influential in vision
but above all in admitting to and explaining an obsession with photographing.
She remains unequalled in confrontation through photography.**

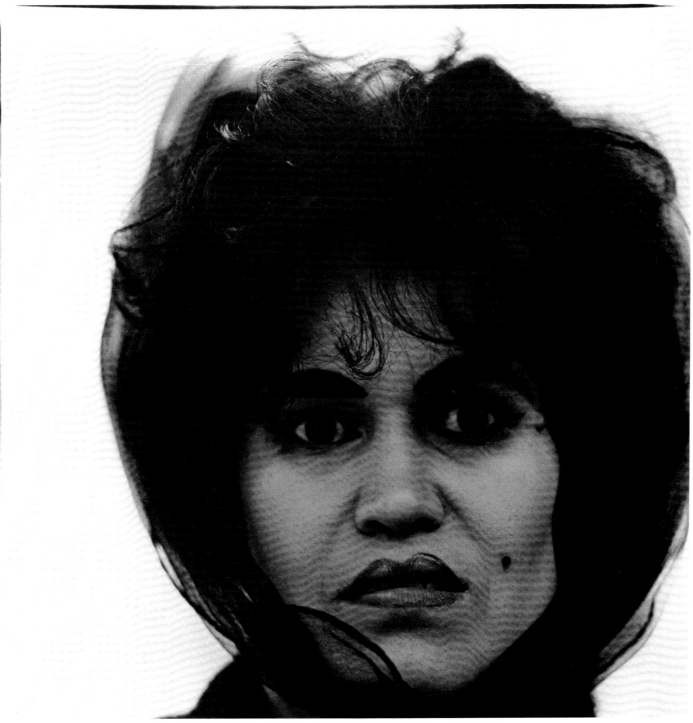

Puerto Rican Woman with a Beauty Mark, New York 1965
Courtesy of Lunn Ltd

Patriotic Young Man with a Flag, New York 1967
Courtesy of Lunn Ltd

Albino Sword Swallower at a Carnival 1970
Courtesy of Lunn Ltd

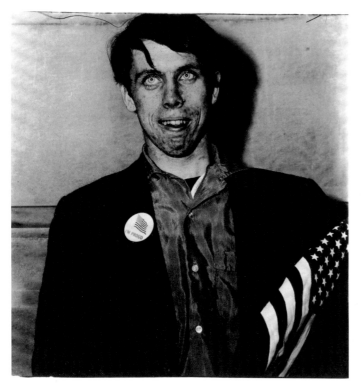

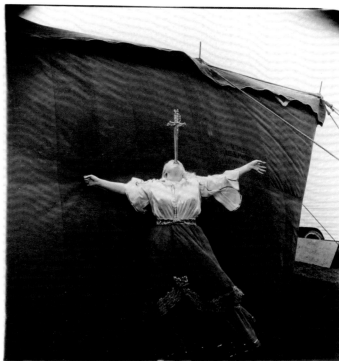

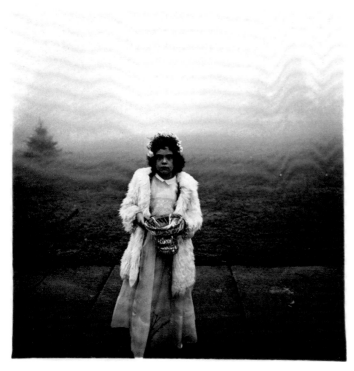

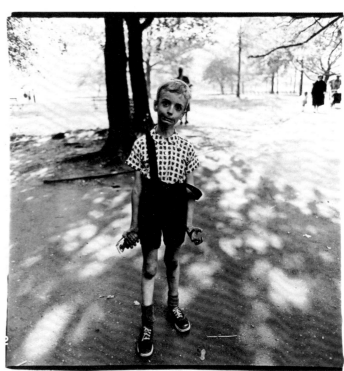

A Flower Girl at a Wedding, Connecticut 1964
Courtesy of Lunn Ltd

Child with a Toy Hand-Grenade in Central Park, New York 1962
Courtesy of Lunn Ltd

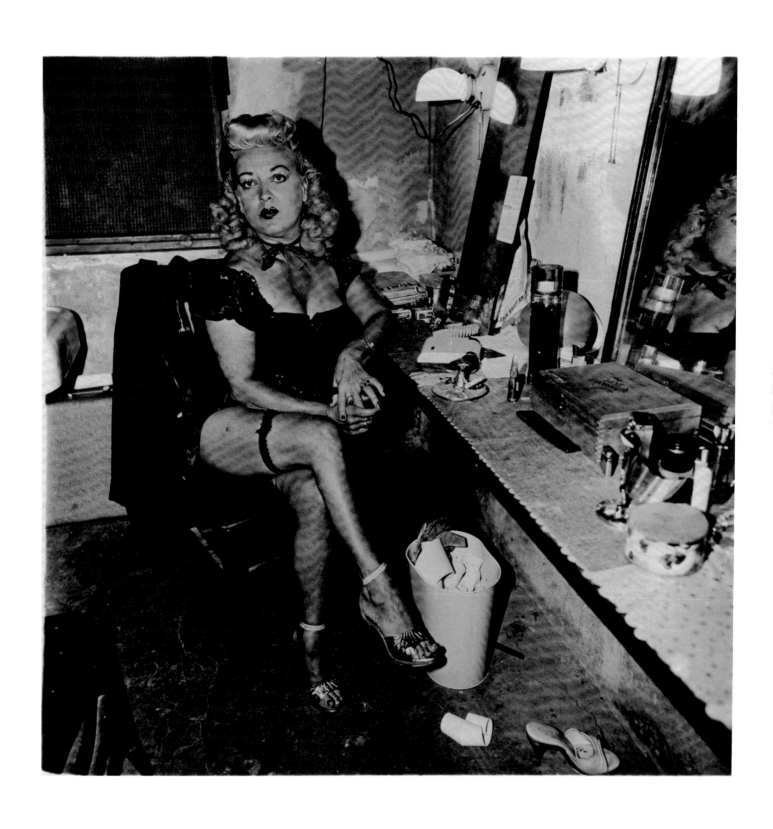

Burlesque Comedienne in her Dressing Room, Atlantic City 1963
Courtesy of Lunn Ltd

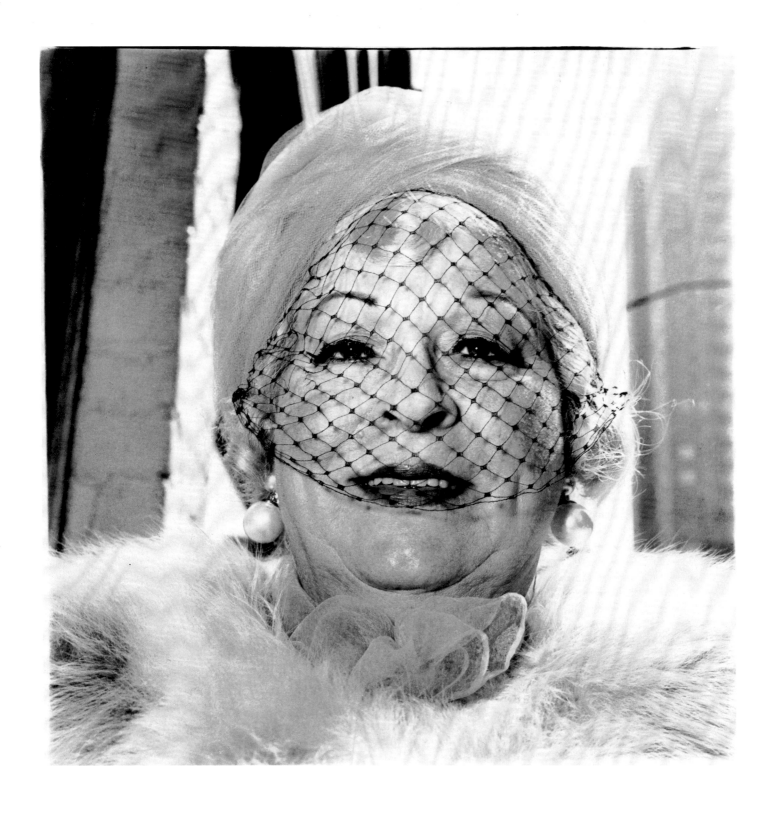

Woman with a Veil, Fifth Avenue, New York 1968
Courtesy of Lunn Ltd

LEWIS BALTZ

AMERICAN PHOTOGRAPHY IN THE 1970s

The social and personal landscape, presaged by Frank and White, informed photography in the 1960s. A more austere vision was to characterize the next decade. As their work gained acceptance in an arena where video and performance art was new and photography was taken as a logical extension of traditional forms, so photographers looked closely at ways that marked their medium as particular. The 1970s were a time of exploration and diversity, but one mode — the photographer as topographer and cool describer — came to dominate. Life-affirming generalities were dismissed while America looked inward, assessing its national and international record as a Western power.

Lewis Baltz considers here the forces contributing to such a change.

TOO OLD TO ROCK, TOO YOUNG TO DIE

Some events pass more quickly in America than in Europe. The British Century, from Waterloo to Sarajevo, very nearly spanned its allotted ten decades; the American Century dispensed with itself in only three. Those thirty years were bracketed by two iconic images, the first of US Marines raising the American flag on Mount Suribach in February 1945, the second of another American flag, folded and wrapped in plastic, being carried by United States Ambassador to Cambodia, John Gunther Dean, as he walked out of Pnom Penh a few days before Khmer Rouge forces captured the city. The first image was one of the most widely reproduced photographs of its time. The second, portraying an equally historic moment, was not.

The two photographs reflect some of the innumerable ways that America's realities and perceptions changed over those thirty years, as well as the changed status of photography. In 1945 Americans communicated the appearance of the world's great events to each other through the medium of still photography; by 1975, by and large, they did not, and not even the recrudescence of the Lazarus-like **Life** magazine could gainsay that difference.

By the 1970s still photographs, so far as they could be claimed to document anything, recorded a more evanescent subject: America's sense of itself. Yet despite the shift from a mass audience to a more limited one – the word 'élite' does not really apply – the 1970s witnessed an intensity of photographic activity in America unequalled since the 1930s, and an acceptance of photography as a major medium of expression unparalleled in our history. Photography was one of the brighter spots in that otherwise bleak decade. Is it not more engaging to think of the 1970s as the years between Diane Arbus and Cindy Sherman than to remember them as the decade that began with the Kent State killings and ended with the election of Ronald Reagan?

In the 1970s a number of institutions came into existence, or came to the height of their powers, that materially affected the enterprise of American photography. The most pervasive of these was the system of higher education. In 1945 very few photographers held academic degrees in photography or the fine arts; in 1975 most of those styling themselves photographers or artists were able to do so on the strength of such academic credentials.

During the 1970s college and university offerings in the fine arts, and most especially in photography, metastasized at both the graduate and undergraduate levels, finding a place in the most respected institutions in the land. Princeton University endowed a chair in the History of Photography and Modern Art, and Yale University endowed a chair in the practice of photography. Even the crimson dowager of American universities, Harvard, while officially cleaving to the traditional line that the history of art is a proper subject of academic interest while its practice is not, none the less offered courses in the practice of photography taught by both resident faculty and distinguished visitors. Oddly enough, in view of such interest at the highest levels of the Ivy League, the most successful and prestigious programme in photography was at the University of New Mexico, which attracted artists and scholars from around the nation and the world, many of whom would go elsewhere and initiate similar programmes in other universities.

Expanding enrolment and expanding employment in the university system (including both private and public colleges and universities, art schools, and two-year colleges) meant that higher education was becoming both major educator and employer of serious photographers. It is probable that teaching had supplanted commercial or magazine work as the 'other' work of most serious photographers by the mid-1970s; especially outside New York where relatively few opportunities existed for the newly-made Master of Fine Arts other than to return as an employee to the system he or she had just left. Such academic recidivism (teachers teaching students to become teachers who would teach students to become teachers *ad infinitum*) was only imaginable in a rapidly expanding sector of a healthy economy. Needless to say it did not last into the 1980s.

While the system was expanding, its benefits were obvious. For the student financial support and, in the 1960s and early 1970s, some shelter from military conscription – the war in Vietnam had made a generation of scholars. For the professor a

secure, if not large pay cheque, an employer more tolerant of artistic freedoms than most, and a power base of sorts. The drawback was that most of this produced a photography that was academic in the most unflattering sense of that word. ★

One of the most salutary effects upon photography of this willy-nilly schooling was, as John Szarkowski noted, ★ not to serve but to create a need. The thousands of students who encountered photography as a fine art, officially encouraged in the highest halls of learning – even those with the good sense to seek their vocations elsewhere – would nevertheless retain something from that contact and might come to form the nucleus of an educated, critical, informed and demanding audience for serious photography. As yet, the goal has been met only imperfectly. Nevertheless it does represent a small step toward the creation of such an audience. And if that audience exists anywhere, European friends would have us believe it is here in America, however far short it has fallen of our best expectations.

Another institution that was seminal in the support of American photography during the 1970s was the National Endowment for the Arts, a Federal agency chartered to provide public funding for the arts in the United States. Originally discussed seriously during the Kennedy administration, it, like so many Kennedy proposals, became a reality only after his death. And, like so many Kennedy programmes passed into law under L. B. Johnson, languished in relative obscurity. After a lacklustre White House Festival of the Arts in 1965, with poet Robert Lowell and photographer Paul Strand publicly refusing to attend, LBJ's ardour for the arts was dampened. Guns, butter, *and* culture seemed to strain our resources too far.

Ironically, it was during the Nixon administration that the NEA began to receive the massive funding that made it the major single factor in American cultural life during the 1970s. Ironic, because of Nixon's well-advertised loathing for the intelligentsia, who had returned his contempt since his early days as a Red-baiting junior Congressman. Reliable sources have it that one of Nixon's advisers suggested that he neutralize the American cultural community by the time-honoured method of buying them off – at an annual cost vastly less expensive than a few hours of war-making in Indo-China. For whatever reason, and with whatever hopes, Nixon agreed to fund the NEA at a level that would make it the most visible presence in American cultural life. The intelligentsia accepted the money and continued to despise Nixon.

One corollary to this was that funding for the arts, if it was to reflect credit on the administration, must be free of any partisan political influence; must be, in fact, above any such suspicion. Toward that end the NEA was staffed by outstanding professionals, Renato Danese, Program Director for Photography, is one example, whose loyalties were demonstrably toward furthering the arts in America rather than toward the government, and it remained the least politicized of any federal agency. It resembled in parts both the Canadian and British Arts Councils, although at its zenith its funding surpassed either.

As a photographer one often felt that there was an unstated attitude, if not policy, of affirmative action toward those mediums least able to survive in the private sector: artists' films, video, performance, and, especially, photography. In its heyday the NEA funded programmes – often several in each category – to sponsor the making, exhibition, publishing, public collecting, and criticism of photographs by living Americans. So pervasive was government funding that

one wit suggested an 'audience participation' grant: close the circle by funding random citizens to go and look at all this product. It is good to remember when such an observation could still be humorous: with the triumph of the know-nothing wing of the Republican party and the election of Ronald Reagan to the Presidency in 1980, funding for the arts was sharply reduced. The NEA remains intact today, but with far less influence than it had in the previous decade, and one doubts that even the valiant souls who steer this ship through its present stormy seas would really argue that it is now merely a tighter, 'leaner' vessel.

A major recipient of assistance from the National Endowment for the Arts was American museums, and nowhere was the effect of this funding more evident than in the area of photographic exhibitions and collections. A number of American museums, including some of the most respected, had an historical commitment to photography in the arts, but the avalanche of interest in the 1970s made nearly every American museum desirous of making, if not a full programme, at least a respectable showing in the area of fine-art photography. Photography was relatively inexpensive to exhibit, acquire, and ship. It had a broad public appeal that did not go unnoticed by museum directors eager to report expanding attendances. And, finally, it was becoming fashionable in the most élite art circles. The 1960s had brought a building boom to the museum world, and a number of cities had impressive edifices without correspondingly impressive collections or exhibition schedules. Photography was part of the solution to that problem.

In the 1950s and 60s a handful of museums dominated the exhibition and collection of photography, most notably the Museum of Modern Art in New York and the George Eastman House in Rochester. Other museums were usually content to accept the often excellent circulating exhibitions that these two leaders organized. NEA funding, more than any other single reason, broke this monopoly. If the NEA had any stated bias it was against the aggregation of culture in one metropolitan centre and in favour of a regional, pluralistic approach to the arts. With NEA asistance regional museums could organize their own exhibitions, become exporters rather than importers of photographic attitudes and works; and most took advantage of this opportunity, using NEA funds as seed money to develop local interest and support in photographic programmes.

Two museum persons dominated the discourse that surrounded the exhibition of contemporary photography in the United States during the 1970s; both were, themselves, photographers. John Szarkowski, at the Museum of Modern Art, New York, and Van Deren Coke, at George Eastman House 1970-3, University Art Museum, University of New Mexico, Albuquerque, 1973-9 and at the San Francisco Museum of Modern Art from 1979 onward, were the two leading figures whose views defined the range of mainstream contemporary curatorial attitudes toward photography in the 1970s. Szarkowski favoured photography in the documentary style, with a special interest in the American vernacular; Coke was more internationalist, his interests lying more in the areas of cross-fertilization between photography and the other visual arts. Taking nothing away from the efforts of other distinguished scholars and curators, there were no other museum figures who either by temperament or position exerted such a

★ See Jay, Bill, 'Photography in America', **British Journal of Photography**, 11-18 July 1980.
★ Szarkowski, John, **Mirrors and Windows: American Photography Since 1960**, MOMA, New York, 1978.

strong influence on American photography during the 1970s and beyond.

Outside the sphere of established museums, and often even more reliant upon public funding, were alternative spaces, though in America these venues play a far less important role than in the UK. Conceived as exhibition halls for works too non-commercial for private galleries and too radical, politically or stylistically, for established museums, alternative spaces for photography turned out, for the most part, to be a disappointment, exhibiting work that was identical in kind, if not quality, to that of their more established counterparts. The effect was less to challenge prevailing attitudes than to institutionalize them even in their less accomplished manifestations.

Most of the conditions favouring photography in America in the 1970s would be familiar, in some degree, to photographic audiences in any modern industrial democracy. But the development of a large, active, private market for contemporary photography would be quite unfamiliar. And no surprise: before the 1970s it was almost unheard of even in America.

In 1969 the late Lee Witkin opened the first commercially viable New York art gallery devoted exclusively to the exhibition and sale of photographs as fine art. To the surprise of most, he prospered. Two years later Light Gallery opened its doors on New York's fashionable upper Madison Avenue, dedicated to an equally daring proposition, the exhibition and sale of the works of living photographers. 'Light', too, flourished throughout the decade. Similar galleries began appearing in New York, as well as Washington, DC, Los Angeles, Chicago, Boston, Houston, San Francisco, Seattle and other regional centres.

More important in the taking of photography out of its ghetto was its incorporation into the exhibition programme of the most prestigious painting and sculpture galleries during the 1970s: Castelli, 1971; Ileana Sonnabend Gallery, 1972; Pace Editions, 1973; John Weber Gallery, 1974; Marlborough Gallery, 1975; Prakapas Gallery and Robert Miller Gallery in 1977. Other galleries followed. While it was extremely difficult to see photographs exhibited as art on New York gallery walls in 1967, by 1977 it was extremely difficult not to.

With a few stunning and well-publicized exceptions the economic consequences for most photographers was slight. More important was the new aura of respectability, attendant on any enterprise in America that is perceived to be lucrative. That, and an inchoate hope for the future: if things continued to go as they had, a serious photographer might someday be able to earn, from the sale of his or her artwork, a living commensurate with that of an automobile mechanic or university lecturer. Events gave the lie to this overly sanguine view of the future; but while it obtained it gave heart to many who were doing as they always had and always would: support their photographic activity with jobs in other, remunerative fields.

The market interest in photography prompted a new level of media interest. Important art journals allocated ever-increasing editorial space to photography. The apotheosis of this was the September 1976 issue of the leading established art journal, **Artforum,** which was devoted entirely to photography. The lofty **New York Times** regularly published critiques of current photography exhibitions, as did the somewhat less lofty **Village Voice.** Both were, in very different ways, national newspapers, and the effect of this coverage was felt far outside New York City.

But none of this adequately answers two questions: why photography? And why now? No one answer can suffice, but an observation by Marvin Heiferman, then Director of

Castelli, sounds as plausible as any. The art world, he said, seems to have a cyclical interest in photography that lies dormant for thirty or forty years, then re-erupts in a flurry of excitement for a few years, a behaviour pattern rather like that of a hyperkinetic child discovering a new toy.

One must consider this in the perspective of what other toys were lying about the art world in 1970. In fact there were surprisingly few. As in every decade since Dadaism the artistic and critical vanguard in the 1960s were cheerfully heralding the 'death of Art'. Oddly enough, in a very small way, and for a very brief period of time, their jeremiad was correct. Which is not to deny that in 1970 there were scores of significant artists producing work of enduring interest and worth. Merely that, by 1972 at the very latest, most of the major movements that had emerged in the previous decade – Minimalism, Post-Painterly Abstraction, Process Art, Earth Art, Linguistic Conceptualism, to name a few – were in their decline, in so far as their major issues had already been announced, major players already identified, and major works already made and entered into the culture. There was relatively little to see that one did not already know something about, and little visible on the horizons of painting, sculpture or conceptualism promised to be as interesting as the work that preceded them.

The few remaining unexploited areas were video (with artists' films), performance, and photography. Laurie Anderson notwithstanding, the audience for performance, though passionate, is usually small. That left video artists' films and photography. Most knowledgeable observers favoured the former, heedless of the inherent suspicion attending 'real-time' art works and heedless as well of the notion that though the vanguard audience's masochism is great, it is not infinite. The knowledgeable observers were wrong, not for the first time.

Many of the reasons for photography's art-world ascendance were shameful, or irrelevant. As the acerbic H. L. Mencken observed fifty years earlier, no one ever went broke underestimating the taste of the American public. Mencken's spiritual descendant, Tom Wolfe, further noted in his broadside **The Painted Word,** that the American art audience, even at its most sophisticated levels, hankers deep down for imagistic art; if possible, figurative art, an art with recognizable forms and an anecdotal content. Most photographs automatically satisfy this in some degree. While abstraction held the high ground in American painting and sculpture since 1945, it has remained, for a number of reasons, only a factional style in American photography. Critics, most of whom if trained at all are trained as writers, also prefer artwork that yields up to literary interpretations. It is, after all, far easier to write about a Diego Rivera painting, or a Cartier-Bresson photograph, than it is to confront the obdurate materiality of, for instance, a Carl André sculpture.

Thus photography inherited some of that portion of the American art audience too intellectually torpid to understand, much less take interest in, the kinds of issues raised by the best American art of the 1960s. Photography appeared more easily accessible. Which it is, though only superficially. The fact that the most intelligent photographic works hold a range of problematic issues as demanding as those raised by any other art of major ambition either came as a rude shock to this segment of photography's public, or else was overlooked by it altogether.

Another less than noble reason why photographs, rather than video or performance art, dominated the stage in the 1970s was because photographs, unprepossessing though they

may be, nevertheless can be shown as tangible objects in a way that video and performance cannot. Not only are photographs a tangible commodity, but, judging from auction prices during the 1970s, a vastly underpriced one at the start of the decade. More than one observer has conjectured that before 1970 it would probably have been possible to purchase every twentieth-century photograph in the Museum of Modern Art's exemplary **Masters of Photography** installation for less than the price of one major contemporary painting. This inequity was more than redressed by the early 1980s when a Los Angeles television producer allegedly paid over $70,000 for an uneditioned mural-size print of Ansel Adams's celebrated **Moonrise Over Hernandez, New Mexico.**

Another development in American photography during the 1970s was the unprecedented quantity and quality of photographers' and artists' publications, some in the form of portfolios of original prints, some in the traditional form of a monograph by an established publishing house, but most often, in the form of inexpensively printed, self-published 'artist's bookworks' that dealt with a single subject or theme. A number of external circumstances contributed to help make this a possibility for photographers in the 1970s: support from the ubiquitous NEA; improvements in the technology of photographic reproduction; the formation of book distributors and retailers specializing in artists' books; and the aforementioned college-age public, which was interested in photography but whose affluence extended to posters and books rather than to original prints. Most important, though, was that this form of organizing and disseminating photographic images responded to a concern generated in photography during the 1970s.

Long constrained by the preciosity of the 'master' print and dismayed by the informational limitations of the single image, many photographers chose to work in groups of serial or sequential images, often narrative but many times not. These photographers came to regard the single print as an element of a larger entity: the series, sequence or group, which was, rather than the individual photograph, the indivisible unit. Further, many of these photographers were coming to resent the reduction of the photograph to commodity status, costly and rare, and preferred to make their ideas and images available at a low cost to the widest possible audience. At the same time they were wary of the magazine as a means of dissemination, being all too aware of the dubious role played by editors in 'mediating' the photographers' intentions. The self-published book seemed an appropriate vehicle.

Among the earliest 'bookworks' was the witty and visually intelligent **Twenty-Six Gasoline Stations,** published by Ed Ruscha in 1962. This modest little paperbound book contained exactly twenty-six photographs of gasoline stations, fulfilling to the letter the claim of its title. Though Ruscha did not, and does not consider himself a photographer as such, this little book, and others by him that followed, had an enormous impact on photography.

Far from being stigmatized as 'vanity' books, artists' and photographers' books increasingly came to be seen as the most vital and interesting area of art publishing, so much so as to rob the high-ticket productions of established publishers of their traditional prestige. It was generally understood that any innovative, serious photography could only be produced through some form of self-publication, leaving the large commercial houses as the dinosaurs of the field, able only to produce safe crowd-pleasers: Ansel Adams monographs, or the celebrity photos of a Linda McCartney.

The most interesting publications during the 1970s were usually done outside commercial channels, as bound portfolios of original prints, self-published efforts, very small presses, such as Lustrum, university presses, or not-for-profit publishing houses, most notably Aperture. The most interesting of these publications were thematic works such as Robert Adams's **The New West, Denver,** and **From the Missouri West;** Larry Clark's genuinely shocking **Tulsa;** Linda Connor's **Solos;** Robert Cumming's **Picture Fictions** and **The Weight Of Franchise Meat;** William Eggleston's **Election Eve,** an epic portfolio of 100 images; Lee Friedlander's classic **Self-Portrait** and **The American Monument;** Ralph Gibson's groundbreaking trilogy **The Somnambulist, Déjà Vu,** and **Days At Sea,** which suggested new possibilities for the sequencing of photographs in book form; John Gossage's **Gardens,** a bound book of original prints with a text selected by Walter Hopps; Chauncey Hare's chilling **Interior America;** and Mike Mandel and Larry Sultan's remarkable **Evidence,** to name a few of the best. The Age of Mechanical Reproduction had begun to filter down to the working photographer.

Perhaps the last institution to be mentioned might be the critical press, if only because it disappointed so many of the expectations it raised. One of the hopes for photography in the 1970s was that it would attract the critical attention of leading writers and thinkers outside the photographic community. This much at least was fulfilled: photography exerted a fascination for art writers who had made substantial reputations for their critical views on the other plastic arts. However, almost without exception they failed to come to terms with photography in any but the most superficial way. The astuteness that had gained them such success in other areas was abandoned as they became seduced by the most trivial instances and trivial issues in photography. Few retired from the field with their reputations untarnished; many were in tatters.

The most egregious example was Susan Sontag's **On Photography,** an edited anthology of articles written for the **New York Review of Books** in the early 1970s. One critic was unkind enough to remark that since Sontag could no longer think nor write she should consider not publishing the results of her losing struggle. Though perhaps too harsh a judgement, there is little doubt that **On Photography,** with its unsupported assertions, poorly reasoned arguments, and internal contradictions, is not Sontag's finest work. Nevertheless the book became the nearest thing to a bestseller that photographic criticism had yet enjoyed, and most right-thinking American readers believed that they could learn everything necessary about photography, both as a cultural artefact and as a form of aberrant behaviour, in the pages of this simplistic book.

By the late 1970s the only predictably serious source of critical writing about photographs came from the Marxist point of view. To their credit, Marxist critics were among the few who addressed photography in terms of social issues, who advertised their biases, and campaigned actively for what little of the photographic they found that met their ideological requirements. To their discredit they, with few exceptions (one thinks here of the often droll Alan Sekula), expressed their convictions in a hectoring, turgid prose, so riddled with appropriated jargon as to be virtually unreadable to any but the initiated. Some found it ironic that the last convincing humanist philosophy would present itself in such élitist trappings; others found the disengagement of theory from practice, and the emphasis on theory, transparently self-serving.

Nevertheless, the Marxists represented the only body of photographic criticism taking a position of militant advocacy

during the 1970s. This seemed to result from a view that most non-Marxist critics took of their own role: they perceived their first duty as taking a censorious position toward work which they deemed inadequate, rather than articulating and supporting the aesthetic of works in which they believed. Such a position may be adequate for newspaper writing but it parts company with the best of twentieth-century art criticism, from Apollinaire to Greenburg, which saw its role as defining and advancing a particular position in the arts, and calling attention to artists and works that advanced that position in practice.

It would be unwise to overlook the terrible creative and destructive energies in American society, how they were brought to bear upon photography in the 1970s, and how these energies transformed the material and philosophical circumstances of American photography. It would be equally unwise to forget that had there not existed a large, vital body of photographic practice in America, the support systems would have counted for little. One could also argue that it was the claims of American photography that brought the support systems into being. Both views are tendentious. In fact the interaction between the large and committed body of photographic practice and existing institutions brought lasting changes to both.

Few would dispute the insularity of serious photography in America prior to the 1970s, although there is disagreement about whether this isolation was benign or stultifying. Photographer Robert Fichter compared photography with a Greek island, in the best sense: a sunny, carefree place in the mind where visitors were welcome to bask. ★ A less generous observer might have characterized it differently: as a mixture of a Rotary meeting and a Klan gathering, replete with secret handshakes, arcane shibboleths, and a fiercely defensive assertion of its parochial values in the face of a harsh and indifferent world. Photography's entrance into the mainstream of American culture changed all of that, the good and the bad, permanently. Henceforth photographic practice and theory would be held to the same standards used to assess other ambitious contemporary art, and a number of practices and attitudes from the 1950s and 60s would no longer play. Traditional photographers could no longer have the luxury of disguising the bankruptcy of their vision behind technically 'perfect' prints and pseudo-spiritual utterances; nontraditional photographers could no longer pretend that Robert Rauschenberg had not gotten there first, and done it better, ten years before. Those stables, and others, were being swept, and those who were brushed aside complained that photography had lost its innocence.

Much of the American photography of the 1970s seems curiously affectless and divorced from the political, social, and interpersonal issues that surfaced during that decade. If it is so, it is less the blame of uncaring photographers than of those same photographers' chastened view of the powers of their medium. During the 1950s and 60s 'concerned' photography was perceived, at least by its makers, as a form of activism. By the 1970s it became clear to more thoughtful photographers that it was, in truth, the antithesis of effective social involvement: a form of élitist play-acting, morally satisfying to the player, but without serious political or social consequence. If one wished to influence social or political issues, then images were no substitute for direct political struggle. Photography's value lies elsewhere: in describing the surfaces of the phenomenal world in a manner unique to itself; hoping, at best, to contribute a precise, if necessarily limited, understanding of the objects and events in front of the lens, and some insight into the mind behind it.

These attitudes did not begin, nor have they ended with the 1970s. Many of the dominant attitudes, issues, styles and personalities of that decade have their origins in the 1960s and, by extension, in the entire history of photography. For those issues inherited from the near past, the 1970s were a culmination and a fulfilment; to such a degree that they could be said to belong to the 1970s, as much as to any other decade.

In the late 1960s three extremely influential exhibitions introduced what would become the mainstream issue in American photographic work throughout the 1970s. These exhibitions were **Toward a Social Landscape, Twelve Photographers of the American Social Landscape** and **The New Documents**. Two of the three exhibitions incorporated in their title the term 'Social Landscape', a phrase coined by Lee Friedlander some time earlier. Friedlander, along with his two colleagues Diane Arbus and Garry Winogrand, formed the nucleus of 'Social Landscape' photography.

It was a useful term to embrace the cool, laconic, post-Pop look of much of the best of contemporary American photographs in the 1960s and 70s. Its subject was an America no longer post-war, and its hidden agenda a redefinition of photographic formalism. Formalism is usually taken in photography in its smaller sense: the orderly and considered distribution of elements within the frame to achieve a 'pleasing' arrangement of shapes, tones, etc. With the works of Friedlander and Winogrand, formalism in photography came to take on the broader definition that critics such as Greenburg and Fried had assigned to it in painting: the investigation of the material and historic possibilities of a medium, using that medium as the tool of investigation. In other words, a definition, *in practice*, of the extreme frontiers of what may be deemed as 'photographic' seeing. This, and not the adoption of the snapshot as a vernacular model, as Janet Malcolm suggested, is the way in which photography became 'Modernist'.

'Social Landscape' had another antecedent than the snapshot: the work of Walker Evans. For a great number of American photographers he is what Cartier-Bresson is to the French: an artist with an inexhaustible heritage. Be this true or false, Evans's ironic, dialectical images informed much of the sensibility of the 'Social Landscape' photographers. Evans's irony was more than a detached superiority, it was, at its best, a form of reserved judgement, an appropriate stance from which to view a society whose ideals, fortunes, and individuals are in constant flux, and this lesson was not wasted on the generation of photographers who came to artistic maturity in the 1960s and 70s.

In very different ways the three leading photographers of 'Social Landscape' challenged the prevailing ideas of what photographs must look like. Diane Arbus's artless, straightforward portraits resemble nothing more than fashion portraiture gone horribly wrong. Photographing the dark underside of American society, Arbus found horror and desolation not only in the most freakish of her subjects but, more eloquently, in the faces, postures, and costumes of 'normal', average Americans. No American photographer had ever taken such a relentless, surgical look at what lay beneath the surface of American society. Her best counterpart might be the writer William Burroughs, whose **Naked Lunch** shared many of the elements of Arbus's sensibility.

★ Quoted by Katzman, Louise, **Photography in California, 1945-80**, Hudson Hills, New York, 1984.

161

Arbus's photographs posed troublesome ethical questions, about her as photographer, and about ourselves as viewers. Did her work exceed the limits of her subjects' 'informed consent'? And how much are we, seduced by her vision, implicated with her – and with the depravity she so often photographs? For if Arbus's photographs are sensational, voyeuristic, and exploitative, they are also undeniably compelling, and for reasons that seem to transcend, or at least short-circuit, our usual moral responses. There has never been anyone quite like Arbus in the history of American photography and, despite her suicide in 1971, her presence was felt throughout much of the decade of the 1970s.

Garry Winogrand's photographs are possibly the highest expression of the phenomenal approach to photography in our time. His work illustrates, explains and fulfils his much quoted aphorism that he photographed in order to see what things would look like in photographs. He was a gifted and often scathing caricaturist, the American Daumier; and in their formal organization Winogrand's images pushed at the boundaries of photography *vérité*.

Taking nothing from the contributions of his contemporaries, Lee Friedlander stands out as the colossus whose work dominated American photography in the period 1967-80 and beyond. He is the only American photographer working whose images have assured him a place of honour among the photographers he admires: Atget, Evans, Cartier-Bresson, and Frank. His crowded, tense and often humorous images, and skein-like interlocking of pictorial elements were so complex, and so thoroughly defied traditional notions of photographic composition, that they were, literally, incomprehensible to many upon initial viewing, and were interpreted by some as metaphors for the obdurate chaos that is modern life. In retrospect that seems naïve. As Jonathan Green observed, for all their apparent disorder the images have a sophisticated and compelling logic, not unlike that of a Rauschenberg assemblage. ★ Like Rauschenberg, who wished to work in the area 'between art and Life', Friedlander's seemingly haphazard compositions allowed his viewers to ponder the dialectic of curiously opposed objects and events that meet within his photographs much as they meet in our everyday vision. Friedlander has modified his strategies over the years, encompassing within his photographs a far wider variety of subjects and situations than any photographer working today.

But if a movement is to be worthy of the name, its vitality must be tested not only by the strength of its progenitors but by the strength of succeeding generations of workers as well. And it is in this critical test that 'Social Landscape' proved so durable, attracting, for a period, a group of photographers as interesting and diverse as Mark Cohen, Bill Dane, William Eggleston, Ralph Gibson, Anthony Hernandez, Joel Meyerowitz; Duane Michals, Tod Papageorge, and Henry Wessel, Jr. Many of these photographers have found their mature expression in styles widely divergent from the 'Social Landscape' aesthetic, others have extended the idiom and forged from it an instrument of strong personal expression. But it touches, at one time or another, all of these prominent photographers of the 1970s and many made their best work in that style.

Another powerful hold from the 1960s was the increased use of photographs by artists not usually thought of as photographers. At first these works surfaced as documentation of body art, earth-works and performance pieces; but by the mid-1960s artists such as Jan Dibbets, Douglas Huebler and Bruce Nauman were producing conceptual pieces in photography that could, in fact, only be executed as photographs. The 1970s saw an acceleration of the use of photographs in conceptual art, and by the mid-1970s artists, such as John Baldessari, Lucas Samaras, and William Wegman, not usually thought of as photographers, were producing bodies of work that were decidedly photographic, both in concerns and in materials. The only argument for creating a distinction between these photographs and 'photography' was the price gradient between photographs and other mediums, a powerful enough argument in a capitalist society.

Muddying the waters further were a number of persons, generally thought to be primarily photographers, such as Thomas Barrow, Michael Bishop, Robert Cumming, Ralph Gibson, Jan Groover, Ken Josephson, Ray Metzker, John Pfahl, and Eve Sonneman, whose work addressed a broad sweep of issues previously considered the domain of other visual arts.

One further development of this trend was a heightened interest on the part of late-1970s American photographers in working in the controllable environment of the studio rather than the haphazard out-of-doors. In the studio, the photographer could direct, exactly and specifically, the content of his or her images, in a way common to other artists, and common to commercial photographers, but unusual in art photography. By changing from an analytic to a synthetic mode, photographers could lay to rest the last doubts regarding the issues of intentionality in their work. One thinks here of the works of JoAnn Callis, Barbara Kasten, Olivia Parker, and Sandy Skoglund. And especially one thinks of Cindy Sherman, whose enormously popular self-portraits utterly parted company with the 'still-life' look of so much made-in-studio work of the late 1970s and resonate with associations of media imagery, autobiography, performance art, feminist role-investigations, and, in an oddly unsentimental sense, nostalgia.

The third, and less pervasive interest inherited from the 1960s that was to find its fulfilment in the years 1970-80 was mixed-media photography. It was a genuine attempt to take photography beyond the physical limitations of the unaltered photographic print and enhance it with the plasticity, objecthood, and visual surface of the other graphic arts. This work failed to gain wide acceptance outside the academic world for two reasons: first, few photographers working in this vein were able to transcend their indebtedness to Robert Rauschenberg's late 1950s work and second, the complexity of facture usually took precedence over the nominal content of the work, reducing photography from a relatively simple art to an extremely demanding craft. An exception should be made here for the work of Robert Heinecken during this period whose best efforts escape self-conscious facture and convey wit, intelligence, sexuality and rage.

Two movements, or trends, seem to belong exclusively to the 1970s, the first, 'New Topographics' (after an exhibition in 1975 of that name), the second, what one might call, for want of a better phrase, 'The Rush to Colour.'

'New Topographics' offered a radically reductive view of the American environment. Where those images that could be gathered under the rubric of 'Social Landscape' had the appearance of candour and immediacy, taking as they had Robert Frank as their mentor and the snapshot as their vernacular model, Topographic photographers opted for a chillier vision, arid and dispassionate. Their mentor was

★ Green, Jonathan, **American Photography, A Critical History**, Harry N. Abrams, New York, 1984.

Timothy O'Sullivan and their vernacular model the commercial real-estate photograph. One useful description of the working ideology was given by photographer Joe Deal in the New Topographics catalogue.★ **'In making these photographs I attempted to make a series of images in which one image is equal in weight or appearance to another. Many of the conscious decisions made while the series was evolving had to do with denying the uniqueness in the subject matter in one exposure as opposed to another in the belief that the most extraordinary images might be the most prosaic.'**

The conscious attempt to, if not eliminate, at least minimize the appearance of 'style' informed this approach to photography, as did the programmatic rejection of most of the elements and devices traditionally employed to make the world seem 'interesting' in photographs. These choices alone might explain why New Topographics work so alienated photographic audiences, defeating as it did the very expectations that they had been taught to bring to photographs.

This approach, unyielding as it may appear, was arrived at through more than sheer perversity. More positive reasons exist for the emergence of this style at this particular historical moment. As Barbara Rose observed, ★in a culture lacking a direct link with the mythologies of the classical world, an established church that encouraged religious art, or a monarchy to define the pinnacles of its social order, American art has traditionally found its most elevated subject matter in the natural landscape, often endowing it with qualities that transcend its literal appearance.

Needlesss to say, this has been even truer of photography in America, where landscape has been among its most important and enduring subjects. Unfortunately, by the late 1960s there was no convincing school of landscape photography in America. The vital West Coast School, founded by Edward Weston, had entered its late-mannerist phrase, typically producing oversized, overworked calendar pictures of mountains and black skies, while the Equivalent, with its roots in Stieglitz and carried through by Minor White, had degenerated into self-indulgent mystification.

Redeeming the American landscape for photography seemed a worthy task and more difficult than one might imagine. The present generation of Americans, for the most part, never experienced the landscape without experiencing its counterforce, industrialism, and it seemed likely that without this dialectic the entire notion of 'pure' landscape might seem so estranged from ordinary reality as to appear escapist and sentimental. In this awareness topographic photographers surveyed the 'new' American landscape, attempting to see it whole and see it clear; motorways, shopping centres, housing tracts and all of the other elements that inform our perception of a landscape neither wholly natural nor wholly an agglomeration of industrial artefacts, the 'middle landscape' of late industrial pastoralism. This, even more than the heightened degree of traditional American photographic irony, was the vision that animated topographic photography in America during the last decade.

During the latter half of the 1970s American photography was overshadowed by one pervasive pseudo-issue, The Rush to Colour, which blurred many of the existing lines demarcating areas of photographic practice and, in the end, cast a treacly pall over the entire enterprise. Unlike most of the trends operating in the 1970s which had diverse and arguable beginnings, the Rush to Colour began on 25 May 1976. On that date the Museum of Modern Art, New York, opened an exhibition of seventy-five dye-transfer colour prints by contemporary Memphis photographer William Eggleston, accompanied by the publication of a book, **William Eggleston's Guide**, the first exclusively colour monograph published by the Museum. Two months after the closing of the Eggleston exhibition the Museum opened its second one-person show of work by a contemporary colour photographer, Stephen Shore.★ MOMA, arguably the most prestigious single institution dealing with photography in America, had placed its imprimatur on colour photography.

MOMA could hardly be faulted for its choices, however controversial they were at the time. Both Eggleston and Shore were and are photographers of exceptional talent and integrity, and cannot be held answerable for the flood of ingratiating rubbish that followed them into the museums and galleries any more than the QEII can be taken to task for the flotsam that accumulates in her wake. Despite radical differences in style, technique, and temperament, Eggleston and Shore shared a commitment to the use of colour as a descriptive, as opposed to decorative, element in their photographs. They were among the last to do so and by the end of the decade it seemed as though their work, almost solely, redeemed the entire shallow, dismal affair that was America's flirtation with photographic colour.

The dominant, or at least prevalent, body of colour photographs that one saw at the shank of the seventies was vapid, overscaled, coffee-table art, the end-product of photography's first demand/supply style of photography: Soft Contemporary, user-friendly pap devoid of any content save colour and any ideology save prettiness. The nearest parallel in recent history is with the second-generation colour painters of the early 1970s, stain-painting and the like. The lesson of this style was to demonstrate that even painting, with its inherent physicality, plasticity, greater scale and, of course, historical momentum, could not build a workable aesthetic upon colour alone. And what was not possible for painting in the early 1970s was even less possible for photography at the close of the decade. Photography had made its blood sacrifice to the twin altars of interior decoration and corporate collecting, and in so doing strained the credulity of its audience, perhaps the most credulous on earth.

Photography's career in the mainstream of America's art world was meteoric, coming and going. Summoned into the limelight in the early 1970s photography was dismissed with equal suddenness in favour of Neo-Expressionist painting, a largely European style that captured the attention of the American art world in 1980 and holds it still. In the public sector Reagonomics dictated the rationale for sweeping reductions in public arts funding, a decision that one cannot help suspect was based as much on ideological as fiscal motives. Reflecting the general hardening of attitudes in the late 1970s and 80s, student enrolment in art and photography courses stabilized and began to diminish. Economics, as well as hubris and poor business sense closed a number of the photographic galleries that had opened in the 1970s and reduced others to a skeletal version of their former selves. Most of the other art galleries that adopted photography into their programme in the 1970s continue to maintain their commitment to the medium, although not at the frenetic pace of eight years ago. If

★ Jenkins William (ed.), **New Topographics: Photographs of a Man-altered Landscape**, International Museum of Photography at George Eastman House, Rochester, N.Y. 1975.
★ Rose, Barbara, **American Painting: The Twentieth Century**, Skira, Switzerland and World Press, New York, 1971.
★ For practical purposes I am ignoring an earlier Helen Levitt exhibition based on projected transparencies. L.B.

we have not seen – by any means – the end of photography in the art world, we have seen its limits. Nothing, as the cliché tells us, lasts for ever.

On the positive side, nearly all of the photographers represented in this section are alive and working, and many are producing the most significant work of their careers. A new generation of colour photographers has emerged, young enough to see colour as simply another aspect of the medium rather than an issue apart or an ornament, and old enough to hold no extravagant hopes for popularity. At least two commercial galleries have opened in New York since 1980 with a commitment to photographic works: Pace MacGill which exhibits photography exclusively and the influential Metro Pictures which has exhibited the works of such post-modernists as Louise Lawler, Richard Prince, and Cindy Sherman. If photography has lost editorial space in the leading art journals, we may be consoled that **Afterimage** (from the Visual Studies Workshop), like the poor of the Bible, is always with us. A number of attitudes, issues, and personalities had to be cast aside when photography made its move upward in the world, and even more as it fell from grace. Yet it seems doubtful, in retrospect, if so many of those triaged photographers' ideas and works will be so sorely missed after all.

Consistent with that Puritanical strain of American thought that views the world and all its contents as temptations placed before us to test our souls, one might view the situation of American photography during the 1970s as such a test. Having survived for so long in obscurity and privation, could the corpus of American photography endure success, even popularity, as well? The answer, from the perspective of the mid-1980s is yes, after a fashion. If our present decade seems less favourable to the enterprise of photography generally, it seems more favourable to certain photography specifically. This decade has proved more discriminating than the last; it could hardly be otherwise. And, if that is not enough, there is a final consoling thought: perhaps Marvin Heiferman was correct, that America's interest in photography is cyclical, and in another thirty years the love affair between America and her photography will blossom once more. Photography will be brought from the shelf and, once again, made much over. And those of us who live long enough can have the 1970s all over again.

LEWIS BALTZ
Baltz's interest in photography in Britain matured when he spent a period here as a US/UK Bicentennial Fellow in 1979. An American photographer with particular concern for the urban environment, he is most closely allied with the 'New Topographic' movement and known internationally for his spare, rigorous documentation of man's encroachment on the land. Baltz has received many awards as a photographer, including a Guggenheim Fellowship in 1976. He is the author of three books. ★ P.T.

IV.
1970-80

JIM ALINDER

Born 1941. Alinder has made a career out of photography's departure from functional imagery. Using the ways in which cameras can abstract and formalize reality, he makes pictures to question concepts of what is and what reality means. Incorporating disciplines from snapshot to document, Alinder acknowledges and proclaims how subversive a camera-given truth might be.

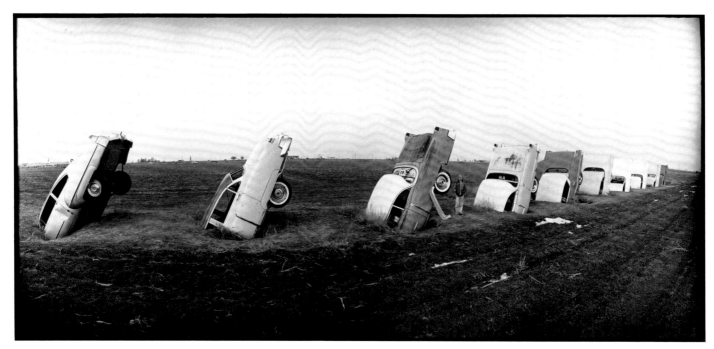

Ten Half-buried Cadilacs, Amarillo, Texas 1976
Courtesy of the artist

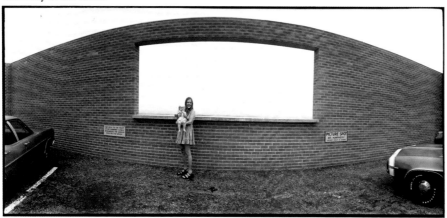

Picture Spot, Great Meteor Crater, Arizona 1970
Courtesy of the artist

LES KRIMS

Born 1943. Some early 1970s photographers discovered a subversion of reality with cameras. Others explored this possibility through subject matter. Krims created tableau settings in which he used psychologically overt images, where his contemporaries only made visual suggestions. He is also fascinated by photography's alliance to reproduction processes, and set up Humpy Press to make books and portfolios of his work.

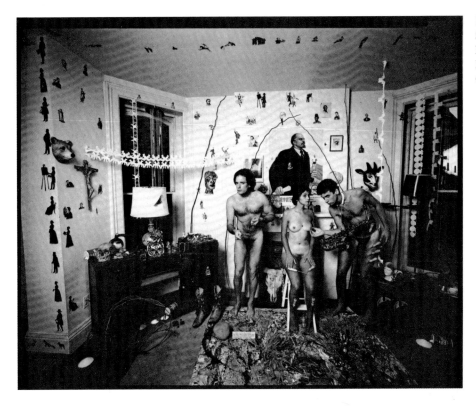

Les Krims Teaches Them to Do It Abe Reles Style: Ice Picks for Kid Twist; Black Dicks — a New Twist; and a Picture Designed to Piss-Off Danny 1980
Courtesy of the artist

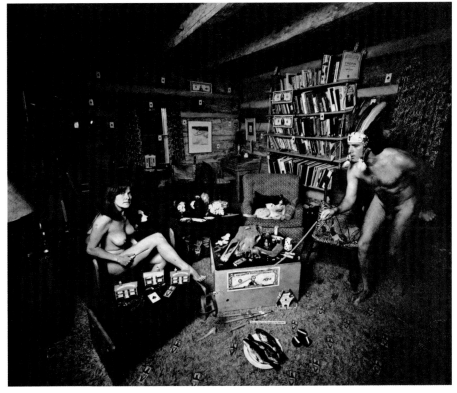

Menage à Trout; and a Thought for Kid Twist 1980
Courtesy of the artist

MARK COHEN

Born 1943. An investigator of the fragmentary vision that most people reserve for the corners of their eyes, Cohen uses the camera as a means to divide and subtract, thus creating images of what is felt rather than what might be seen and recorded. He took up what had been done by his predecessors in the 1960s, found it limiting, and pushed his camera to break boundaries.

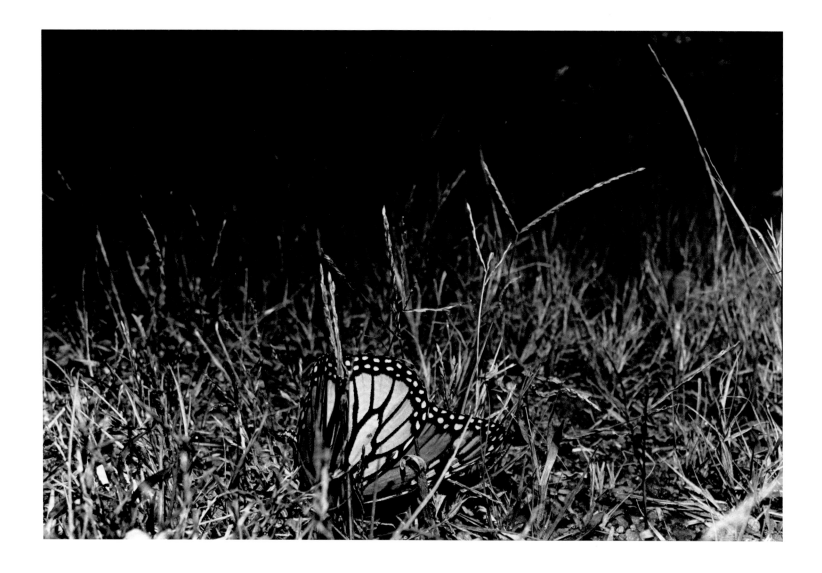

Untitled 1975
Courtesy of the artist

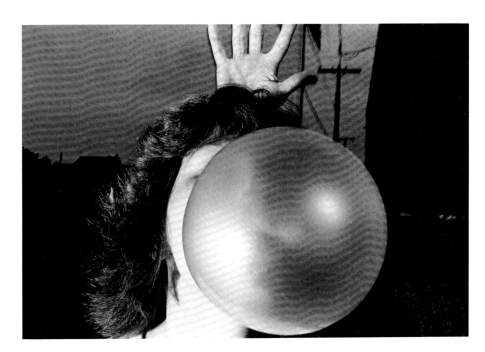

Untitled 1975
Courtesy of the artist

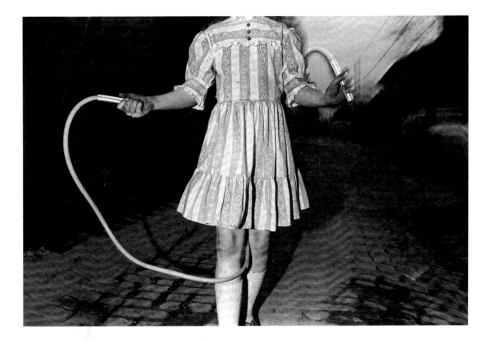

Untitled 1974
Courtesy of the artist

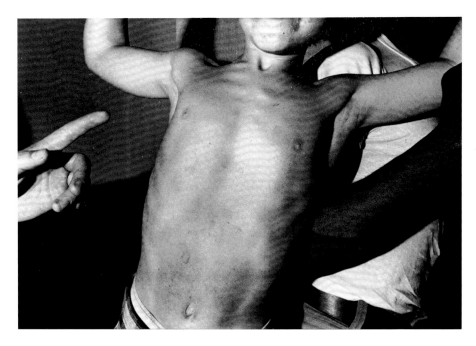

Untitled 1975
Courtesy of the artist

RALPH GIBSON

Born 1939. Gibson has three claims to photographic attention: his photographs, his books and his influence. Of the latter, Europe, rather than the USA, has been more touched by his graphic, constructivist findings. As a maker of books and publisher, he started the 1970s run on the book as a distinct and formal vehicle for photographers to use in showing their work. Lustrum Press, which Gibson founded to publish his first book in 1970, went on to produce the best photography books of that era. As a photographer, growing out of the emotionally expressive legacy of Robert Frank, his graphically defined images extended that tradition and pushed it towards unification with a broader visual avant-garde.

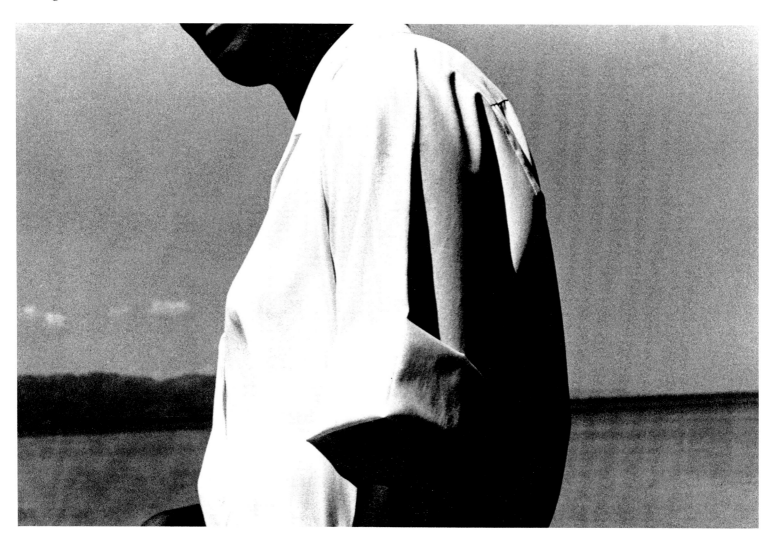

Untitled 1972
Courtesy of The Weston Gallery

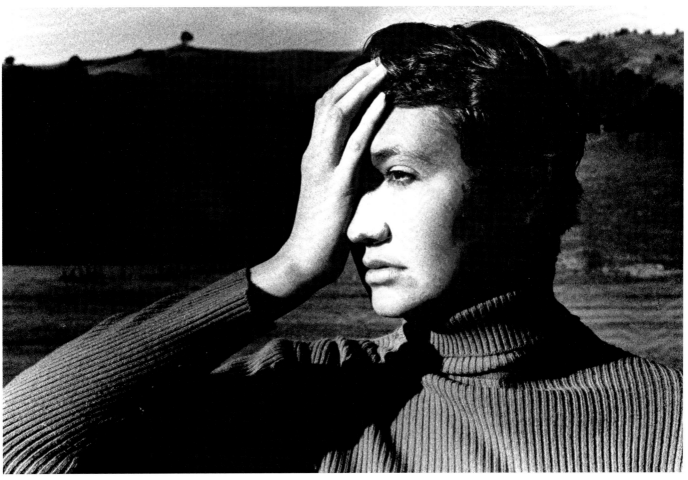

Untitled 1972
Courtesy of The Weston Gallery

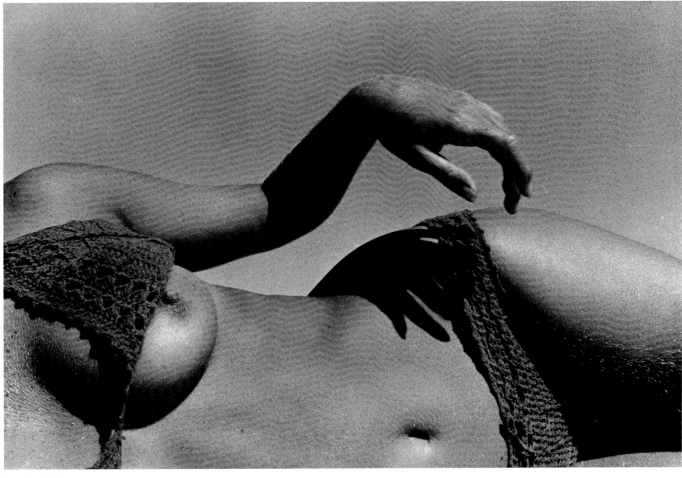

Untitled 1972
Courtesy of The Weston Gallery

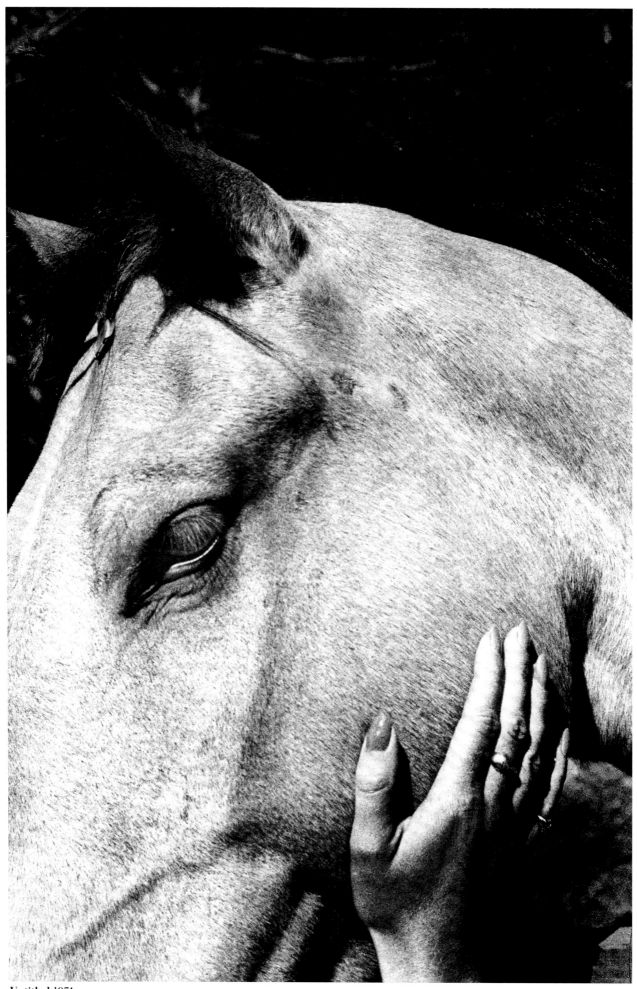

Untitled 1974
Courtesy of The Southland Corporation

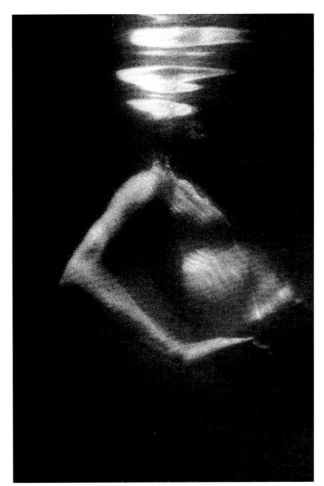

Untitled 1972
Courtesy of The Weston Gallery

Untitled 1972
Courtesy of The Weston Gallery

Untitled 1972
Courtesy of The Weston Gallery

Untitled 1972
Courtesy of The Weston Gallery

BILL OWENS

Born 1938. While many prominent photographers of the 1970s began exploring camera-made transformations, others saw possibilities in extending more traditional forms of picture-making. Committed to reportage but informed by contemporary developments, Owens began adding texts to his pictures, expanding and directing their informational content. His most widely-known work is Suburbia (1972), a document of the life-style of those who had inherited the American Dream.

Untitled c. 1971
Courtesy of the artist

'I enjoy giving a Tupperware party in my home. It gives me a chance to talk to my friends. But really, Tupperware is a homemaker's dream, you save time and money because your food keeps longer' c.1971
Courtesy of the artist

'How can I worry about the damned dishes when there are children dying in Vietnam' c.1971
Courtesy of the artist

'Sunday afternoon we get it together. I cook the steaks and my wife makes the salad' c.1971
Courtesy of the artist

176

LARRY CLARK

Born 1943. Larry Clark's book Tulsa (1971) had an impact on American photography comparable to The Americans by Robert Frank. Certainly, both works showed a side of the nation that the nation was unwilling to admit to. Clark's book, however, is autobiographical. A photographer, film-maker, rock singer and participator in sixties drug culture, he pictured his friends in Tulsa, Oklahoma. Their lives were ordered by sex and drugs and rock 'n roll, which he photographed with loving intimacy. What he showed frightened the uninitiated.

Untitled and undated from Tulsa 1971
Courtesy of The Freidus/Ordover Gallery

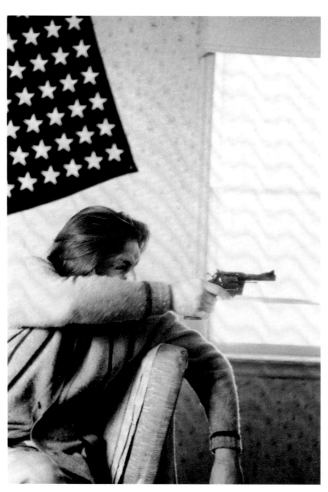

Untitled and undated from Tulsa 1971
Courtesy of The Friedus/Ordover Gallery

Untitled and undated from Tulsa 1971
Courtesy of The Freidus/Ordover Gallery

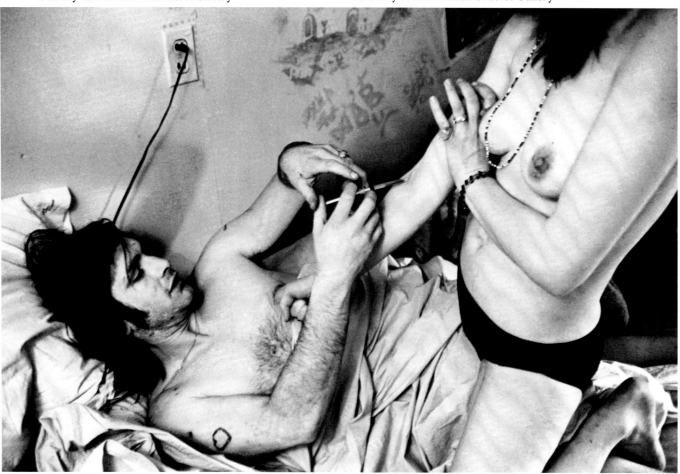

Untitled and undated from Tulsa 1971
Courtesy of The Freidus/Ordover Gallery

MARY ELLEN MARK

Born 1941. At a time when photographers retreated from journalism because their outlets vanished, victims of the popularity of television, Mark was one of the few who successfully continued to pursue it. Counting on an increased visual awareness in her audience, she used symbol, metaphor and compositional dynamics to bring still documentary into the 1970s.

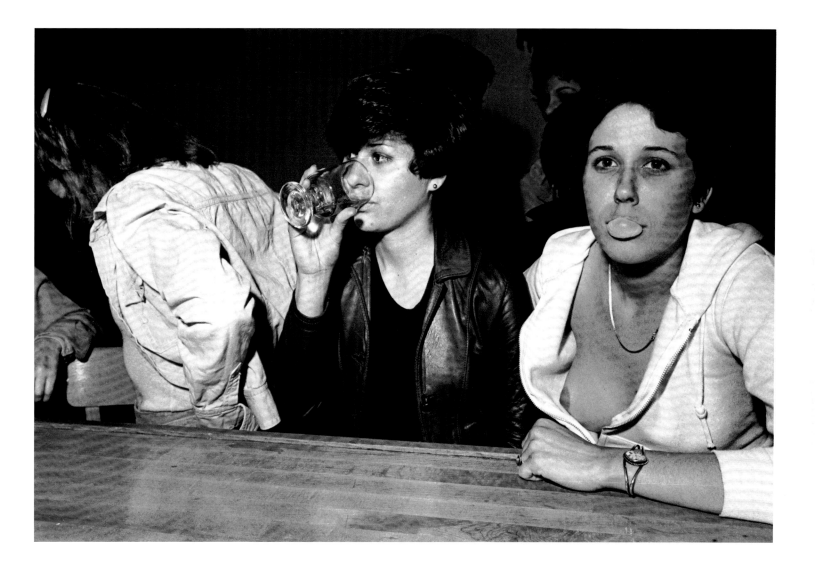

Singles Bar, New York 1977
Courtesy of the artist and Archive Pictures Inc.

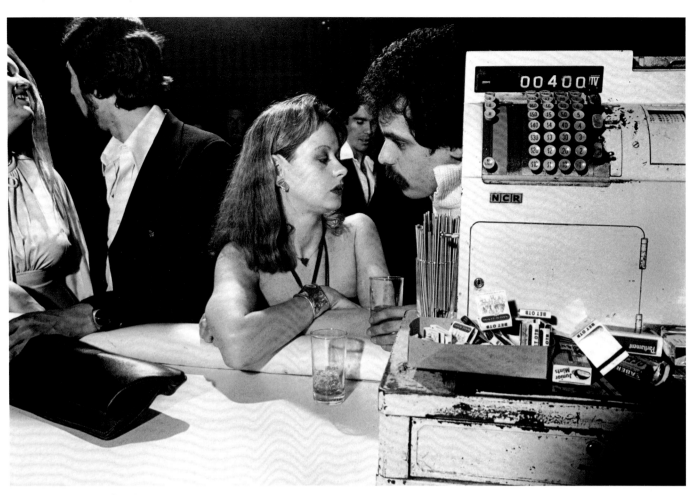

Singles Bar, New York 1977
Courtesy of the artist and Archive Pictures Inc.

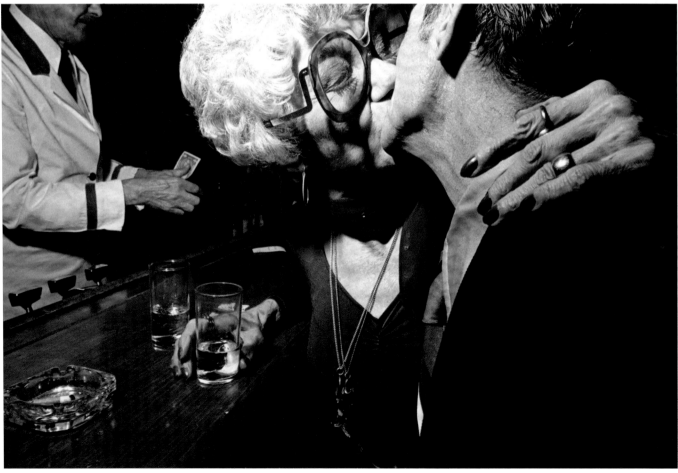

Singles Bar, New York 1977
Courtesy of the artist and Archive Pictures Inc.

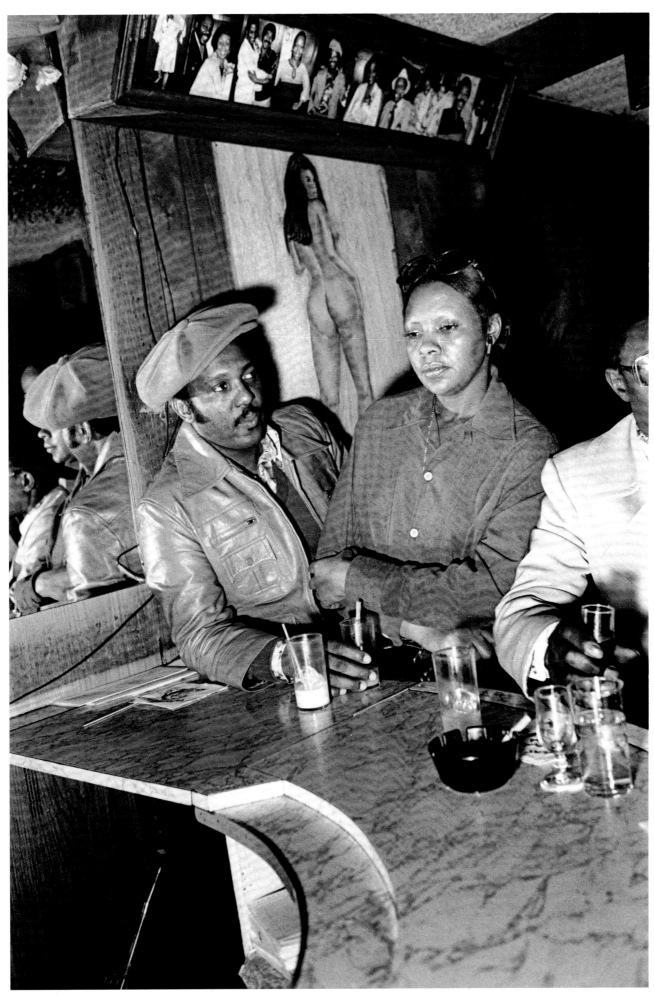

Singles Bar, New York 1977
Courtesy of the artist and Archive Pictures Inc.

LARRY FINK

Born 1941. Working as an artist and supported by teaching, Fink makes strong, square pictures — often using flash to catch gestures while bathing his subjects in revealing light. Like his teacher, Lisette Model, he could be described as a documentary photographer; but this would deny that his fact-filled pictures are concerned with him and the precision of his flash-lit seeing.

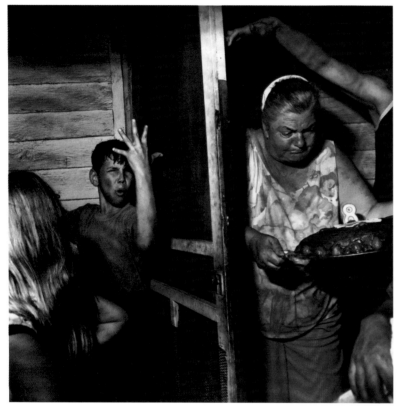

Birthday Party 1979
Courtesy of the Light Gallery

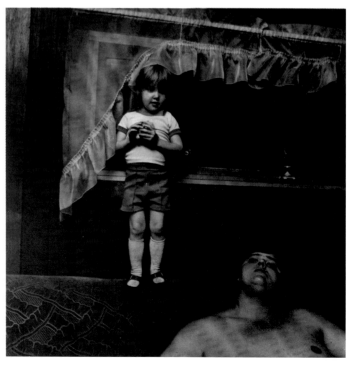

Martin's Creek 1980
Courtesy of the Light Gallery

TOD PAPAGEORGE

Born 1940. Papageorge's works evidence a sophisticated understanding of how subject-matter can be processed through a knowledge of the medium and its history. Texture, tonal sensuality and a love for accumulating detail are characteristic of his work.

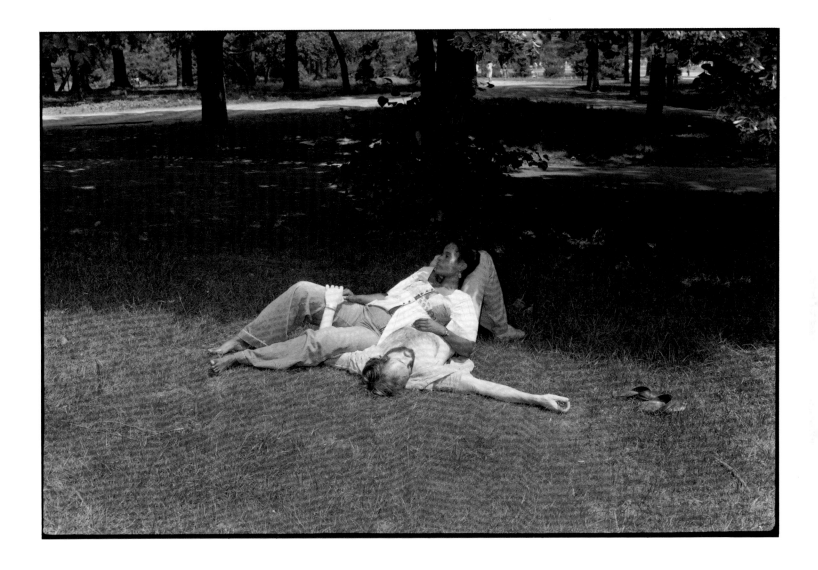

Central Park 1978
Courtesy of Daniel Wolf Inc., New York

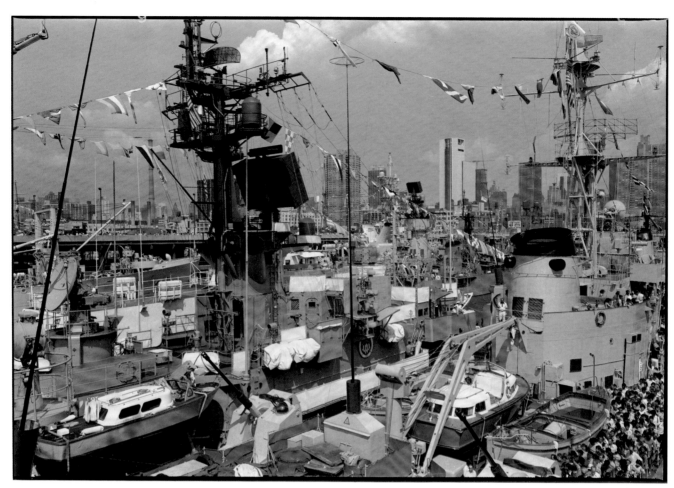

New York City Pier 1976
Courtesy of Daniel Wolf Inc., New York

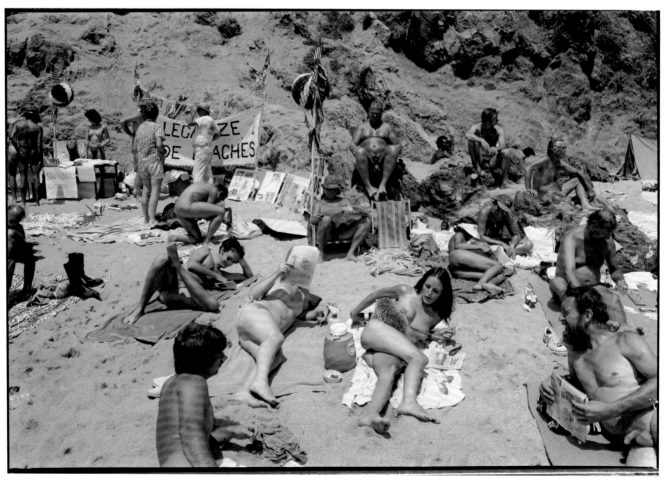

Zuma Beach 1978
Courtesy of Daniel Wolf Inc., New York

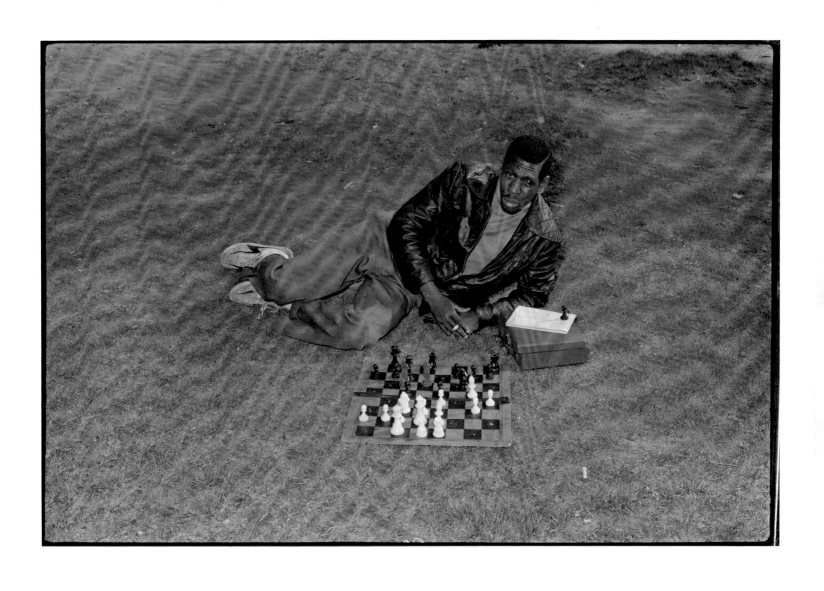

Central Park 1977
Courtesy of Daniel Wolf Inc., New York

ROGER MERTIN

Born 1942. Consciousness of the camera circumscribes Mertin's photographs. He is driven by its ability to re-present environmental facts and order them according to his own value system. In 1978 Charles Desmarais, critic and curator, wrote: 'Roger Mertin sees the blending of the natural and the controlled as the most potent symbol of our time and his embrace of that blend is the root of his basic optimism.'

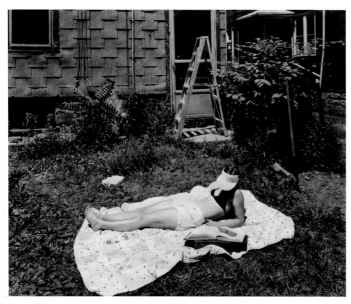

Michaela, Backyard, Rochester 1977
Courtesy of the artist

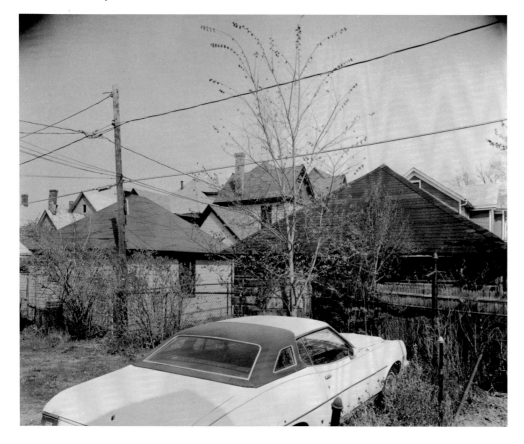

Backyard, Rochester 1977
Courtesy of the artist

HENRY WESSEL JNR

Born 1942. Space, or how photography records space in two dimensions, is important to Wessel's pictures. By manoeuvring himself and his camera, sometimes fractionally, he controls proportions and thus a viewer's attention to the object relationships he selects. The effect is to encourage an extraordinary view of what, without the camera, might seem commonplace.

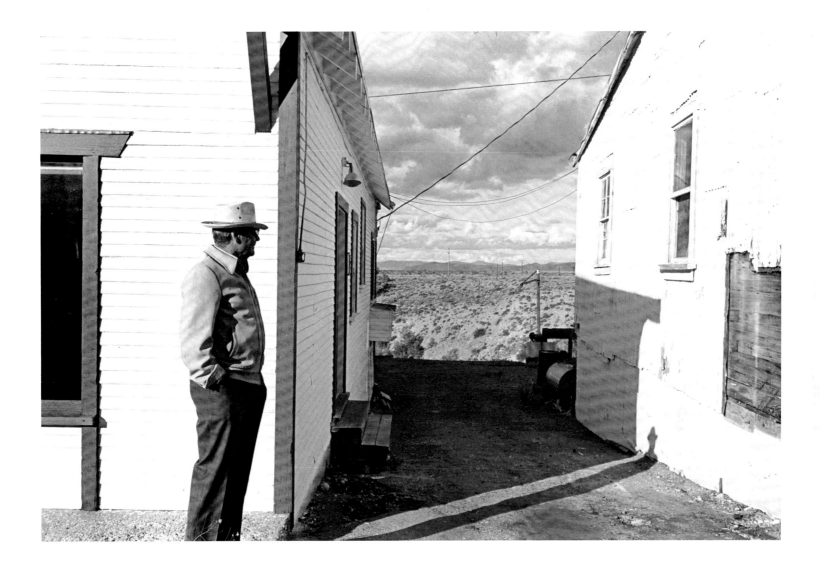

South-west 1973
Courtesy of the artist and Fraenkel Gallery

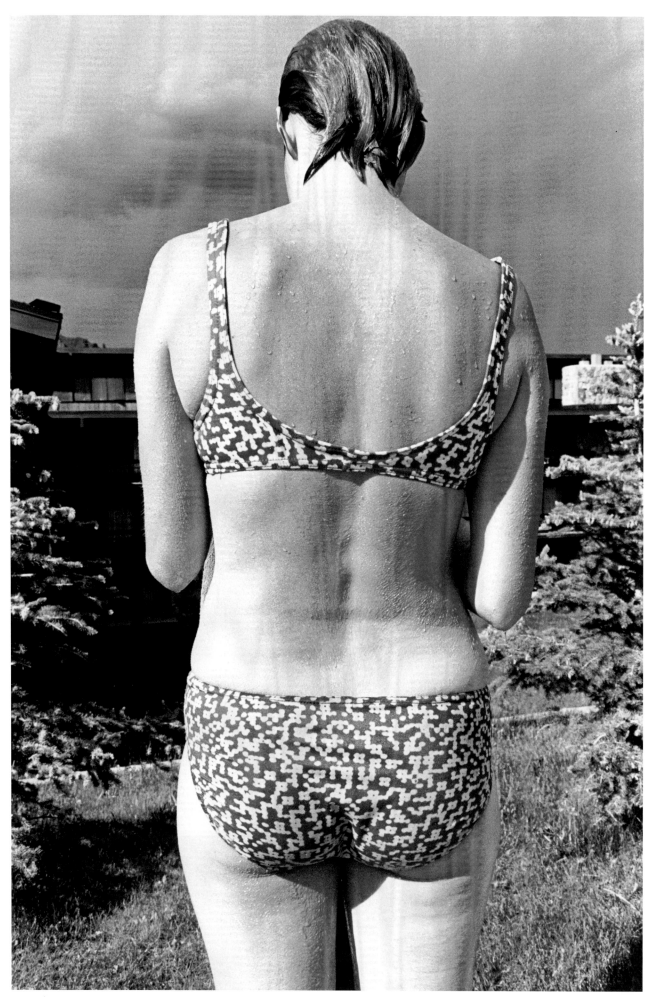

Colorado 1973
Courtesy of the artist and Fraenkel Gallery

EMMET GOWIN

Born 1941. Gowin studied with Callahan and Siskind and absorbed the influence of Frederick Sommer. He is a visualizer and philosopher, focusing on the ways in which what is private can have public meanings. Bound by the intensity of his craftsmanship, he has put forward intimate and human history as a means of explaining his own individual presence.

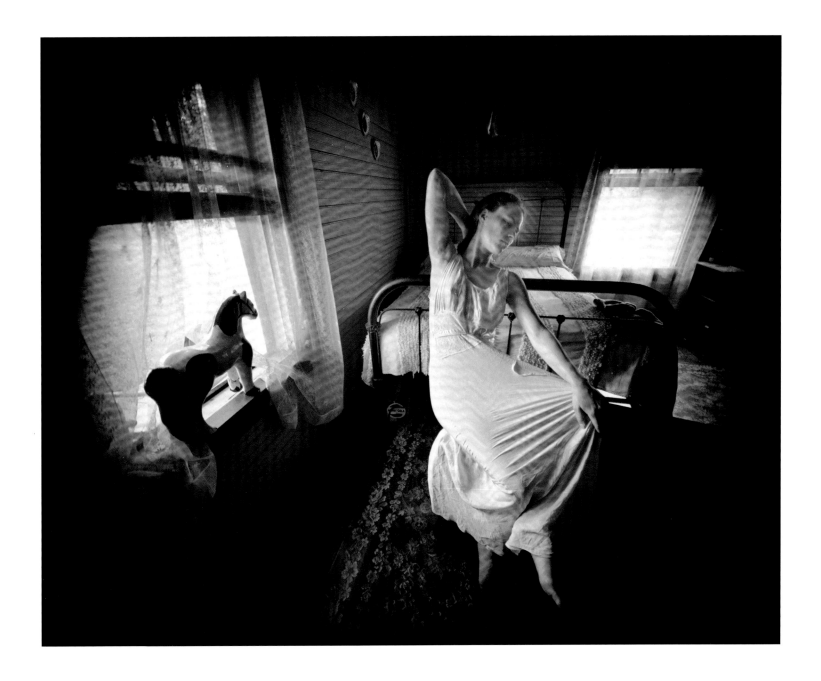

Edith, Danville, Virginia 1971
Courtesy of the artist

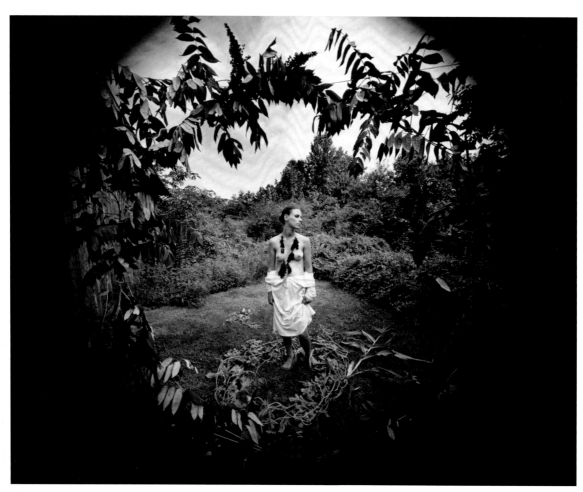

Edith, Danville, Virginia 1970
Courtesy of the artist

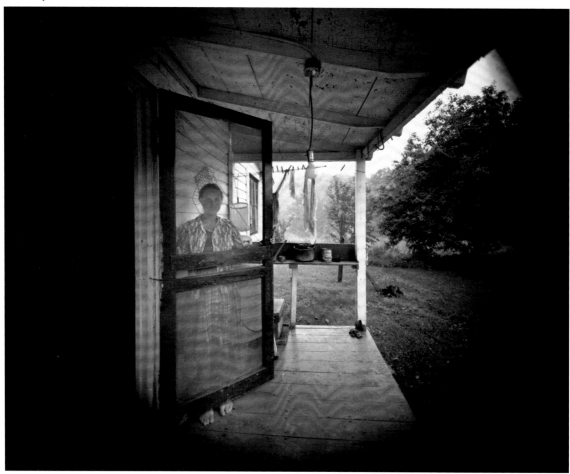

Edith, Danville, Virginia 1972
Courtesy of the artist

190

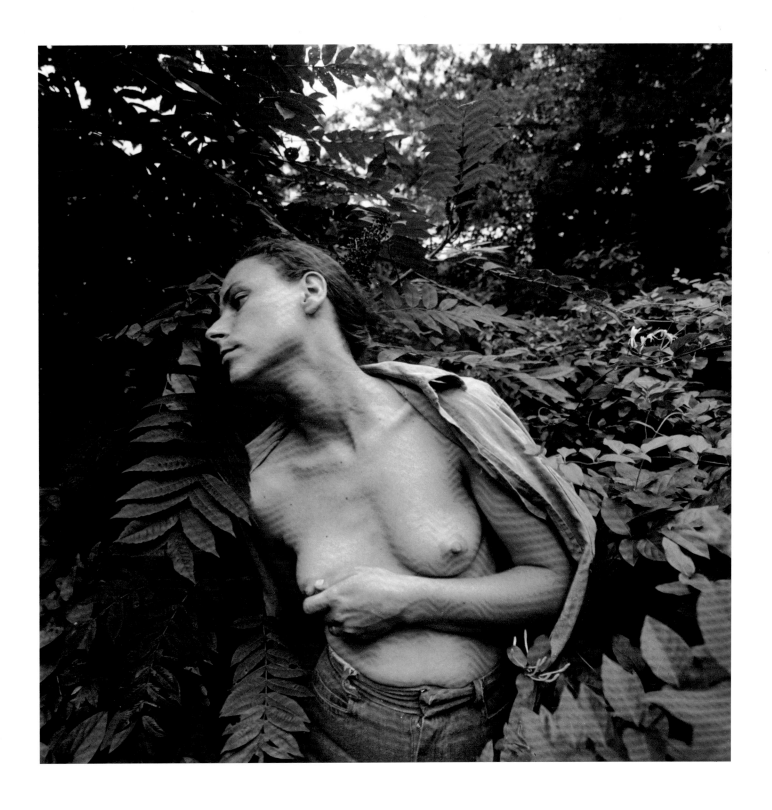

Edith, Danville, Virginia 1970
Courtesy of the artist

DUANE MICHALS

**Born 1932. Finding single images too limiting, Michals developed the
sequence as a vehicle for his philosophic concepts. He has been highly influential,
especially in Europe where his links with surrealism are generally appreciated.
'When you look at my photographs,' he once wrote, 'you are looking at my
thoughts ... I am the limits of my work; you are the limits of yours ... I believe in
the imagination. What I cannot see is infinitely more important than what I can.'**

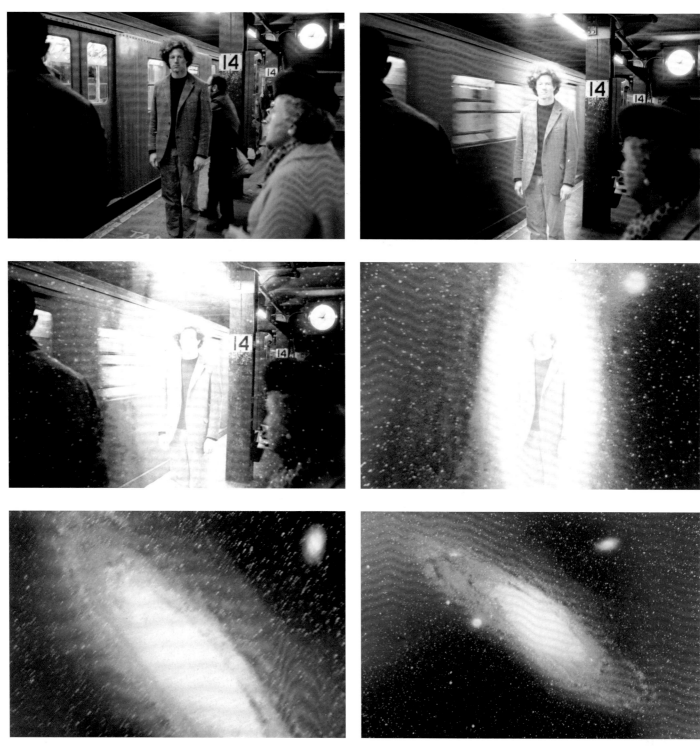

The Human Condition 1969
Courtesy of the artist

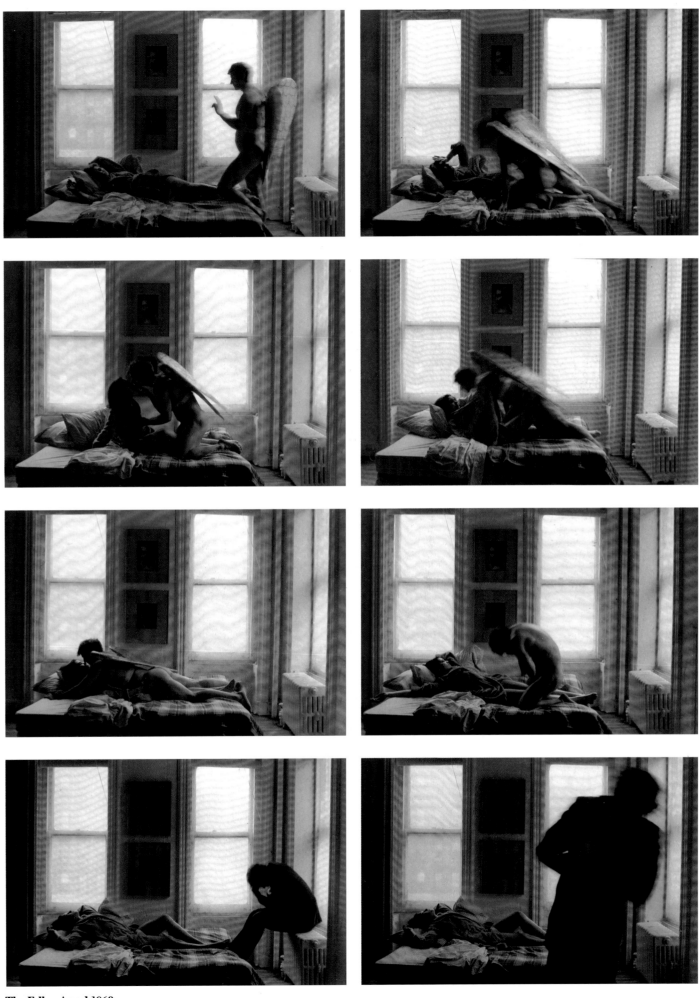

The Fallen Angel 1968
Courtesy of the artist

The Pleasures of the Glove, 1974
Courtesy of the artist

Although he had to walk blocks out of her way, it
had become a daily ritual with him to look in the
store window. He was strangely pleased to see that
they were still there.

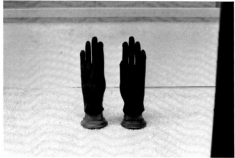

Of course it had occurred to him to buy the gloves, but
to own them would have ruined it. It would not be
the same.

He sat much too long staring at ~~them~~ his gloves.

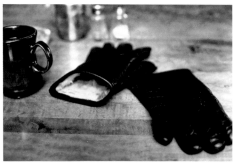

His eyes kept returning to the curious shape his
gloves had taken. One had become a queer furry
tunnel, all warm and dark inside.

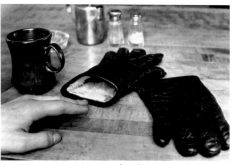

"How marvelous to let his hand enter the tunnel,"
he thought.

the glove swallowed his hand.

She sat there reading the "Times" wearing only one
glove

Absentmindedly she brought her hand to her hair

He could almost touch the glove

The hand in her glove became his hand

The hand moved slowly along the contours of her face

... and down her body.

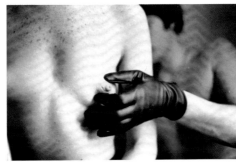

The glove did what it wanted to do.

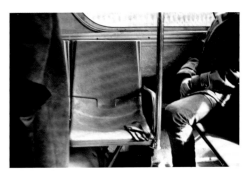

She rose abruptly leaving one glove

~~that~~

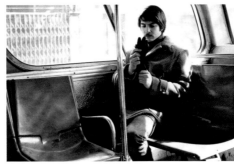

"How wonderful"

Take One and see Mt Fujiama 1975
Courtesy of the artist

Take One and see Mt Fujiyama

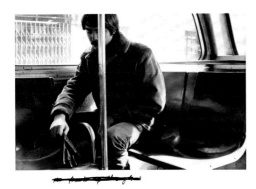

It was a hot day. The book was dull. He was bored.

Someone slipped an envelope under the door

There was something peculiar written on it.

Inside were some green pills and without any
hesitation he gulped down a pill.

He felt like a balloon with its air being let out.
Instantly he became six inches tall.

"The door squeaked behind him, as the largest woman
he had ever seen entered the room behind him.

195

She grew larger as she approached his chair. Soon she would be towering over him.

She appeared not to see him. He became excited by her size.

His excitement became terror, when he realized that she was going to sit on his chair and on him.

As her colossal ass descended upon him, he tried to run but was paralyzed. His tiny legs refused to move.

He stood frozen with excitement, as the leg behind settled down, closer and closer.

She sat on him!

Miraculously, in the darkness, he began to see the snow covered peak of Mt. Fujiyama.

196

ROBERT HEINECKEN

Born 1931. As photography grew in stature through the 1960s and early 70s its boundaries were slowly extended. Heinecken draws on his works, adds and subtracts colour, employs a variety of print-making and constructional techniques and ignores silver-print conventions. He was a strong contributor to the movement broadening the medium's conceptual base. Highly influential as an educator, he helped to break down barriers between media and create an important interdisciplinary dialogue.

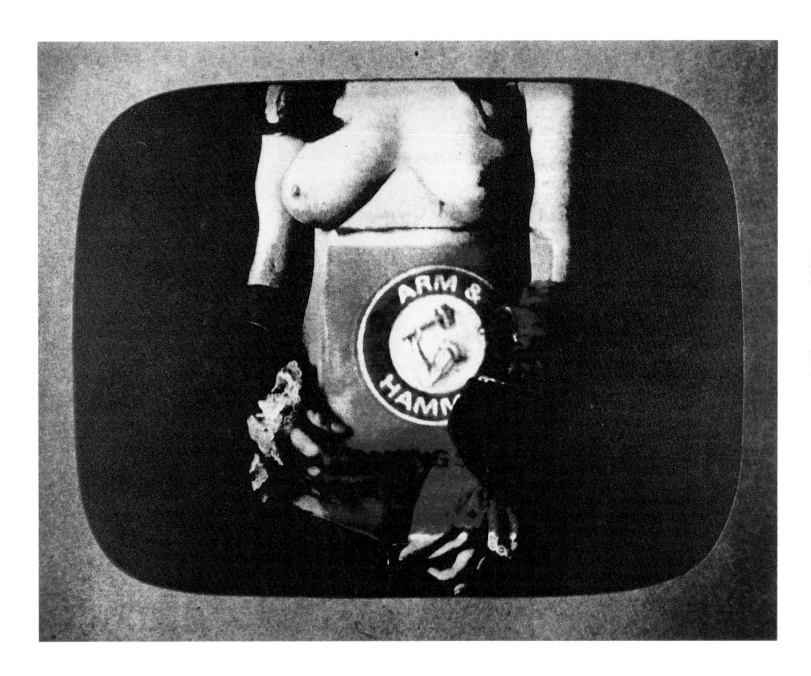

Daytime Color TV Fantasy/Arm & Hammer 1976
Courtesy of the artist

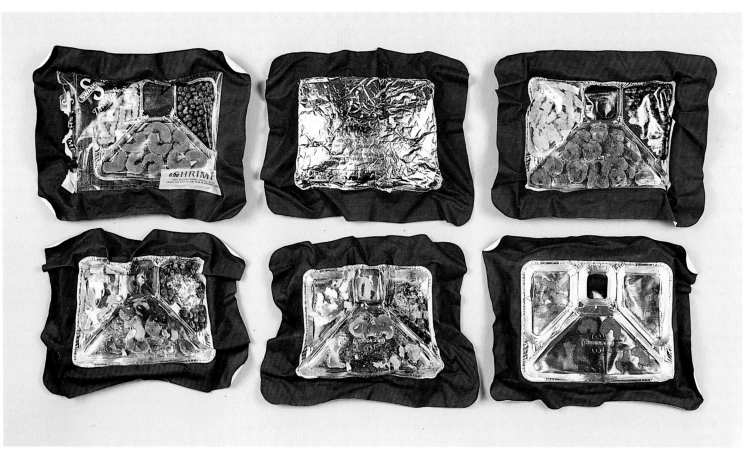

TV Dinner/Shrimp (six pieces) 1971
Courtesy of the artist

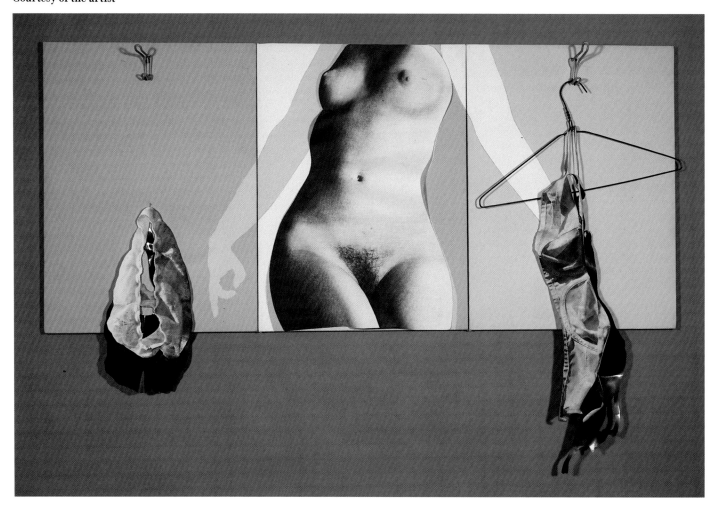

Lingerie for a Feminist Suntan no. 5 1972
Courtesy of the artist

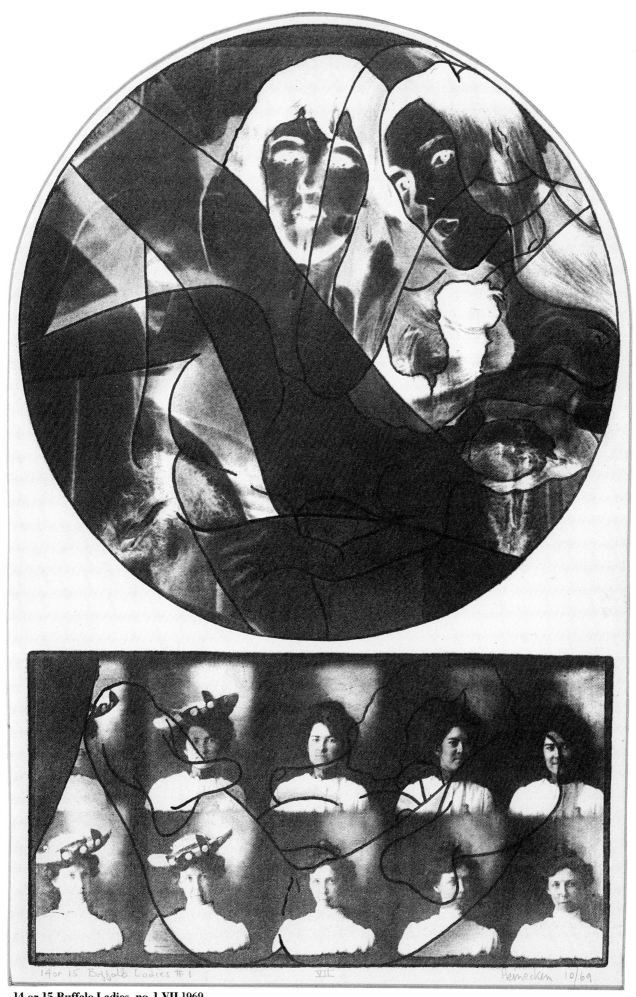

14 or 15 Buffalo Ladies, no. 1 VII 1969
Courtesy of the artist

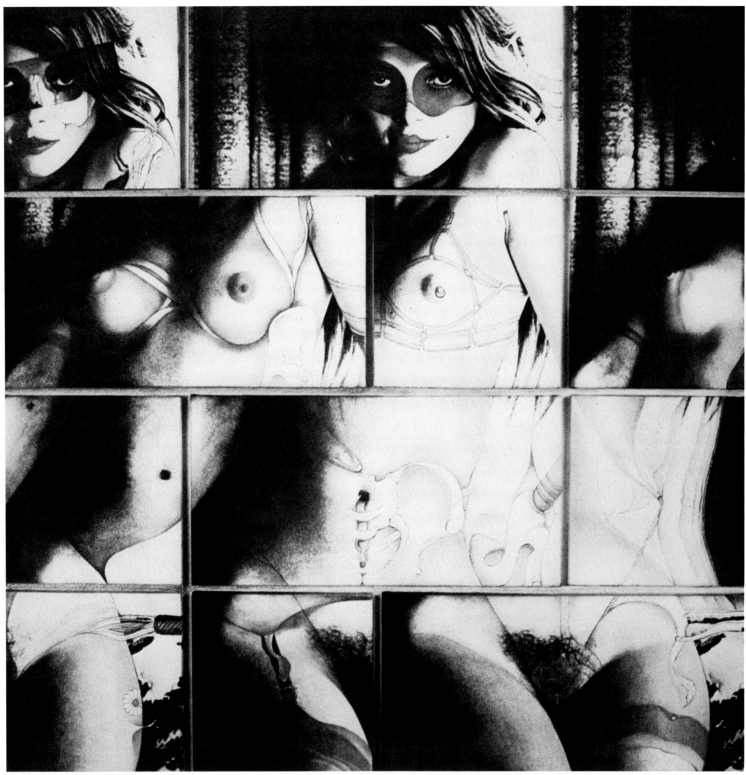

Vary Cliché/Fetishism 1978
Courtesy of the artist

200

JAN GROOVER

Born 1943. 'Formalism is everything' was Groover's comment in 1979. Taking as a model the machine-age works that emerged from 1920s and 30s modernism, she looked into the variety of forms and colour values possible in a controlled environment. The results are frequently sculptural and typological — there is no external reality to these pictures and yet they are seen to contain what is common.

Still Life 1980
Courtesy of the artist

Pears and Fish 1983
Courtesy of the artist

KEN JOSEPHSON

Born 1932. Photography creates its own realities, as several 1970s photographers recognized, among them Josephson. His pictures are about pictures — about considering reality as a concept as well as a physical presence. What we see is not what we think. What we think is not always born of what we think we see.

Washington DC 1975
Courtesy of the artist

Michigan 1981
Courtesy of the artist

THOMAS BARROW

Born 1938. Over and above his photographic works, Barrow has pursued the medium as a curator, writer, editor, designer and teacher. When his 'Cancellation Series' received a view as part of an exhibition called The Extended Document: An Investigation of Information and Evidence in Photographs (1975), people were shocked to see finely-rendered urban landscapes disfigured by an apparent act of violent negation. Many viewed this as a comment on the growing practice of limiting prints by scoring through the negative at the end of an edition. In fact Barrow's concerns were much more positive: 'These are photographs, not reality. They function within themselves' would be a more appropriate reading.

From the series **Cancellations, Truss Shadow** 1974
Courtesy of the artist

From the series **Cancellations, Pasadena Parallel** 1974
Courtesy of the artist

JOEL-PETER WITKIN

Born 1939. In 1983 Els Barents of the Stedelijk Museum, Amsterdam wrote an essay on Witkin. She likened him to Edgar Allan Poe who 'used perversity as the motif and motor of his stories', **described his method as that of an alchemist and wrote:** 'To watch things that both attract and repel one is an ambivalent affair, in which the interaction between emotions and reason is not only unstable, and therefore remains undecided, but besides it also brings about a paralyzing indecision. ... With the pictures he presents to us he undermines the opinions held in Western civilization about human dignity, individuality and death.'

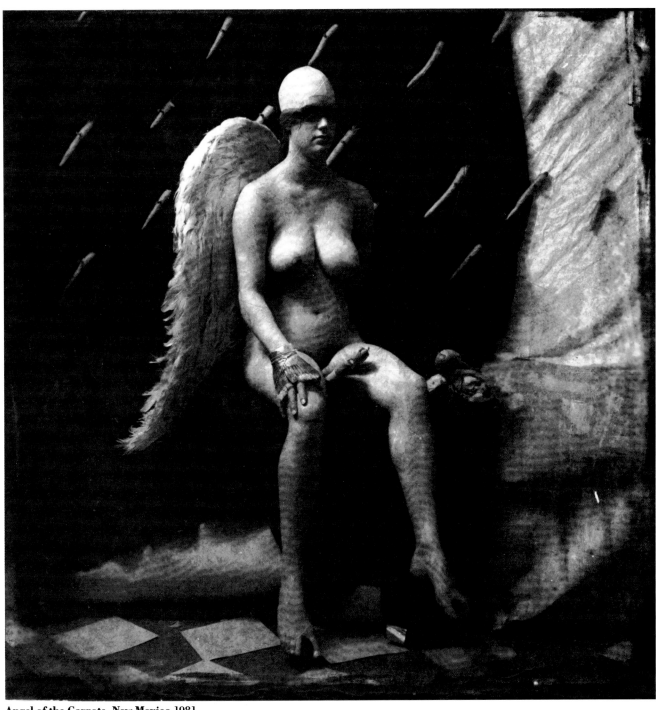

Angel of the Carrots, New Mexico 1981
Courtesy of the Pace/MacGill and Fraenkel Gallery

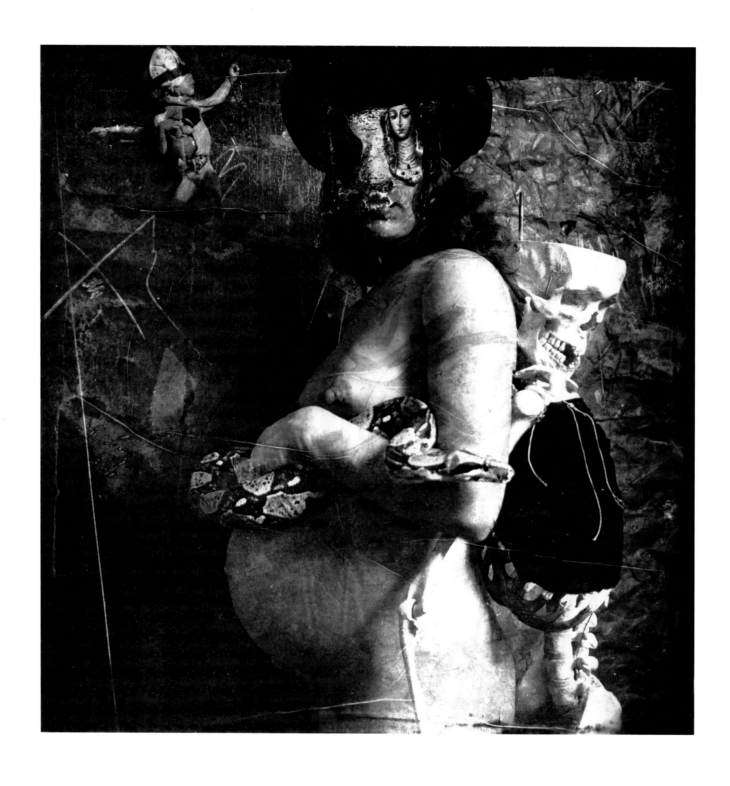

The Wife of Cain, New Mexico 1981
Courtesy of the Pace/MacGill and Fraenkel Gallery

WILLIAM LARSON

Born 1942. The effect of technology is a fascination for Larson. In the mid-1970s, when some of his contemporaries were exploring possibilities involving such image-generators as photo-copiers and die-line printers, he became involved in data processing. Using electronics and a Graphic Sciences Teleprinter, he sent pictures down a phone line to make his work. The image is not simply transformed by the process but created by it. Turned into an impulse, it can be added to electronically from a non-visual vocabulary.

Photo-transmission 1973
Courtesy of the artist

Photo-transmission 1974
Courtesy of the artist

ROBERT CUMMING

Born 1943. Cumming works in drawing, painting, sculpture, video,
photography and writing. His photographic pieces are based on the medium as a
documenter of ideas. As it happens, those ideas are bound up in how viewers
decode the information presented in photographs and so, although a conceptual
artist, he has been assimilated into the photographic community. Form, matter
and meaning are all parts of his iconography, together with a leavening of
humour and a sense of pictorial (as opposed to purely intellectual) purpose.

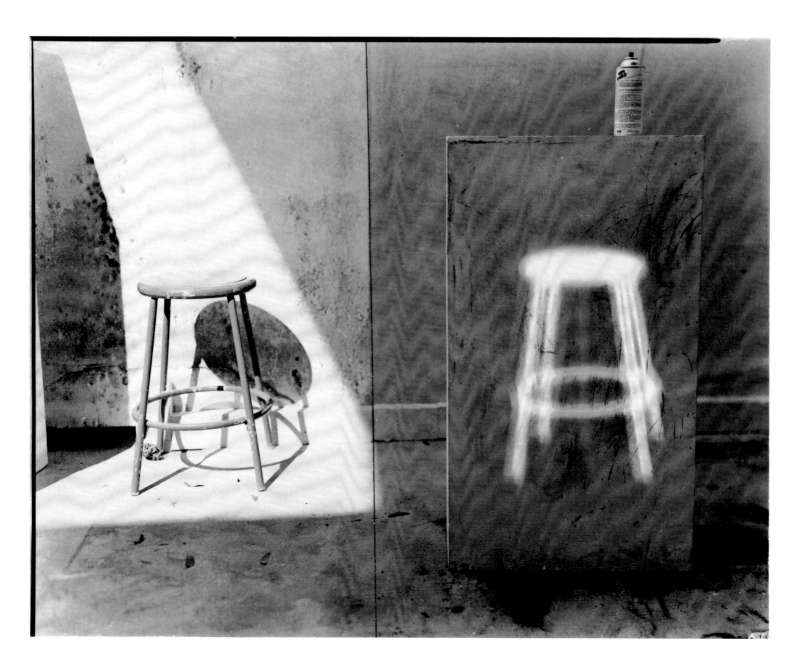

Quick Shift of the Head Leaves Glowing Stool After-image Posited on Pedestal 1978
Courtesy of the artist

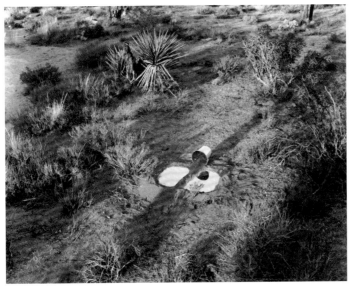

Two Explanations for a Small Split Pond 1974
Courtesy of the artist

Energy Transforms Matter 1977
Courtesy of the artist

Distracted in Mid-Stride; Spike-heeled Man Kneels to Read 1975
Courtesy of the artist

Zero plus Zero equals Zero
A Doughnut plus A Doughnut equals Two Doughnuts 1974
Courtesy of the artist

 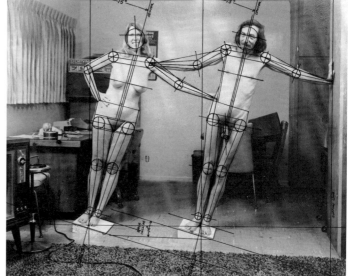

Leaning Structures 1975
Courtesy of the artist

OLIVIA PARKER

Born 1941. Drawing together remnants and leavings, Parker has created a photographic universe dependent on myth and evocation. Her pictures are assembled in the manner of still-lifes and made pregnant with possibility by tense or lyrical juxtapositions. Writing in 1978, Parker said: 'The expression of the classical ideals of form is dead matter for me. But even mortuary examples can come alive through time and human transformations.'

An Orderly Mind 1977
Courtesy of Brent Sikkima

Eliza 1977
Courtesy of Brent Sikkima

212

RICHARD MISRACH

Born 1949. There is a pressure in photography rapidly to define a personal style or signature and continue to develop and improve it. Misrach defies that notion, and has moved from an early, broadly humanist involvement to personal investigations into formalism. His concern is to see what cannot be seen without a camera. He uses flash to change his subjects and charge them with a sense of illusion dislodging them from common perceptual experience. Light, space and time are all parts of the photographic equation — in his cactus pictures, Misrach shifts each into a new relationship with the other.

Boojam Tree 1976
Courtesy of the artist

Ocotillo 1975
Courtesy of the artist

LINDA CONNOR

Born 1944. Much of photographic formalism is born of lucid, cool description. Connor, no less a formalist, is concerned with myth, symbol and evocation. In 1979 she wrote: 'My work has never been about temporal situations, I had always gravitated towards images that reveal the "essence" of something, the apparition of a form or idea.' Using photography's sense of immediacy, she calls up memories and mysteries that make the past ever-present.

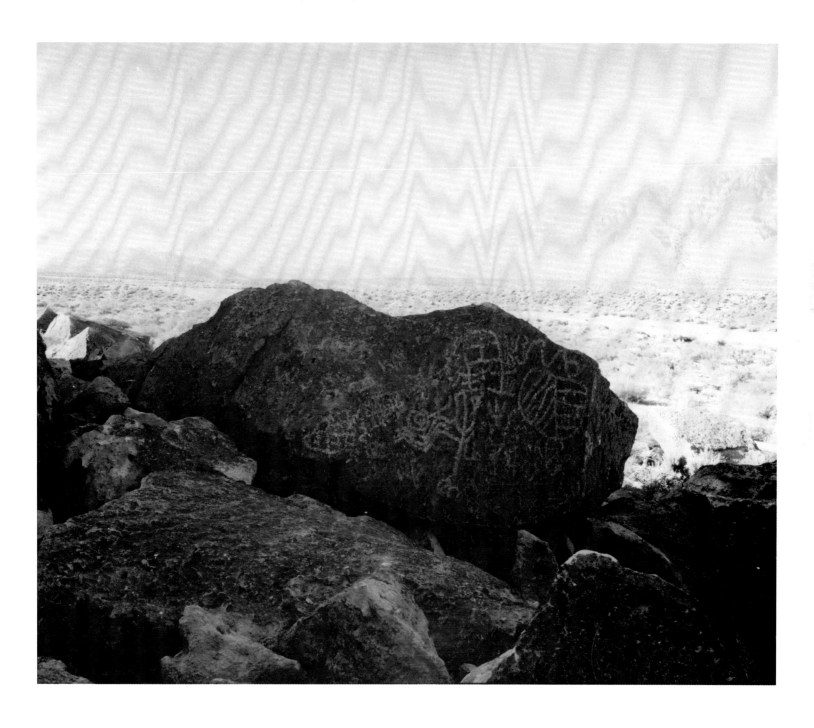

Petroglyphs near Bishop, California 1978
Courtesy of the artist

Untitled 1976
Courtesy of the artist

Untitled 1976
Courtesy of the artist

216

BILL DANE

Born 1938. Originally a painter and sculptor, Dane began taking photographs in 1970. Inspired by the ironies and visual strategies of Lee Friedlander he produced a remarkable series of images that deliberately played upon the ambitions and methods of commercial postcard manufacturers. Though thousands of his pictures have passed through post boxes, Dane does not properly belong to the category of 'Mail Artists', who operated in America and Europe in the early 1970s. They sought the democratization of photography among the avant-garde through the medium of the post. Dane is interested in using the postcard for his own visual ends.

San Francisco c.1980
Courtesy of the Fraenkel Gallery

Reverse side

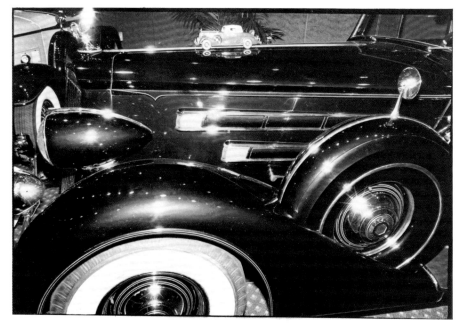

San Francisco c.1980
Courtesy of the Fraenkel Gallery

Reverse side

Hawaii c.1980
Courtesy of the Fraenkel Gallery

Reverse side

Buena Park, California c.1980
Courtesy of the Fraenkel Gallery

Reverse side

JOHN PFAHL

Born 1939. As an audience outside mass market magazines grew, so photographers felt more at liberty to make a critical exmination of their medium and isolate its particulars. Pfahl, recognizing how visually literate his world was becoming, developed a pictorial method based on perceptual confusion. He likes to play with visual beliefs, physically adding to what is in front of him. When three dimensions are reduced to two, inconsistencies become apparent and it is these that inform his work.

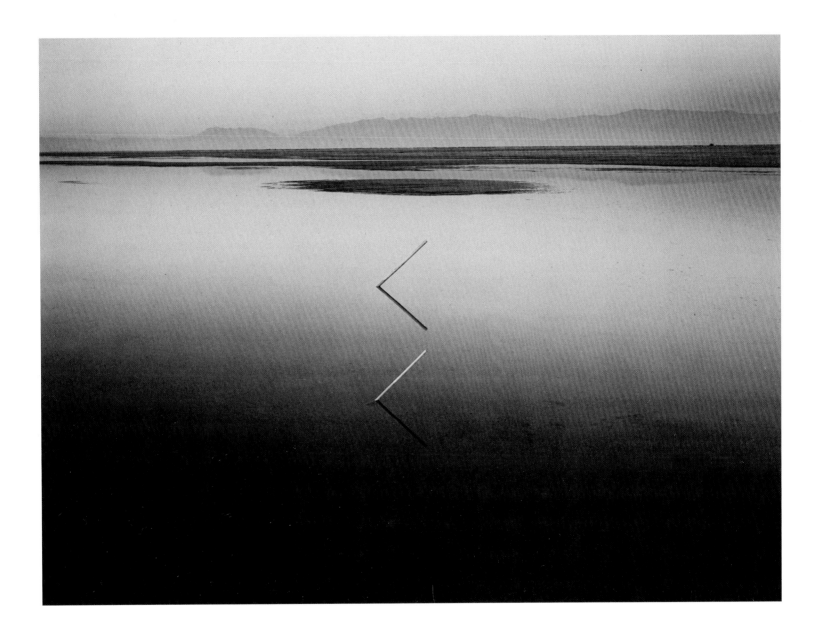

Great Salt Lake Angles, Great Salt Lake, Utah 1977
Courtesy of The Friedus/Ordover Gallery

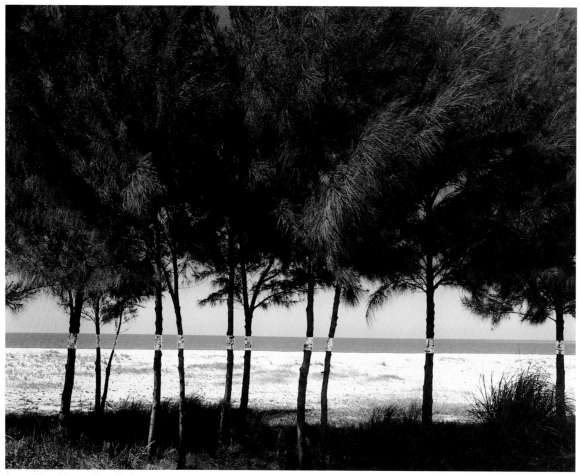

Australian Pines, Fort DeSoto, Florida 1977
Courtesy of The Friedus/Ordover Gallery

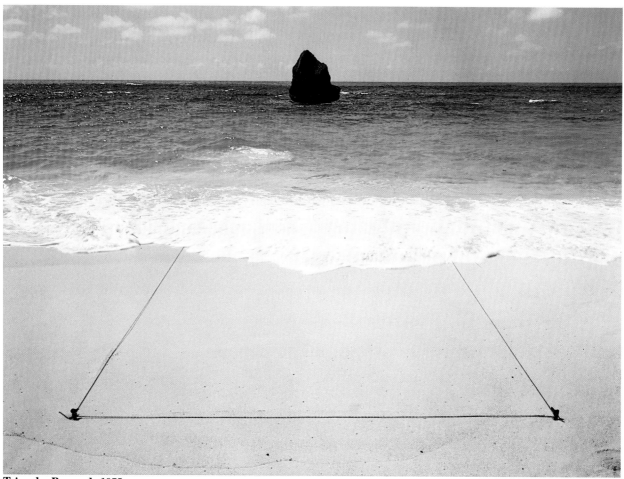

Triangle, Bermuda 1975
Courtesy of The Friedus/Ordover Gallery

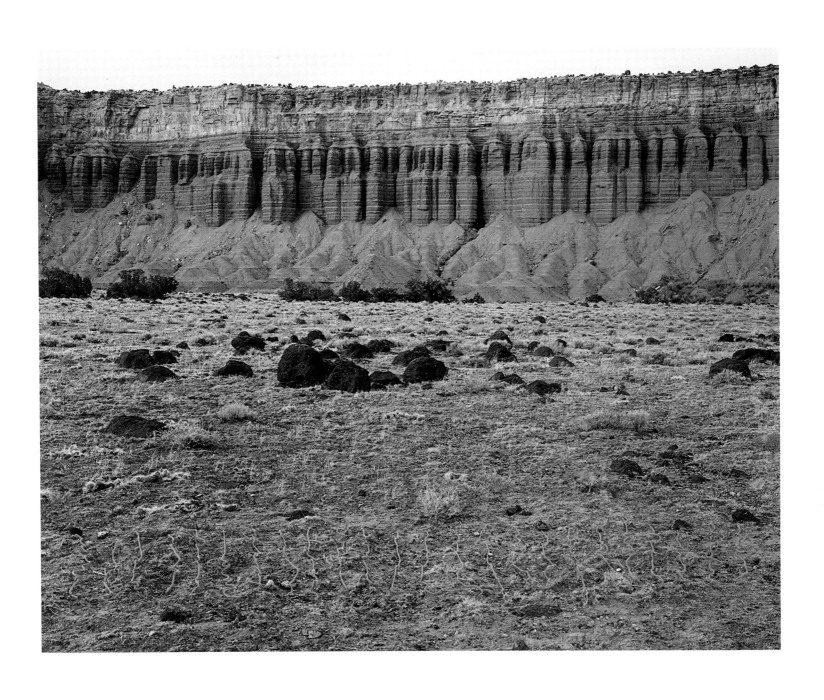

Red Rock Wall Repeat, Capitol Reef National Park, Utah 1977
Courtesy of The Friedus/Ordover Gallery

LUCAS SAMARAS

Born 1936. Sculpture and painting were the cradle of Samaras's photographic ideas. Successful in these fields, in 1969 he came upon the automatic and seemingly inviolable Polaroid system and began to explore photography as a means of making work. Playing with the then malleable chemistry of the SX-70 process, he created auto-portraits that took the ultimate snapshot medium into realms of grotesque symbolism. They are undeniably photographs, and yet no more nor less than themselves as objects.

Photo-transformation, 14 December 1976
Courtesy of the Pace/MacGill Gallery

Photo-transformation, 30 May 1976
Courtesy of the Pace/MacGill Gallery

Photo-transformation, 1 February, 1974
Courtesy of the Pace/MacGill Gallery

Photo-transformation, 21 July 1976
Courtesy of the Pace/MacGill Gallery

WILLIAM EGGLESTON

Born 1939. As photographing in colour became an issue during the 1970s, practitioners were polarized between its uses as a cool, descriptive medium and its capacity to add heat and vividness to their works. Eggleston chose the former. He produces large bodies of work, usually in America's South, thematically linked so that the particulars of each image might add to a general observation. Each image, however, has a specific and independent identity based on Eggleston's formal concerns with the problems of colour as a factor, not a fact, and his liking for what he photographs.

Louisiana Project 1981-2
Courtesy of the Middendorf Gallery

226

Louisiana Project 1981-2
Courtesy of the Middendorf Gallery

Louisiana Project 1981-2
Courtesy of the Middendorf Gallery

Louisiana Project 1981-2
Courtesy of the Middendorf Gallery

Louisiana Project 1981-2
Courtesy of the Middendorf Gallery

Louisiana Project 1981-2
Courtesy of the Middendorf Gallery

Louisiana Project 1981-2
Courtesy of the Middendorf Gallery

Louisiana Project 1981-2
Courtesy of the Middendorf Gallery

WILLIAM CHRISTENBERRY

Born 1936. It was Walker Evans who encouraged Christenberry to see his photographs, made in the service of painting and sculpture, as art in themselves. In 1972 Evans wrote: 'They seem to write a new little social and architectural history about one regional America (the Deep South). In addition to that, each one is a poem.' Christenberry uses this poetic sensibility to overlay each of his records with a sense of paradox. In this respect the nominal naturalness of colour is put to work against the grain, creating a sense of fiction out of matters of fact.

China Grove Church, Hale County, Alabama 1979
Courtesy of the Middendorf Gallery

JOEL STERNFELD

Born 1944. Contradictions seem at the root of Sternfeld's work. His large photographs contain considerable detail, but require careful reading if the facts are to emerge. Many of them are touched with irony and deal in disaster, yet little emotion seems present. And they are visually restrained yet their subject matter brings expectations of drama. It has been suggested that they function metaphorically and are a commentary on contemporary civilization. This would explain their need to contain contradictions.

McLean, Virginia 1978
Courtesy of Daniel Wolf Inc., New York

Exhausted Renegade Elephant, Woodland, WA 1979
Courtesy of Daniel Wolf Inc., New York

JOEL MEYEROWITZ

Born 1938. Joel Meyerowitz was an advertising art director. In 1962 he worked alongside Robert Frank and was so affected by the experience that he took up photography himself. He began by photographing street-life and has retained this interest while developing a separate formalism with a view camera. Colour is exciting to Meyerowitz, it 'suggests more things to look at'. Like a speed-reader he picks up the syntax of the city, throwing a linking frame around colours and gestures, stilling them into the coherence particular to photography.

Sixth Avenue, New York 1974
Courtesy of the artist

Fifth Avenue and 52nd Street, New York 1974
Courtesy of the artist

Madison Avenue and 60th Street, New York 1976
Courtesy of the artist

Broadway and West 46th Street, New York 1976
Courtesy of the artist

STEPHEN SHORE

Born 1947. With his clean, serene, precise and understated pictures, Shore has proved one of the more emulated recent photographers. He photographs things as they are, not for their intrinsic merit but because he can turn them into pictures. In 1979 John Szarkowski of the Museum of Modern Art wrote: 'His pictures, for all their complexity, for all their coolness have a distinctive, personal character. A Shore picture is very classical in spirit, very quiet, very poised, very much at rest, very much having to do with the moments between events, and yet very potential. Not boring, not empty – but suspended.'

US 93, Lingman, Arizona 1975
Courtesy of the Pace/MacGill Gallery

Church Street at 2nd Street, Eastern Pennsylvania 1974
Courtesy of the Pace/MacGill Gallery

Holden Street, North Adams, Massachusetts 1974
Courtesy of the Pace/MacGill Gallery

Country Club Road, Tucson, Arizona 1976
Courtesy of the Pace/MacGill Gallery

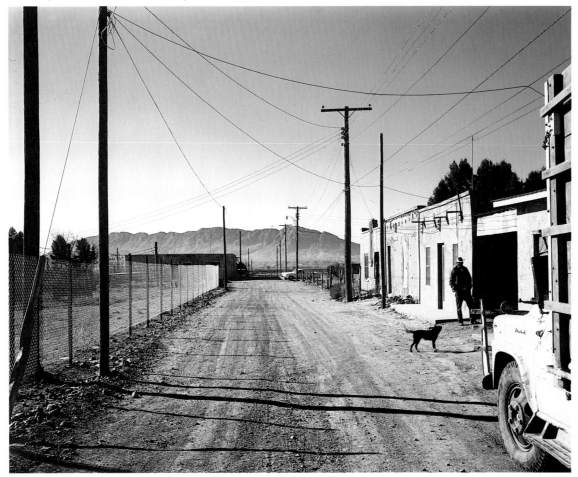

Presido, Texas 1975
Courtesy of the Pace/MacGill Gallery

Broad Street, Regina, Saskatchewan 1974
Courtesy of the Pace/MacGill Gallery

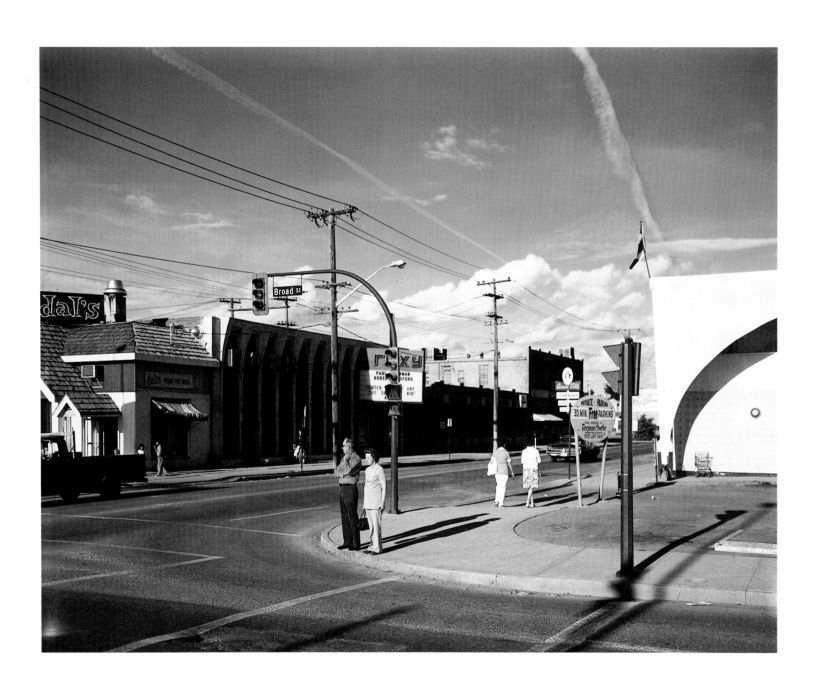

JOHN GOSSAGE

Born 1946. In a country where land is immense, powerful, dominant and under attack, Gossage photographs backyards. Trees, shrubs, fences and flower-beds — landscapes in miniature, they are man-made, display a kind of botanic craziness and serve as microcosms of his inheritance. He presents them as structurally complex and individually, photographically, beautiful; which is part of that gift too. The land has often served as a metaphor for the human spirit and the city a sign of fleshly decline. Gossage depicts a battle between the two, using visual literacy as a mediator.

Los Angeles, California 1980
Courtesy of Castelli Graphics, New York

Seattle, Washington 1979
Courtesy of Castelli Graphics, New York

Washington DC 1977
Courtesy of Castelli Graphics, New York

Washington DC 1978
Courtesy of Castelli Graphics, New York

JOE DEAL

Born 1947. Deal is one of a number of photographers described as 'New Topographers'. In the 1975 exhibition catalogue which first defined them as a movement he wrote of his intentions, saying: 'The most extraordinary images might be the most prosaic, with a minimum of interference (i.e. personal preference, moral judgement) by the photographer.' After years of debate some photographers were once again saying 'Let the fact speak for itself'. With severity rather than overt outrage he points his camera down from high vantage points upon the housing developments constructed at the edge of Los Angeles.

Backyard, Diamond Bar, California 1980
Courtesy of the artist

Backyard, Diamond Bar, California 1980
Courtesy of the artist

Backyard, Diamond Bar, California 1980
Courtesy of the artist

Backyard, Diamond Bar, California 1980
Courtesy of the artist

LEWIS BALTZ

Born 1945. Like Deal, Baltz is defined as a taker of topographic views. His work is conceived of and produced in groups. Park City is the most extensive — an exercise in thorough documentation which describes in painful detail man's brutality to the land. Gus Blaisdell collaborated as writer with Baltz on the project as a book (1980). He said then: 'What is shown is that this less distinguished society, which is ourselves, has the power to overwhelm nature, depriving her of her apocalypses. Yet we forget that in subduing her we also destroy a part of ourselves, albeit one which is hidden, private and unknown – a part we do not understand. So we avenge our ignorance.' **That Baltz invests his works with a cool, graphic resonance is a testament to the influence of Walker Evans, who examined America's myths of land and man in collision, and to Baltz's own faith in the future.**

Park Meadows, Subdivision 5, looking West 1978
Courtesy of the artist

246

Lot 123, Prospector Park, Subdivision Phase 3, looking North-west
1978 Courtesy of the artist

Lot 105, Prospector Village, looking North 1978
Courtesy of the artist

Lot 65, Park Meadows, Subdivision 2, looking East 1978
Courtesy of the artist

Lot 81, Prospector Village, looking South-east 1978
Courtesy of the artist

Between Sidewinder Road and State Highway 248, looking North
1978 Courtesy of the artist

Snowflower Condominiums During Construction, looking West 1978
Courtesy of the artist

Snowflower Condominiums During Construction, looking East 1978
Courtesy of the artist

ROBERT ADAMS

Born 1937. One of the 'New Topographer' group, Adams made pictures that are frequently concerned with dualities — how the land endures the domesticating influence of man. He views the Western landscape and looks for its redemptive qualities with subtle, understated formalism, reminiscent of those nineteenth-century photographers for whom it was a great frontier. Concerned above all for the future, he applies a basic optimism to this work. In 1981 Adams wrote 'The darkness that art combats is the ultimate one, the conclusion that life is without worth and finally better off ended. Photography as art ... works to convince us of life's value.'

Nebraska State Highway 2, Box Butte County, Nebraska 1979
Courtesy of the artist

East from Flagstaff Mountain, Boulder County, Colorado 1979
Courtesy of the artist

South Table Mountain, above Golden, Colorado 1979
Courtesy of the artist

Clear-cut and Burned, East of Arch Cape, Oregon 1979
Courtesy of the artist

Santa Ana Wash, Norton Air Force Base, California 1979
Courtesy of the artist

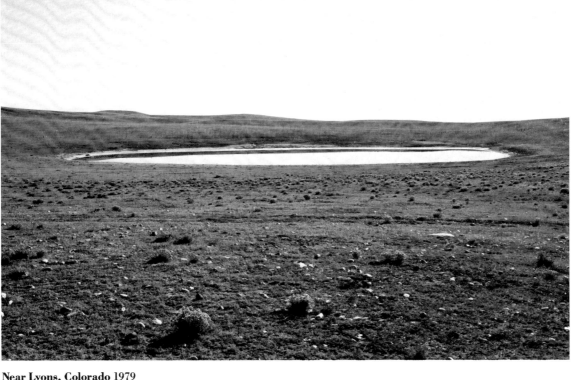

Near Lyons, Colorado 1979
Courtesy of the artist

CINDY SHERMAN

Born 1954. With photography absorbed into the avant-garde of contemporary art, some practitioners have drawn their ideas from a broader span than the medium alone. Performance art is closely related to Sherman's work, as are issues such as feminism, sexual role-casting and meaning through photographic representation. She is her own subject, not as artist but as model or film-star. Sherman was born into a media-rich world and has learnt the photographic parallels between fact and fiction.

Untitled Film Still 1980
Courtesy of Metro Pictures

Untitled Film Still 1978
Courtesy of Metro Pictures

SELECT BIBLIOGRAPHY

Ackley, Clifford S. (ed.), **Private Realities: Recent American Photography** Museum of Fine Arts, Boston, 1974.

Adams, Ansel, **Ansel Adams Images, 1923-74** New York Graphic Society, Boston, 1974.

Adams, Robert, **From the Missouri West** Aperture, Millerton, New York, 1980.

Alinder, Jim, **Picture America** New York Graphic Society, Boston 1982.

Arbus, Diane, **Diane Arbus** Allen Lane, London, 1974.

Baltz, Lewis (ed.), **Contemporary American Photographic Works** Museum of Fine Arts, Houston, Texas, 1977.

Baltz, Lewis, **Park City** Artspace/Castelli Graphics, New York, 1980.

Barrow, Thomas, *et.al.* (eds), **Reading Into Photography: Selected Essays, 1959-80** University of New Mexico Press, Albuquerque, 1982.

Bullock, Wynn, **Wynn Bullock: Photographing the Nude. The Beginnings of a Quest for Meaning** Peregrine Smith, Utah, 1984.

Callahan, Harry, **Harry Callahan** Aperture, Millerton, New York, 1976.

Caponigro, Paul, **Landscapes** McGraw-Hill, New York, 1975.

Chiarenza, Carl, **Aaron Siskind: Pleasures and Terrors** New York Graphic Society, Boston, 1982.

Christenberry, William, **William Christenberry: Southern Photographs** Aperture, Millerton, New York, 1983.

Clark, Larry, **Tulsa** Lustrum Press, New York, 1971.

Cohen, Joyce Tennison (ed.), **In/Sights: Self Portraits by Women** Gordon Fraser, London, 1979.

Coke, Van Deren, **The Painter and the Photograph** University of New Mexico Press, Albuquerque, 1964.

Connor, Linda, **Solos** Apiron Workshops, Millerton, New York, 1979.

Cumming, Robert, **Cumming Photographs** The Friends of Photography, Carmel, California, 1979.

Cunningham, Imogen, **Imogen! ... Photographs 1910-73** University of Washington Press, Seattle, 1974.

Danese, Renato (ed.), **American Images: New Work by Twenty Contemporary Photographers** McGraw-Hill, New York, 1979.

Davidson, Bruce, **Bruce Davidson Photographs** Agrinde, New York, 1979.

DeCarava, Roy, **Roy DeCarava: Photographs** The Museum of Fine Arts, Houston, Texas, 1975.

Diamonstein, Barbaralee (ed.), **Visions and Images** Travelling Light, London, 1982.

Doty, Robert (ed.), **Photography in America** Thames & Hudson, London, 1974.

Eauclair, Sally, **The New Color Photography** Abbeville Press, New York, 1981.

Edey, Maitland, **Great Photographic Essays from 'Life'** New York Graphic Society, Boston, 1978.

Eggleston, William, **William Eggleston's Guide** Museum of Modern Art, New York, 1976.

Erwitt, Elliott, **Recent Developments** Simon & Schuster, New York, 1978.

Faurer, Louis, **Louis Faurer Photographs from Philadelphia and New York, 1937-73** University of Maryland Art Gallery, Maryland, 1981.

Fink, Larry, **Social Graces** Aperture, Millerton, New York, 1984.

Frank, Robert, **The Americans** Aperture, Millerton, New York, 1978.

Freed, Leonard, **Black in White America** Grossman, New York, 1968.

Friedlander, Lee, **Lee Friedlander Photographs** Haywire Press, New York, 1978.

Gassan, Arnold, **A Chronology of Photography** Handbook Company, Athens, Ohio, 1972.

Gee, Helen (ed.), **Photography of the Fifties: An American Perspective** Center for Creative Photography, the University of Arizona, 1980.

Gibson, Ralph, **Syntax** Lustrum Press, New York, 1983.

Gossage, John, *et.al.* (eds), **14 American Photographers** The Baltimore Museum of Art, Maryland, 1974.

Gowin, Emmet, **Emmet Gowin: Photographs** Alfred A. Knopf, New York, 1976.

Green, Jonathan, **American Photography: A Critical History** Harry N. Abrams, New York, 1984.

Green, Jonathan (ed.), **The Snapshot** Aperture, Millerton, New York, 1974.

Gruber, Fritz and Renate, **The Imaginary Photo Museum** Penguin Books, London, 1982.

Guttman, John, **The Restless Decade** Harry N. Abrams, New York, 1984.

Harbutt, Charles, **Travelog** MIT Press, Cambridge, Massachusetts, 1973.

Harbutt, Charles and Jones, Lee (eds), **America in Crisis: Photographs for Magnum** Michael Joseph, London, 1969.

Heinecken, Robert, **Robert Heinecken, The Friends of Photography** Carmel, California, 1980.

Hill, Paul and Cooper, Thomas, **Dialogue with Photography** Thames & Hudson, London, 1980.

Hume, Sandy, *et.al.* (eds), **The Great West Real/Ideal** University of Colorado, Boulder, 1977.

Jeffrey, Ian, **Photography: A Concise History** Thames & Hudson, London, 1980.

Jenkins, William (ed.), **New Topographics: Photographs of a Man-Altered Landscape** International Museum of Photography at George Eastman House, Rochester, New York, 1975.

Jenkins, William (ed.), **The Extended Document** International Museum of Photography at George Eastman House, Rochester, New York, 1975.

Katzman, Louise (ed.), **Photography in California, 1945-80** Hudson Hills, New York, 1984.

Kertesz, Andre, **Andre Kertesz, Sixty Years of Photography, 1912-72** Thames & Hudson, London, 1972.

Klein, William, **New York** Editions du Seuil, Paris, 1956.

Krims, Les, **Fictocryptokrimsographs** Humpy Press, Buffalo, New York, 1975.

Levitt, Helen, **A Way of Seeing** Horizon Press, New York, 1981.

Lyon, Danny, **Pictures from the New World** Aperture, Millerton, New York, 1981.

Lyons, Nathan (ed.), **Photographers on Photography** Prentice Hall, Englewood Cliffs, New Jersey, 1967.

Lyons, Nathan, **Notations in Passing** MIT Press, Cambridge, Massachusetts, 1974.

Mann, Margery and Noggle, Ann (eds), **Women of Photography: An Historical Survey** San Francisco Museum of Art, 1975.

Mark, Mary Ellen, **Ward 81** Simon & Schuster, New York, 1978.

Mertin, Roger, **Records 1976-8** Center for Contemporary Photography, Columbia College, Chicago, 1978.

Metzker, Ray K., **Sand Creatures** Aperture, Millerton, New York, 1979.

Meyerowitz, Joel, **Cape Light** New York Graphic Society, Boston, 1978.

Michals, Duane, **Duane Michals** Museum of Modern Art, Oxford, 1984.

Misrach, Richard, **Untitled** Grapestake Gallery, San Francisco, 1979.

Model, Lisette, **Lisette Model** Aperture, Millerton, New York, 1979.

Morris, Wright, **God's Country and My People** Harper & Row, New York, 1968.

Naef, Weston, **The Collection of Alfred Stieglitz: Fifty Pioneers of Modern Photography** Metropolitan Museum of Art/Viking Press, New York, 1978.

Newhall, Beaumont, **The History of Photography from 1839 to the Present Day** Secker & Warburg, London (rev. ed.), 1982.

Newman, Arnold, **One Mind's Eye** David R. Godine, Boston, 1974.

Orkin, Ruth, **A Photo Journal** Viking, New York, 1981.

Owens, Bill, **Suburbia** Straight Arrow, San Francisco, 1973.

Parker, Olivia, **Under the Looking Glass** New York Graphic Society, Boston, 1983.

Penn, Irving, **Irving Penn** Museum of Modern Art, New York, 1984.

Petruck, Peninah R. (ed.), **The Camera Viewed: Writings on Twentieth-century Photography** (vol.2), E. P. Dutton, New York, 1979.

Rothstein, Arthur, **The Depression Years** Dover, New York, 1978.

Samaras, Lucas, **Photo-transformations** Pace Gallery, New York, 1974.

Sherman, Cindy, **Cindy Sherman**, Schirmer/Mosel, Munich, 1982.

Smith, W. Eugene, **W. Eugene Smith: His Photographs and Notes** Aperture, Millerton, New York, 1969.

Sommer, Frederick, **Sommer: Words/Images** Center for Creative Photography, Arizona, 1984.

Sontag, Susan, **On Photography** Allen Lane, The Penguin Press, London, 1978.

Steichen, Edward (ed.), **The Family of Man** Museum of Modern Art, New York, 1955.

Stettner, Louis (ed.), **Weegee** Alfred A. Knopf, New York, 1977.

Strand, Paul, **Paul Strand: A Retrospective Monograph** Aperture, Millerton, New York, 1971.

Szarkowski, John, **The Photographer's Eye** Museum of Modern Art, New York, 1966.

Szarkowski, John, **Looking at Photographs** Museum of Modern Art, New York, 1973.

Szarkowski, John, **Mirrors and Windows: American Photography since 1960** Museum of Modern Art, New York, 1978.

Szarkowski, John, **American Landscapes** Museum of Modern Art, New York, 1981.

Tucker, Anne (ed.), **The Women's Eye** Alfred A. Knopf, New York, 1975.

Uelsmann, Jerry N. **Jerry N. Uelsmann: Silver Meditations** Morgan & Morgan, Dobbs Ferry, New York, 1975.

Wessel, Henry Jr, **Henry Wessel Jr** Grossmont College Art Gallery, Il Cajon, California, 1976.

Weston, Brett, **Voyage of the Eye** Aperture, Millerton, New York, 1975.

Weston, Edward, **Edward Weston: Fifty Years** Aperture, Millerton, New York, 1973.

White, Minor, **Rites and Passages** Aperture, Millerton, New York, 1978.

Winogrand, Garry, **Public Relations** Museum of Modern Art, New York, 1977.

Wise, Kelly, **The Photographer's Choice** Addison House, Danbury, New Hampshire, 1975.

Witkin, Lee and London, Barbara, **The Photograph Collector's Guide** New York Graphic Society, Boston, 1979.

INDEX